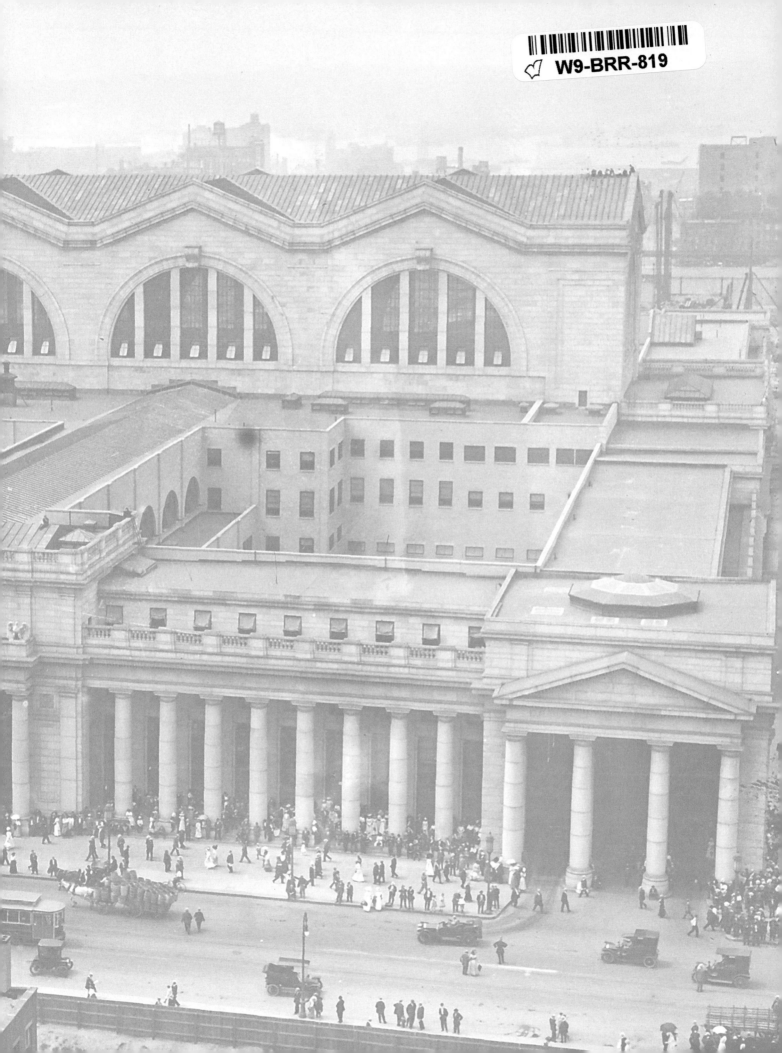

BAIN'S NEW YORK

The City in News Pictures
1900–1925

Michael Carlebach

Dover Publications, Inc.
Mineola, New York

Bibliographical Note

Bain's New York—The City in News Pictures 1900–1925 is a new work, first
published by Dover Publications, Inc., in 2011.

International Standard Book Number

ISBN-13: 978-0-486-47858-6
ISBN-10: 0-486-47858-0

Manufactured in the United States by Courier Corporation
47858001
www.doverpublications.com

ACKNOWLEDGMENTS

This book could not have been written without the commitment of the Prints and Photographs Division of the Library of Congress to collect and preserve the work of American photojournalists. Despite the central role of photographs in the expansion of the newspaper and magazine business at the turn of the last century, and their importance as a kind of indelible visual history of the country, publishers routinely discarded both pictures and negatives when they were through with them. Archivists at the Library of Congress rightly believe in the historical significance of news photographs, and over the years they managed to save a great many, including the George Bain News Service files. I am most grateful, therefore, to Beverley Brannan, Curator of Prints and Photographs, and Barbara Natanson, chief archivist of the Bain collection.

The Library's decision to make many of the Bain News Service images available on flickr ("News in the 1910s: historic photos pilot project"), and to solicit comments from users was extremely helpful. Over the years, a legion of astute viewers provided detailed information about many of the events and persons in the photographs.

Dover Publications is similarly dedicated to preserving, explaining, and publishing the work of the first photojournalists. Dover's catalogue of titles dealing with the medium—original works as well as reprints of historic volumes—is long and varied, and shows a fine appreciation for news and documentary photographs that might otherwise be forgotten. Many thanks, then, to my editors, John Grafton, who guided the project from the beginning, and to Alison Daurio.

I am grateful to archivists and librarians at the New York Public Library, the Museum of the City of New York, Columbia University, Princeton University, Saint Louis University, and Duke University. Thanks also to Bain descendant Martha Durke of MarthaDurkeDesign of San Antonio, Texas, who provided family history as well as a fine early portrait of George Bain. I owe special thanks to my wife, Margot Ammidown, who read many drafts of this material over the years, always providing both encouragement and wise analysis.

Finally, researching the historical use of photographs by the American press is complicated by the disappearance of so many newspapers over the years, and the decision by most of those that remain to charge for access to their archives. To make matters worse, some papers now exist only in the form of microfilm, which does a decent job of reproducing words, but usually renders photographs as crude, unreadable blots. Once again, the Library of Congress provides an invaluable service in their "Chronicling America: Historic American Newspapers" website, which allows all of us access to newspapers that tell the story of the American experience.

TO MY SON ADAM

INTRODUCTION

New York is the concentrate of art and commerce and sport and religion and entertainment and finance, bringing to a single compact arena the gladiator, the evangelist, the promoter, the actor, the trader and the merchant. It carries on its lapel the unexpungeable odor of the long past, so that no matter where you sit in New York you feel the vibrations of great times and tall deeds, of queer people and events and undertakings.
—E. B. White, *Here is New York*

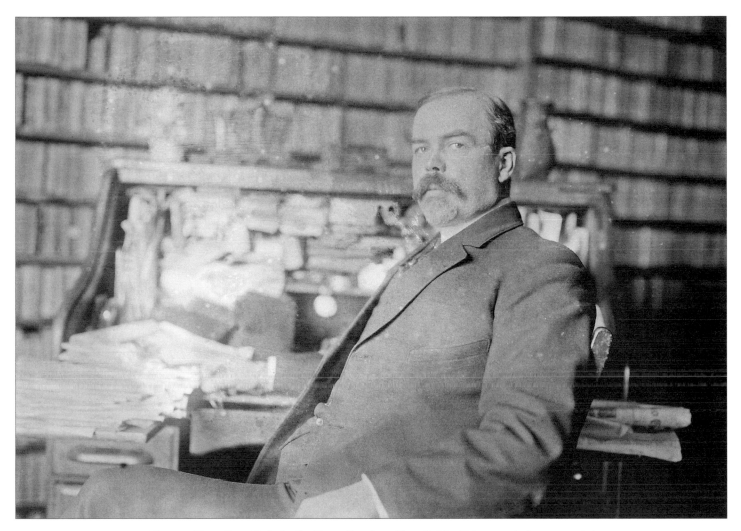

George Grantham Bain in the News Service office. Behind him are shelves containing many thousands of glass-plate negatives.

His friends dubbed him the "Father of News Photography," but George Grantham Bain was no photographer, nor did he invent photojournalism. Nevertheless, there is some truth to the "father" moniker, because Bain was one of the first Americans to recognize that news photographs would ultimately transform the business of journalism, and especially because in 1898 he established the first commercial organization in this country to collect and distribute them. Bain's stunning contribution to the history of journalism occurred during the first decades of the twentieth century, a time when newspapers and magazines in America grew rapidly and reached an unprecedented number of readers, becoming in the process immensely powerful and persuasive institutions. A century has passed since George Bain helped create news photography, and today

newspapers struggle just to stay alive. The capacity of news pictures like these to evoke and persuade, however, is undiminished, if little appreciated. This book is that long overdue appreciation, not only of Mr. Bain and his prescience, but also of the anonymous photographers who made the pictures.

At the turn of the last century, newspapers and magazines were just beginning to experiment with photographs, few publications had photographers on staff, and wire-service photography was still three decades away. With considerable experience in the business of syndicating news stories, Bain saw no reason why images could not be marketed the same way. Although he never lost his fondness for or his belief in the power of the printed word, invariably listing his occupation as "journalist" or "magazinist," the fact is, that for most of his adult life George Bain collected and sold pictures for a living. During his career in journalism he wrote and published short stories, helped define and refine the art of the interview, and began writing a memoir in which he described himself, essentially, as a man of letters, but in the end his most significant contribution to American journalism was the creation of a system that supplied newspapers and magazines in the first decades of the twentieth century with pictures of people and events in the news.

Photographs on the printed page are ubiquitous now, and it may be difficult to imagine newspapers and magazines without them. To be sure, lots of images based on photographs appeared in nineteenth-century publications like *Frank Leslie's Illustrated Newspaper* and its chief competitor *Harper's Weekly*, but they were the work of artists who copied photographs onto steel or wood plates. The original may have been made with a camera, but on the page the illustration looked like an engraving or woodcut. That all changed with the development of the halftone process in 1880. Now at last printed photographs actually looked like photographs, not engravings. It took more than a decade for the process to be perfected and for halftones to be used routinely in the high-speed presses favored by metropolitan newspapers, but by 1897, much of the daily and weekly press in America was running as many photographs of events and people as they could get their hands on.[1] The new pictures helped to popularize newspapers and magazines, as did reductions in per unit price and sensational coverage that appealed primarily to a mass—as opposed to an elite—audience. Fierce competition between the new barons of American media, Joseph Pulitzer, William Randolph Hearst, and Edwin Willis Scripps, led to the extravagant use of screaming headlines, short, pithy news stories, long and occasionally lurid investigative reports, and always, lots of illustrations. The public contest between Hearst and Pulitzer for the services of Richard Outcault, creator of the comic character "The Yellow Kid," led some over-heated critics to characterize all popular daily journalism at the turn of the last century as "yellow," which they understood to be raucous, sensational, and dishonest, a blanket condemnation that seemed aimed as much at the readers as it was at the publishers.

Fussy elitists who claimed only to cherish the beauty and power of the written word really could not abide the strident new journalism because it was directed not at themselves, not, in other words, at the intellectual, business, and governmental elites, but at what they considered to be the unwashed, unlettered masses. The fact that such journalism yielded immense profits and power was especially galling. "There is no malignancy, no virulence, no spite in all these triumphs of journalistic enterprise, but only a calm, keen-witted, sagacious hunt after the almighty dollar," sniffed the editors of *The Illustrated American* in 1890. "Make a stir of some sort, excite the curiosity of the public, tickle its basic appetites, and people will buy your paper; even though they regret the purchase afterward, the price thereof has been transferred from their pockets to yours."[2]

Publishers of the "yellow papers" dismissed the abundant hostility as the self-serving caviling of an old and corrupt moneyed elite, now suddenly afraid, with good reason as it turned out, that their absolute control of the nation's press might soon evaporate. There were political repercussions as well, for some of the new papers had a decidedly progressive and populist slant. E. W. Scripps, whose media empire began with the founding of the *Cleveland Penny Press* in 1878, freely admitted

that his purpose was to promote change. He wrote that the "press of this country is now, and always has been, so thoroughly dominated by the wealthy few of the country that it cannot be depended upon to give the great mass of the people that correct information concerning the political, economic and social subjects which it is necessary that they shall have in order that they shall vote and in all ways act in the best way to protect themselves from the brutal force and chicanery of the ruling and employing class." Scripps vowed to supply the people with news that would, presumably, help them wrest control of their lives from the ruthless grip of the ruling class.[3] Much of that information was in the form of photographs.

There is nothing in Bain's background, personal papers or, for that matter, in his published writing to suggest he harbored the same political views as Scripps and the others, though he clearly came to share their appreciation of photographs. He was born in Chicago in January 1865, and grew up in Saint Louis where his Scottish-immigrant father, also George Bain, owned milling operations scattered throughout the Midwest, including the Minneapolis Mill, then the largest in the United States. Young George excelled in school, first at Smith Academy, a strict Catholic prep school for boys, and then at Saint Louis University where he majored in the classics and earned both bachelor and masters degrees. By his own reckoning he became a journalist almost by accident. The senior Bain was, for a time, president of the Millers' National Association as well as the Saint Louis Merchants' Exchange. As

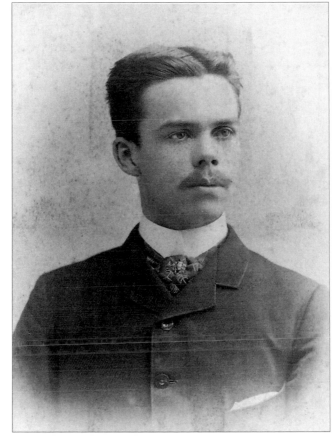

Portrait of Bain as a young journalist.
Courtesy of Martha Durke.

a prominent citizen of the city, reporters naturally sought his views on economic matters, and it was not unusual to have them come to the house in search of an interview. In 1885, Bain's father lost a great deal of money on a deal to export flour to several foreign cities, and the loss was followed almost immediately by a general economic crash. Bain senior collapsed from what his son called "over-strain" and was put under the care of doctors.

The family's attorney at this time was Frederick N. Judson, a neighbor and friend who would one day be named trustee of Joseph Pulitzer's estate. He insisted that his client be shielded from reporters clamoring for a statement, though he also confided to young George, who at the time was working in his father's company, that someone "ought to see the newspapers and give them a statement," if only to counteract the flurry of damaging rumors circulating through the city. Bain volunteered for the job and proceeded downtown to speak with editors at the *Globe-Democrat* and the *Missouri Republican*. At the *Republican* Bain dictated a statement to a reporter, stipulating that it was to be printed as coming directly from his father; he then went down the street to the *Globe-Democrat*. There the city editor, Will Thornton, informed him there was no one available to take his statement, but that he could write his own. He did so.

The next morning both papers ran interviews with Bain's father, though in fact he "was quite beyond the power of giving an interview and wholly unconscious of the visits of the reporters."

This was both a revelation and embarrassment, as each statement was essentially made up. They were Bain's first journalistic efforts, and though somewhat chagrined that the interviews with his father were fake, the pleasure of seeing his own words in print got his attention. "They were the only bogus interviews I ever wrote on any serious matter," he wrote later, adding that the "story had the entire approval of Mr. Judson and later of my father when he was well enough to read them."[4] Less than a year later he left his father's employ for good, determined to become a journalist.

Joseph McCullagh, editor of the *Globe-Democrat*, agreed to hire the young college graduate on a trial basis, thanks to a personal request from Bain's father. McCullagh was a leading citizen of Saint Louis, his renown based in part on his reporting from the front lines during the Civil War for the *Cincinnati Commercial*, and also on his role in the development of the personal interview as an effective method of presenting news.

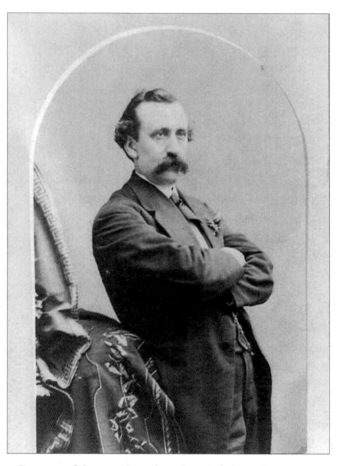

Portrait of George Grantham Bain's father, also George Bain, made in St. Louis in the 1890s.

While in Washington, D.C. shortly after the war, McCullagh spoke at length with President Andrew Johnson, and his reports were published in the *Commercial* as verbatim accounts—a journalistic first.[5] When he eventually joined the *Globe-Democrat* as editor he made sure all reporters were well versed in interviewing techniques. Not surprisingly, the first assignment he gave to George Bain was to "go out and get some interviews on the militia question." The order confused him for a moment. Who, Bain asked, should he interview? McCullagh replied, "I don't care," then swiveled his chair around and went back to work.[6]

Bain's approach to this assignment tells us a good deal about his journalistic instincts and indicates a remarkable level of self-confidence for such an inexperienced reporter. His family's high standing in Saint Louis did not hurt either. He decided the first interviewee would be General William T. Sherman, Civil War hero (or villain, depending on one's sympathies during the war), recently retired Commanding General of the Army, as well as a Bain family friend and the father of George's former schoolmate, Tecumseh. Sherman spoke with Bain at some length, despite the fact that he was no great fan of the *Globe-Democrat*. Bain next went to see Shepard Barclay, a prominent state circuit court judge active in the recent reorganization of the National Guard, and another family friend. He added a few more interviews, and then wrote a two-column story on deadline that the paper ran with but a single minor word deletion. The next day, McCullagh made his position full-time, which is no exaggeration; Bain recalled that initially he worked about twelve hours a day, seven days a week.

Today, Bain's method of interviewing the powerful and famous (his favorite subjects) would be viewed with extreme skepticism, for he took no notes and adamantly refused the services of a stenographer. "If the persons concerned knew they were being reported with stenographic accuracy," he wrote, the result "would be stilted and unnatural." Instead, Bain felt that his purpose was to distill what was most meaningful out of the exchange and present it in compelling prose to the

reader. He never sought to bamboozle or trip up his subjects, to catch them in a lie or reveal some fatal flip-flop. Instead, his purpose was to relay to the reader the "cream of what an intelligent man has said, separated from the skim-milk by the intelligence of the interviewer." Throughout his career this approach served him well, winning him many friends in high places, and not one of whom ever accused him of being a muckraker or yellow journalist. If a person spoke with Bain on the condition that he not be quoted, the reporter dutifully obeyed, though he might write out the story anyway and allow his subject to see it and perhaps agree to its use. If the answer was still "no," the matter ended there. Eventually, Bain decided to allow all his subjects the right to read and even revise his stories before submitting them for publication. This practice would be anathema to journalists today, but it gave Bain unfettered access to some of the nation's most powerful people, and that was very good for his career.[7]

Bain's success attracted the attention of the editors at the *Saint Louis Post-Dispatch*, Joseph Pulitzer's flagship paper, and they lured him away from the *Globe* after less than a year with the offer of a starting salary of twenty-five dollars a week, a considerable sum in those days. Though young and the son of privilege (Bain described himself as a "one-time society man"), he apparently got along well with his fellow reporters at both papers. "Maybe I had a winning way and was unconscious of it," he said.

In the last decades of the nineteenth century, rapid expansion in the newspaper business and a shift away from an emphasis on local news to national and international coverage led publishers to establish out-of-town bureaus. To his surprise and delight, shortly after joining the *Post-Dispatch* Bain was named its first Washington, D.C. correspondent. No doubt the paper's editors

Bain with an unidentified passenger in his car outside of a New York City lunchroom.

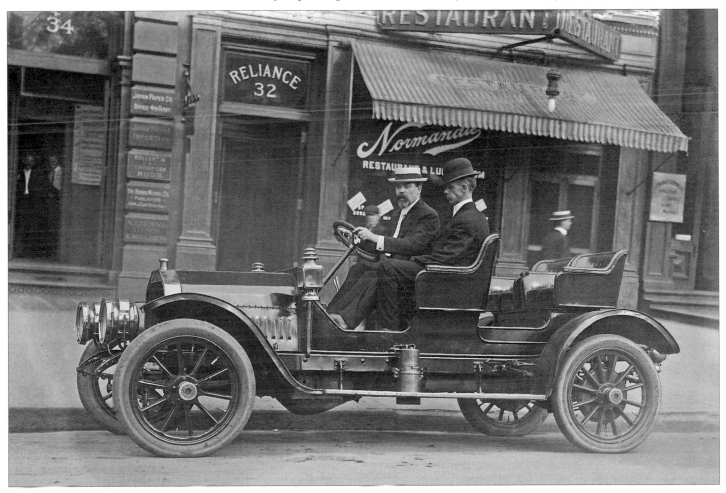

felt that Bain's cordial relations with political and governmental figures outweighed his youth and inexperience, and they were correct. Moving to Washington instantly made George Bain a figure to be reckoned with, and he left his hometown with no regrets at all. "I do not count myself a Missourian," he wrote later. "I say this with no feeling of superiority. I lived in Missouri from an early age until I was twenty years old. But as my ancestors were English and Scotch I do not feel myself akin to the soil." So much for Saint Louis and the family milling business. [8]

Bain's contacts in Washington included members of Grover Cleveland's administration and a host of Congressional and Senatorial power players. One of his favorites was Congressman William McKinley from Ohio, who as Chairman of the House Ways and Means Committee from 1889–1891 pushed hard for the passage of high tariffs on imports to protect American industry. The two remained close after McKinley was elected President in 1896, an event that gave Bain unprecedented access to the inner workings of the White House. In Washington he also caught the eye of Joseph Pulitzer himself, who by this time had moved from the Midwest to New York City where he published the *New York World*. One day, the Washington correspondent for *The World*, Theron Clark Crawford, told Bain that Pulitzer wanted him to come to his hotel and write some letters. The job, he was led to believe, might result in Bain being named Pulitzer's private secretary. Bain refused the offer, preferring the newsroom to a cushy sinecure as private secretary for the wealthy publisher. There may have been other considerations as well. For one thing, Pulitzer and Bain occupied opposite sides of the political spectrum. "My views I have to admit are hopelessly Victorian," Bain wrote, "and no doubt would command the scorn of the 'modern' social leaders of today." Pulitzer, on the other hand, was unabashedly liberal, progressive, and Democratic—the antithesis of Victorian. By temperament and philosophy, Bain was no fan of the new journalism represented by Pulitzer, and it is difficult to see him serving even briefly as an assistant to the man who started it all. There is a hint of something more, as well, a sense that

Bain simply did not approve personally of Mr. Pulitzer, however much he respected his skill as a newsman.

"Pulitzer was not so much interested in news as he was in politics in those young days," Bain remembered. "He got himself elected to the Missouri Legislature and there he achieved a record which made him the object of criticism and abuse—which no doubt he liked." Bain concludes this reminiscence by describing a cartoon of Pulitzer, presumably published in a Saint Louis newspaper other than the *Post-Dispatch*. The drawing, a profile, accentuated "the size of his nose, which was…distinctly Jewish. As I recall it, Pulitzer's face and his enormous Jewish nose appeared…much exaggerated." The artist drew a hand grasping the nose, and added the caption, "Pull it, Sir." Bain seems amused by the picture; Pulitzer, probably not. [9]

After a few years with the *Post-Dispatch*, Bain left the grind of daily journalism to explore the possibilities of syndication. He teamed up with William Frank O'Brien, assistant manager of the United Press Association (UP), an organization founded in 1872 to compete with the Associated Press (AP), and in 1888, the two established the O'Brien-Bain Correspondence Bureau. Their purpose was to distribute letters and short, gossipy items to a variety of publications, pieces that were perhaps outside the confines of regular breaking news and editorial comment. They contributed regularly to the breezy Washington gossip column published each week by the *New York Tribune*, and managed to compile an impressive number of subscribers around the country. [10] The partnership was short-lived, however, because on March 13, 1889, Frank O'Brien died after contracting pneumonia covering the inauguration of President Benjamin Harrison. [11]

Not long after O'Brien's death, the UP's general manager, Walter Polk Phillips, hired Bain to manage the Washington office. Now for the first time Bain had a truly national audience for his stories on government and politics, though the real impact of the job for Bain was that he was able to add significantly to his knowledge of the ins and outs of syndication, of how to supply timely articles and other materials to

periodicals and newspapers around the country. For newspapers the syndication system was vital, allowing them access to important national and international news for the price of a modest monthly subscription. Bain used exactly the same system when he established the country's first syndicate for news photography.

At the UP Bain continued to file stories centered on the activities of Congress and the President, and by all accounts he was both talented and tenacious. In fact, on more than one occasion in 1890, he earned the wrath of Joseph N. Dolph, Republican Senator from Oregon, who became enraged when the proceedings of a supposedly secret committee meeting were made public by Bain for the UP and by A.J. Halford of the Associated Press. Dolph went to the floor of the Senate and threatened to have the two reporters arrested for contempt if they did not immediately reveal the source of the leaks. Both refused. Senator Dolph's long-winded fulminations against these two reporters and other members of the press went on for years, eventually catching the attention of the *New York Times*. "It is possible that Dolph expects to lead a successful fight against the newspapers, the result of which is…to so terrify them that there shall be no more criticism of the Senate," wrote the *Times*, which warned of dire consequences if the hirsute Senator from Oregon "could once get his thumbscrew, rack, [and] crypt…to the Senate in operation." Bain may have been generally a stalwart friend and ally of the power elite, but he was also an energetic and resourceful reporter, and he never informed on anyone who told him things in confidence.[12]

As manager of the Washington office, Bain was in a position to keep for himself the most interesting and important stories instead of assigning them to other reporters. This was the case in August 1890 when he traveled all the way to Auburn, a small city in the Finger Lakes region of New York, to witness and report on the first use of electricity as a means of execution. The process was supposed to be humane, clean, and efficient, and thus a marked improvement over hanging, and it brought an aura of technological wizardry to the noisome business of meting out the ultimate punishment for capital crimes. The first use of

an electric chair was only part of the reason for Bain's trip, however. What really moved this story from the local to the national stage was a bitter dispute between Thomas Alva Edison and George Westinghouse, the founding fathers of the Age of Electricity, who developed competing systems for delivering electric current. Edison's direct current (DC) system was touted as safer, though it required heavy copper cable and numerous power stations, all of which increased costs, while Westinghouse's high-voltage alternating current (AC) had the advantage of being less expensive and much easier to deliver over long distances. Edison contended that AC was far too dangerous for general use since a relatively small amount could kill, and he lobbied the state government in Albany to use the Westinghouse system. If AC was used to kill prisoners, the thinking went, the public would come to believe that it was too risky to allow into the home.

Westinghouse fought just as hard to persuade the state *not* to use his AC system, arguing that electrocution is cruel and inhuman, but Edison prevailed; death at the Auburn Prison would be delivered by alternating current. On August 6, 1890 at 6:38 in the morning William Kemmler, convicted the previous May of killing Tillie Zeigler, his common-law wife, shuffled into the prison's small execution room. Seventeen witnesses sat or stood just a few feet in front of the new electric chair, and several doctors and prison officials stationed themselves behind it. After guards attached straps and electrodes, Kemmler uttered his last words, and warden Charles F. Durston gave the order to begin. It took two long bursts to kill Kemmler. The first jolt lasted about seventeen seconds but failed to completely still his breathing; the second, at roughly twice the voltage, lasted until the room filled with acrid smoke and the nauseating odor of burning hair. It was by all accounts a gruesome scene, and too much for George Bain. He turned to a physician sitting next to him and complained of feeling weak and dizzy. The doctor told him to lie down and began gently fanning him. The only other correspondent in the room, a reporter from the *New York Herald*, mentioned the swoon in his report, and Bain apparently felt he had to defend himself.

On August 12, an article in the *Washington Post* with the headline "Mr. Bain Saw All," put a more positive spin on the incident. Fatigue and a skipped breakfast caused the dizziness, according to Bain, and at any rate he never lost consciousness. "From where he lay he could see and hear all that transpired, and he continued to make notes during the time he was lying down. He soon felt better, and was quickly on his feet again. He did not faint." The following day another article, this one sounding as if Bain wrote it himself, complimented the UP on its coverage of the execution. "The very graphic and complete account of Kemmler's death furnished to its clients by the United Press was written by George Grantham Bain, the Washington correspondent… and a quicker and more brilliant piece of work has never been done in season for afternoon papers."[13] The two *Post* articles offer some evidence of Bain's reportorial skills as well as a certain gift for public relations and damage control. In this and many other cases, Bain seemed eager to explain himself, and to use the media to burnish his reputation.

Six months later, in January 1891, Bain left his job as News Editor of the United Press to explore the possibilities of long-form or narrative journalism.[14] Daily news reporting, whether for a local newspaper or national news service, requires reporters to adhere closely to facts: who, what, when, where, and how. The kind of descriptive journalism and in-depth interview that Bain enjoyed had little or no place at the UP, while numerous general-interest magazines promised a ready market for longer, more creative articles. In addition, Bain wanted to continue syndicating materials like those compiled and sent out by the ill-fated Correspondence Bureau including weekly interviews with public figures. In his new role as a freelance journalist, Bain distributed letters to newspapers around the country that described and commented on the social and political landscape of Washington, an early version of today's ubiquitous political blogs. As with William O'Brien, Bain solicited eminent persons for their thoughts and ruminations, and sent the "interviews" to newspapers around the country. In May of 1897, for instance, Bain asked a select group of elected officials, among them the Populist Democrat governor of Washington, John Rankin Rogers, to comment upon this burning question: "In your judgment, has the celebration of [July 4] lost its patriotic significance and has the anniversary become only a meaningless holiday?" He promised to publish responses in a "syndicate of papers" on Independence Day, which fell on a Sunday that year. Bain's question was made to order for politicians eager to showcase their patriotism, and the need of newspapers for lots of fresh copy, especially on holiday weekends, seemed to promise a good return for his efforts. Rankin's reply ran to over five pages of dense prose (he was in favor of the Fourth of July), but whether it ever ran is not clear. Some of Bain's schemes succeeded; others disappeared without a trace.[15]

During most of the 1890s, Bain wrote articles and short stories for that era's many general-interest magazines, though he avoided any formal association with the growing number of muckraking journals. In 1894, he even ventured briefly into the world of music, providing a revised libretto for Eugenie Lineff's "A Russian Peasant Wedding," a light opera performed most recently at the Chicago World's Fair in 1893. According to *The New York Times*, Lineff's musical needed revision since "there was but one English-speaking character in the piece, and American audiences found it hard to follow the development of the play." Bain's solution was to add a new character, a British artist representing a weekly newspaper "who comes among the Russians to make a study of their customs." The revised version played for one night at Koster and Bial's Music Hall at Broadway and 34th Street with proceeds going to feed the poor.[16]

Throughout the 1890s, Bain's contacts in Washington together with a carefully nurtured reputation for probity continued to give him access to the highest levels of government. Illustrations were now commonplace in magazines, and Bain began including photographs with his submissions since almost all editors seemed more inclined to publish if an article was accompanied by pictures. As an astute student of the press, Bain knew the value and impact of illustrations, and he had

a passing acquaintance with photographers in Washington who supplied pictures to the press. Most of these were primarily studio photographers who were glad to contribute their portraits of the rich and famous to illustrated magazines as a kind of free advertising, but a few were much more. For instance, Bain used to see the aged Mathew Brady during strolls around town, and he knew most of the photographers who worked up on Capitol Hill, either for the government or the press.[17]

The exact moment when Bain realized that the business of supplying photographs to the press might someday supersede that of supplying words is lost to us. It is likely, in fact, that there never was a grand eureka moment, but rather a gradual appreciation of the potential monetary value of photographs combined with the certainty that magazines and newspapers would eventually do just about anything to get them, including paying for pictures that they once got for free. Bain's own experiences with a camera convinced him that photographs were much more than mere ornamentation; they also conveyed information that could corroborate and enhance his written reports. Armed with a simple Kodak camera, Bain made informal portraits and occasionally casual outdoor snapshots of his subjects and included prints with his written profiles. Editors loved the combination of words and pictures, and always asked for more.

As he remembered it years later, a chemistry course in college provided Bain with a basic knowledge of photography, including the preparation and development of glass-plate negatives. However, Bain's early interest in photography may have been influenced even more by his older brother by six years, Robert Edward Mather Bain, who achieved considerable fame as an amateur art photographer in the 1890s, perhaps even eclipsing for awhile his brother's eminence in journalism circles. Robert contributed regularly to photographic journals and exhibited his work in this country and Europe. His principal business was as a travel agent in Saint Louis, representing at various times the Anchor, White Star, and Holland-American Lines, but his renown derived mainly from photographs he made in the Middle East, Turkey, Greece, and Italy for a large-for-mat book titled *Earthly Footsteps of the Man of Galilee*, which was published in 1894. In the introduction, Reverend James W. Lee, one of the authors, noted that "Mr. Bain's capacity to plant a camera before an object so as to take it, to the best advantage, with proper accompanying skyline and perspective, has been settled by the medals he has received…from conventions both in Europe and America." Bain's images documented places important in the lives of Christ and the Apostles, and the book was well received, especially in religious circles.[18]

George Bain mentions neither his brother nor his brother's photography in his published and unpublished writing, and none of the four hundred images Robert made for his book are included in the Bain News Service Collection in the Library of Congress. For that matter, Bain is mostly silent on the subject of religion, noting only that "religious stories do not come easily to my memory."[19] There are several possible explanations for these omissions. First, fine art, amateur, and professional photography were worlds apart in the late nineteenth century, and it would have been unlikely to see what were considered to be artistic or pictorial photographs run as news. That Robert Bain enjoyed success as an amateur, even to the extent that his work was exhibited and published to wide acclaim in a book, did not make the pictures newsworthy (though it must be noted that street scenes shot by Robert throughout the Middle East would not have been out of place in the News Service files). It is just as plausible that Robert's Holy Land photographs were once part of the Bain collection but were lost when a fire in January 1908 destroyed the original collection. There is also the possibility that animus impelled one or both brothers to ignore the work of the other, but that conjecture is unsupported by any hard evidence.

In 1890 and early 1891, Bain published three illustrated articles in *The Cosmopolitan* that presage the future direction of his career. The magazine was published and edited in those years by John Brisben Walker, who attracted a sterling list of writers including Theodore Dreiser, Rudyard Kipling, Annie Besant, and Jack London to write for him, and Bain must have been pleased

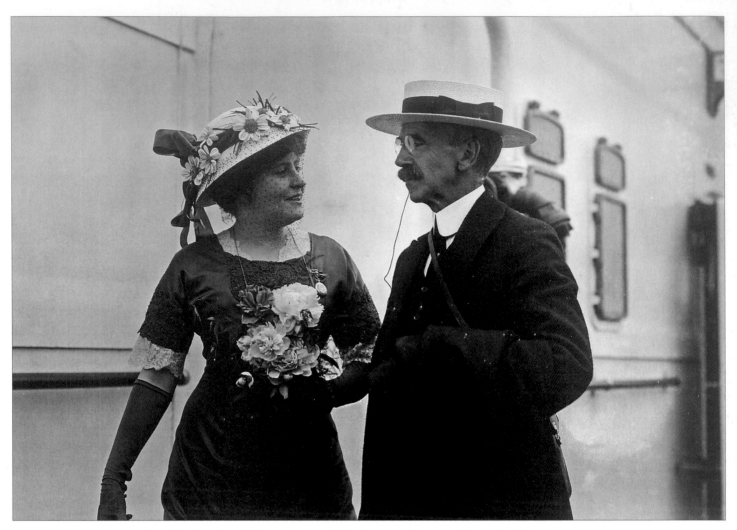

Mr. John Brisben Walker, editor of The Cosmopolitan, *and his wife Ethel.*

to be included in that company.[20] His subject was the administration of the newly elected president, Benjamin Harrison, a Republican from Ohio who narrowly defeated the Democratic incumbent, Grover Cleveland. Bain's articles offer an intimate view of the Executive Branch including the White House, but what makes them especially compelling are the illustrations. The photographs were made by twenty-six year old Frances Benjamin Johnston, whose studio attracted the cream of Washington society. Family connections were initially as important to Johnston as they had been for Bain, but like him, she made her own way in the world, achieving success and fame by dint of her own hard work and creativity.

For Johnston, publication of the Executive Branch stories may have been somewhat bittersweet since only the photographs in the second article were explicitly credited to her. It was not unusual to run photographs without credit in Bain's day, for despite the increasing prominence of photographic illustrations, the name of the person behind the camera was almost always considered less important than the name of the person supplying the words. But Frances Johnston was not just any photographer. An article in the March 1893 edition of *The Cosmopolitan* profiled her as one of America's "women experts in photography," and a frequent contributor to the country's leading periodicals. "An artistic training, with a thorough knowledge of technical detail in photography, are united in the person of Miss Frances B. Johnston, of Washington," wrote Clarence Bloomfield Moore, who would eventually be known for his work in archaeology, not journalism. He added that there was much more

*Frances Benjamin Johnston in her Washington D.C. studio. On the walls are
imprints and covers from many of the publications for which she worked.*

to Johnston than a collection of pictures, since she "possesses a facile pen, and her descriptions are as graphic and as spirited as...the camera work which they describe."[21] That the gritty professions of journalism and photography were too messy or difficult for women to master—a fairly common view in Victorian circles—never occurred to her. "Photography as a profession should appeal particularly to women, and in it there are great opportunities for a good-paying business," she wrote in 1897, adding that the successful woman must have "good common sense, unlimited patience to carry her through endless failures, equally unlimited tact, good taste, a quick eye, a talent for detail, and a genius for hard work."[22] She proved that all her life.

In the years after their first collaboration, Bain occasionally acted as both her agent and advisor,

and in 1898 he called on her to make pictures for his new agency, the George Bain News Service, located at 15 Park Row in the heart of New York City's newspaper district. Bain had been flirting with the idea of a full-time photo agency for some years, and had previously established the Montauk Photo Concern to work with freelance photographers. By 1898, despite the proliferation of illustrated newspapers and magazines, many publishers were still reluctant to hire their own staff photographers or establish in-house photo morgues, and chafed at having to pay for the images they published. Still, the trend toward more and better illustrations on the printed page could not be denied. "The demand for illustrations for periodical publications is now so imperative that almost every possible device is exercised by the publishers...to secure original prints,"

observed Walter Sprange, a frequent contributor to photographic journals, in an article on the illustrated press written for *Wilson's Photographic Magazine*.[23] Bain's venture into the business of supplying news pictures to American publications must have seemed a pretty sure bet.

"There was a great need of news photographs when the use of halftone engraving in newspapers developed," Bain wrote, "and there was no one in the whole United States to supply that need." The centerpiece of the new agency was a syndicate that delivered by mail or messenger approximately eight photographs with explanatory text a day to member papers, excluding holidays and Sundays; in return papers were required to send Bain a similar number of their own photographs. The monthly fee was higher for an exclusive contract in a city, ranging from thirty to as much as sixty dollars. Bain augmented the News Service files with photographs purchased from professional photographers and studios in this country and abroad, and on occasion he hired freelance photographers to work on specific stories. Such was the case with Frances Benjamin Johnston in 1898.

Along with the rest of the American press, Bain had watched the deterioration of relations between Spain and the United States with interest. His old friend William McKinley was now in the White House, and Bain supported those in the Administration who called for war to liberate Cuba and Spain's other colonies.[24] Bain managed to procure photographs of Cuba immediately after the fighting ended, but there were few pictures available of Admiral George Dewey, commander of American naval forces in the Pacific, whose ships decimated the Spanish navy in the Battle of Manila Bay on May 1, 1898. Dewey's lopsided victory made him and his flagship *Olympia* instant celebrities, yet the press had no pictures to go with the stories. Bain contacted Johnston who was about to leave on a European vacation and commissioned her to obtain portraits of Dewey on board his flagship during the fleet's triumphal

Frances Benjamin Johnston with Admiral Dewey aboard the Olympia.

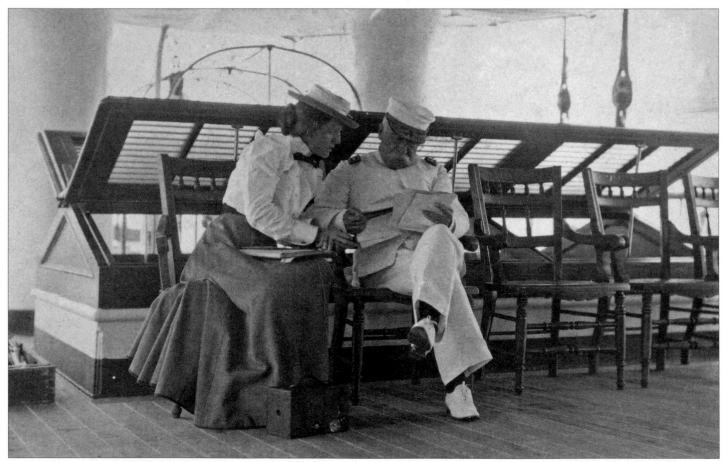

tour of European ports. He emphasized the need for speed, and warned her that there might be competition from another photographer, John C. Hemment. "I have canvassed the situation and I honestly believe that if you cover this subject in your best style and quickly you can make enough out of it to pay for your entire European tour," Bain wrote, sounding downright giddy at the prospect of scooping the world and making a good profit. "Make 150 pictures if you can," he said. "They'll start in at $100 and sell down to $5: but they'll all sell!!!...I hope you'll have the best luck and that we'll make a fortune."[25]

Johnston met the ship in Naples, Italy in early August, presented her credentials, which included a handwritten testimonial addressed to the Admiral from Teddy Roosevelt, and got permission to photograph. While on board she met her competition, John Hemment, who worked for Hearst's *New York Journal* during the war in Cuba but was now freelancing. The two were friends, or at least acquaintances, and after she got the glass-plate negatives developed she entrusted the whole lot to Hemment who planned to return to New York before her. But when Hemment arrived in New York the only negatives he had were his own (Johnston's pictures were left in London), so for about a month he had the lucrative Dewey market to himself. Bain was furious. "And *why* did you entrust your negatives to the only person who was working against you?" he asked. She never offered any explanation. As it turned out, when Bain finally received her pictures they sold surprisingly well; in fact, he sold one of the Dewey portraits to *Leslie's* for $100, a record

Johnston's best-selling portrait of Dewey.

price at the time. And just in case anyone failed to credit her for the best Dewey portrait, Johnston's name and copyright symbol were printed neatly on the lower left hand corner of the negative.[26]

The Bain News Service began with just a dozen subscribers—the first to sign up was his old employer, the *Saint Louis Globe-Democrat*—but his business grew rapidly since initially there was no competition. Eventually, his first office at 15 Park Row could not accommodate the growing collection of prints and negatives, and in 1907 he moved operations to the Parker Building on 19th Street and 4th Avenue, a twelve-story high rise with a reputation for being fireproof. Realizing that he could not long rely on the services of independent contractors like Johnston, and generally dissatisfied with the work produced for him by studio photographers, Bain decided to hire and train his own staff. "It seems almost incredible in these days of swarming cameramen but in that day there was not a news photographer in the country," he remembered later. This particular memory fails to account for the likes of Jimmy Hare, America's preeminent war photographer at the turn of the last century, as well as unaffiliated photographers such as Johnston and her rival, John Hemment. Nevertheless, Bain did indeed become a pioneer in the business of photojournalism, "beginning with the collection of photographs from all over the world and going on through the training of news photographers from such unlikely material as office boys."[27] He could teach his staff just enough to get by about the mechanics and techniques of photography, but

a great deal about the news business and the visual requirements of newspapers and magazines, and they soon fanned out across the city in search of pictures. One of his early hires was J. Hal Steffen who served a two-year apprenticeship with Bain from 1904 to 1906 after working for some years as a grocery clerk in his uncle's store. He left Bain to join the photo staff of the *New York Tribune*, and in time became one of the highest regarded press photographers in New York.[28]

Within a few years the News Service collection was worth, by Bain's estimate, $50,000. His photographers were adept at making feature and breaking news pictures in New York, while assignments given to professionals around the world and images sent in from member papers augmented the library. The five-by-seven inch prints sent out by Bain rarely credited the photographer, just the company. Like Mathew Brady during the Civil War and many others since then, Bain took credit for all pictures distributed by his News Service. As a result, it is usually impossible to know for sure exactly who made specific images in the Bain library, and who, for that matter, deserves to share the credit for pioneering the profession of news photography.

The Saint Louis World's Fair of 1904 should have provided Bain an ideal platform to showcase both his journalistic credentials and the operations of his agency, but in the end most of the publicity he received during the Fair was negative. There was no possibility that the kind of news photographs produced by his staff would be exhibited in either the Fine Arts or Liberal Arts buildings. That photographs made for newspapers could or should be exhibited alongside works of art would not have occurred to anyone connected with the Fair, and such an idea would have surprised Bain as well. News pictures were the stuff of commerce—prosaic and ordinary; essentially they were non-art. Moreover, owing to a very public dispute between the organizers of the Fair and Alfred Stieglitz, head of the Photo Secession and the most famous photographer in America, there were only a few American pictorial photographs displayed at all, and more than one critic complained of the paucity of the American contingent.[29] But Saint Louis was Bain's hometown, and he knew many of the Fair's directors, so he came up with another way to participate and, perhaps, further his career as collector and distributor of photographs.

With the initial blessing of the Board of Lady Managers of the Women's Building, Bain asked some four hundred prominent and wealthy women from around the country to submit portraits for exhibition in the Women's Building. The collected portraits—each neatly framed—were delivered as promised, but the reaction to them was decidedly negative; some Board members expressed dismay at Bain's near total emphasis on wealth and social standing as criteria for inclusion. According to the *New York Times*, the Managers insisted, "we don't want money bags and social prominence. We want American women who have done something to deserve this honor." Many of those originally solicited by Bain subsequently received official letters from the Board notifying them that their portraits would not, in fact, be exhibited. Imagine their consternation when they also received letters from something called "The American Woman—World's Fair, St. Louis, 1904" that suggested that for a fee of one hundred dollars their portrait would be published after all in a so-called "beauty book." One H.W. Sierichs, who may have been Bain's secretary, signed the letter. The idea for the book was not new. Compilations of biographical sketches, with or without illustrations, were and still are common. However, Bain failed to secure the approval of the Fair's Board of Lady Managers for his book, and they strongly denied any involvement in the project. Mr. Sierichs referred all questions to Bain who referred them back to the Lady Managers. Pressed by the *Times* reporter for more information, Lavinia Egan, secretary to the Board's president Mary Manning, replied, "We have not given authority for the promotion of such a scheme, or anything like it. The Board is endeavoring to perform the duties laid out for it, and no recognition has been granted to private enterprises of any sort." For a time the portraits solicited by Bain were stored in boxes in an unused corner of the Women's Building.[30] Whether some or all of them ever graced the walls of the building is uncertain, but it is clear that the promised "beauty book," never happened.

If stung by this failure, Bain appeared

nonplussed and as determined as ever to succeed in business by really trying. The News Service continued to function smoothly, and more and more editors called on Bain to provide news pictures as well as what came to be known as stock photos—generic views of landmarks, urban landscapes, and the like. He was happy to oblige, and directed his photographers to augment their assignments with feature shots that could be combined with text and sold as special packages, further broadening the appeal of the agency.

It is not always easy to accurately describe what is going on in Bain News Service pictures. All of the people and some of the places in the photographs are long gone, of course, and some were not especially newsworthy in the first place. Events that may have seemed vital and riveting a hundred years ago, and which therefore demanded documentation, are now all but forgotten. Most Bain negatives contain but a simple caption hand-printed on the glass-plate negative, a caption that may be misleading; a very few also contain the date the image was made. As a result, the precise meaning and significance of Bain photographs is often difficult to determine. Several years ago, the Prints and Photographs division of the Library of Congress wisely made Bain News

Service pictures available on flickr.com ("News of the 1910s"), and since then astute viewers have provided vital information about a great many of the photographs. We now know, for instance, that Bain's photograph captioned "Susan B. Anthony," made between 1910 and 1915, actually shows Florence ("Daisy") Jaffray Harriman, a prominent New York suffragette and social reformer, waving a banner that includes Anthony's famous exhortation, "Failure is Impossible." It is a fine, dynamic news picture, but it is definitely not Susan B. Anthony, who died in March 1906.

Other pictures in the file continue to defy explication. One of the most popular Bain images on the Internet is "Making [a] Death Mask," a photograph made from an 8-by-10 negative that shows two men in the process of creating a plaster death mask in what looks like an artist's studio. No one in the picture is identified, not the artist or his assistant, and not the person half covered in plaster. The image was most likely made in New York City sometime after January 1908, at a time when the practice of creating death masks was in decline. It seems unconnected to any particular news story regarding funerary practices or the death of a particular person. The location is puzzling as well, since masks made of prominent

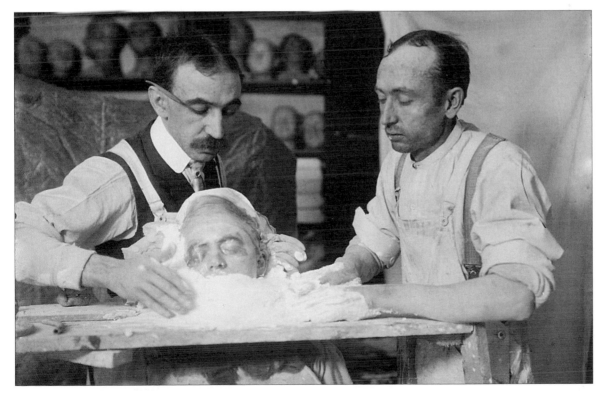

Iconic but unidentified image of a death mask in the making.

persons were almost always taken at the home of the deceased. Even more perplexing is the identity of the sculptor and his assistant. There were not many artists in the city making death masks in those days; the practice was arcane, gruesome, and usually unnecessary anyway given the availability of photographic portraits. That said, there was one prominent sculptor in New York known to routinely make post-mortem masks. William Ordway Partridge was a prolific creator of busts and statues, some of which were based upon death masks. "No piece of sculpture," he wrote in 1895, "can, by the most careful study, be made so like as a death mask or a cast from a living model...."[31] True to his word, in June 1900 Partridge made a death mask for the family of the Rev. Dr. Richard Slater Storrs, pastor of the Church of the Pilgrims in Brooklyn. And in February 1904, Partridge and an assistant went to the mansion of the recently deceased William C. Whitney at 68th Street and 5th Avenue to take his death mask. The *Times* reported that the mask would be used to "perpetuate Mr. Whitney's memory in bronze or marble."

The men in the Bain image resemble Partridge and his occasional assistant Lee Oscar Lawrie, a talented sculptor in his own right who later produced in collaboration with René Paul Chambellan the iconic statue of Atlas at Rockefeller Center. The men in the picture look like Partridge and Lawrie, but it is not an exact match. In the end we are left with a photograph that is stunning in its clarity and subject matter, but perhaps forever elusive in its full meaning and significance.

As a business model the Bain News Service succeeded brilliantly, and it was not long before Bain had competition from similar agencies in New York and Washington, D.C. Having gotten there first, though, and with his superb contacts with editors and publishers around the country and in Europe, the Bain News Service thrived; at least it did until Friday, January 10, 1908. A fire that night swept through the supposedly impregnable Parker Building and destroyed everything in it. Three firemen died fighting the blaze, and fourteen others—firemen and policemen—were injured.

The fire and deaths associated with it were major stories in New York and across the nation, and numerous investigations sought to determine both the cause of the fire and the reasons for the inability of the fire department to fight it effectively. Although one city commission issued a scathing report dividing blame between Deputy Fire Chief John Binns, who directed the placement of fire engines, and Fire Commissioner Francis J. Lantry, who supposedly supplied the department with inferior hoses, several more reasoned analyses placed most of the blame on structural and design features of the building itself. *The American Architect and Building News* stated without equivocation that the "Parker Building did not represent even approximately the modern up-to-date type of skyscraper. A large amount of wood was used in the construction and trim, and the structural members were inadequately protected." The place was a disaster waiting to happen.[32]

The fire probably started a little before 8 p.m. near the rear stairway on the fifth floor and spread rapidly upward and down. The first to discover it was an employee of the Detmer Woolen Company, the major sixth floor tenant, who noticed a large number of mice scurrying about in panic, then saw an orange glow in the sixth floor stairwell. After locking the company's books in the safe, he notified the fire department, which arrived within minutes, but it was already too late. The building was filled with combustible materials, and narrow stairwells and unprotected elevator shafts allowed the fire easy access to each floor. Shortly before ten o'clock a large portion of the building along the rear wall suddenly collapsed, killing the three firemen. For the rest of the night the fire department struggled mostly just to contain the fire.

In the nineteenth century photographers often got the blame for city fires, since some of their materials, like the ether used in the manufacture of collodion and powdered magnesium for flash photography, were known to be both volatile and flammable. In the case of the Parker Building fire, however, none of the reports cited or even mentioned Bain. The days of wet-plate (collodion) photography were long gone, and nitrate negatives, which are notoriously unstable and highly flammable if improperly stored, were

not to be widely used until after 1910. It is most likely that the vast majority of negatives stored in Bain's office were gelatin dry plates, the preferred films of professionals in those days. Undoubtedly materials in Bain's office like large quantities of paper for printing, magnesium used in low-light situations, and all the wooden furniture must have burned freely, but the fire most likely started elsewhere.[33]

Bain heard of the fire at a dinner party. Told the blaze was out of control, he elected to remain with his friends instead of rushing over to 19th Street in hopes of salvaging something—anything.[34] On the way home, he stopped by to take a look at the wreckage, then returned to his apartment, presumably to think

A 1909 Bain News Service photograph credited to Henry Raess showing heavyweight Jim Jefferies, "the boilermaker," sparring with Sume Berger.

Minor fire at the Bain News Service building.

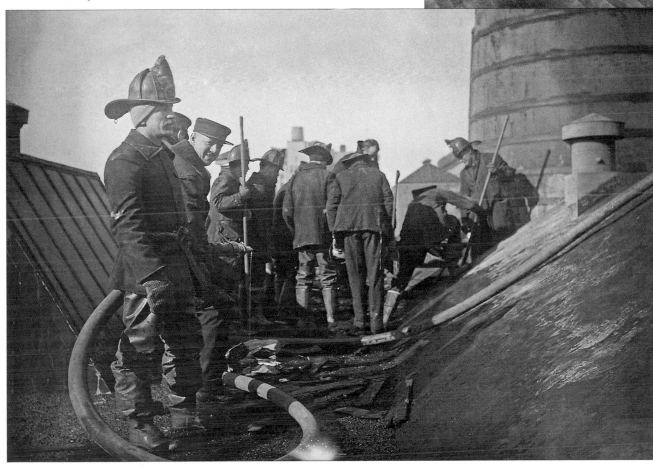

about what to do next. In the morning he went first to the apartment of his best and most reliable photographer, Henry F. Raess, and told him the awful news. There were tears at first, and then Bain got lucky. Office policy forbade photographers from taking home images (a firing offense) since they were solely the property of the Bain News Service, but over the years Raess repeatedly disobeyed. When Bain came to tell him about the fire, Raess admitted everything. "Mr. Bain," he said, "I am going to tell you something. I know you will discharge me, but I have to tell you. You gave me orders not keep any of the photographs I had made. I kept a great many of them, and here they are." Raess handed over a thick stack of prints that became the genesis of the new Bain News Service collection.[35] By the end of the day Bain found new quarters, Raess (chastened, no doubt, but forgiven) and his colleague shot a full day's worth of pictures, and according to Bain's biographer Emma Little, by nightfall he managed to service all his member papers, in town and out.

Four years later, almost to the day, another fire occurred in a building housing the News Service collection, probably the new office at 32 Union Square East. This time nothing was lost, and one of the Bain photographers even managed to make a picture of a group of somewhat laconic New York City firemen working on the roof of the building.

During the next several decades Bain continued the main work of supplying news pictures to the media, though he also sought to expand the agency into other, perhaps more lucrative, areas, especially in the 1920s when faced with increasing competition from agencies such as Harris and Ewing in Washington, D.C., Paul Thompson's company, and Underwood and Underwood in New York. To improve the speed and efficiency of printing news pictures, Bain invented and in 1911 was granted a patent for an automatic printing apparatus that he described as "easily handled," "very simple," "not likely to go out of order," and inexpensive to operate. The device presaged the mechanical printers found in the photo departments of newspapers before digital photography made the development and printing of images obsolete. In 1913, one Donald

Bain News Service 1910 contract with the Toronto Star Weekly.

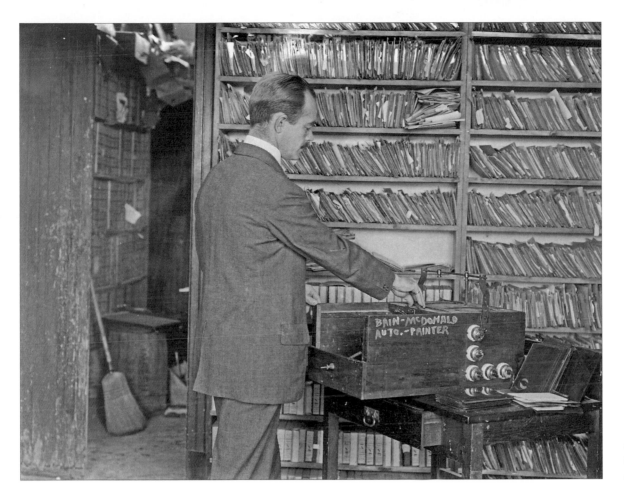

Donald McDonald using Bain's automatic printer.

McDonald of New York City received a patent for a timing device for automatic printers, an improvement on Bain's original machine. Several prints in the News Service collection show a man, presumably Mr. McDonald, at the controls of a printing machine identified on the negative as the "Bain-McDonald Auto Printer."[36]

While current events—breaking and feature news—remained the principal focus of the News Service, they could not by themselves sustain the business. Newspapers and magazines now offered their readers much more than straight news, adding pages devoted to fashion, entertainment and especially sports, and Bain enthusiastically included these areas in the work of the News Service. He knew well the value of celebrity, for instance, and began marketing portraits of entertainers to independent dealers and the public as well as to newspapers and magazines. Bain partnered with the Victor Talking Machine Company to produce photographs and posters of the company's major recording stars, and marketed the pictures through the News Service and in the form of posters sold by subscription to record and sheet music vendors throughout the city. In a flyer sent to dealers, Bain wrote, "This service is closely allied to the Supplements and to Victor advertising; that is, it is based on the Bain News Service of Victor artists...." He added that the portraits on each poster were real photographs that could be removed and either framed or mounted in an album.[37] This poster service may not have succeeded greatly, but Bain's other work with Victor kept the News Service supplied with pictures of some of the most popular entertainment figures in the country. Then, as now, celebrity was good business. So good, in fact, that in the late 1920s, the Bain News Service letterhead included the phrase "Photographs of Musical Celebrities for Publication and Window Display," followed by "Victor Color Poster Service, Hand-Painted with Supplement Photograph."

Bain had a keen interest in the entertainment world, especially in opera and the stage, but it

Is simply charming in "Same Old, Dear Old Place"

Victor Record

Nº 74,681 Price $1.75

© B.N.S.

Victor poster of soprano Sophie Braslau of the Metropolitan Opera.

would be a mistake to assume that is reason for all the celebrity photographs in the collection. The pictures of all those stars are there because they sold well. Historian Peter Bacon Hales got it exactly right: "...Bain was preeminently a businessman, sensitive to the needs of his mass media customers and ready in an instant to mold his treatment to fit the demand."[38] By the same token, there is nothing in Bain's writing to suggest he had a compelling interest in sports, yet the file is filled with portraits of athletes. Despite robust criticism by the old cultural elites of newspapers' new fascination with the world of athletics, the public could not get enough of it. The resulting increase in sports coverage during the first decades of the twentieth century convinced the founders of the American Society of Newspaper Editors, among others, that the business was utterly controlled by "ham-minded men" whose overriding goal was to maximize profit by taking advantage of "undifferentiated readers," luring them with splashy sports pages and mawkish profiles of the latest sports figures.[39] Bain might have agreed with that sentiment, but if the newspapers and magazines demanded pictures of sports heroes, in action and repose, he would gladly supply them. In fact, in 1911 Bain announced a "special sport service" that promised three sports photos a day for only five dollars a week. The first picture in the series showed "Turkey Mike" Donlin with his New York Giant teammates and manager John McGraw upon his return to the Polo Grounds after a three-year hiatus as an actor.

Basically, the events and persons that attracted the attention of the media in the first decades of the twentieth century also attracted the attention

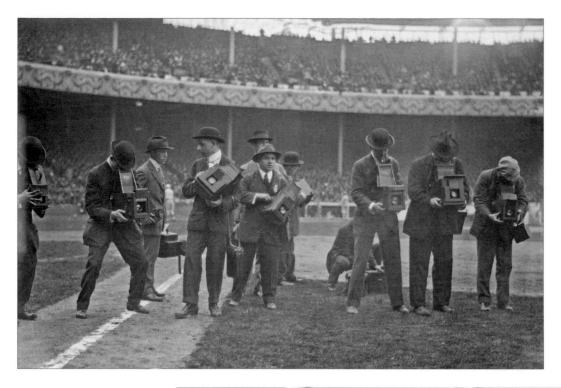

News photographers at the opening game of the 1913 World Series between the New York Giants and the Philadelphia Athletics.

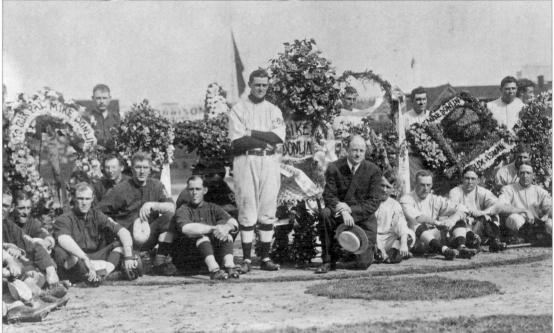

Promotion for Bain's "Special Sport Service" showing "Turkey Mike" Donlin of the New York Giants with manager John McGraw and his teammates.

of George Bain and his photographers. The movement for women's suffrage was a major story across the nation and Bain made sure the News Service had pictures of the principal players as well as the marches and parades that finally led to the passage of the 19th Amendment on August 26, 1920. Immigration also transfixed the country then (as it still does), and Bain's photographers covered it all, from the dismal processing stations on Ellis Island to the noisy, crowded neighborhoods on the lower east side of Manhattan where many of the new arrivals ended up. Strikes and demonstrations by organized labor roiled the business community, and the News Service documented all of it. It is doubtful that George Bain felt much affinity for labor leaders like Big Bill Hayward or other stalwarts of the Industrial Workers of the World (IWW or Wobblies), but they are all in the file, because they were all news. By the same token, the Bain files contain relatively few images of

African Americans, Hispanics, Asians and other minorities, because there were few calls for those subjects from the mainstream press.

During the 1920s Bain looked increasingly to ventures like the Victor posters and something he called the National Identity and Address Bureau, a company providing leather-bound photo-ID cards to individuals and businesses, to augment the work of the News Service.[40] Undoubtedly, he had begun to feel the strain of competition from Wide World Photos, organized by the *New York Times* in 1919, Pacific and Atlantic Photo Syndicate, a joint venture of the *New York Daily News* and the *Chicago Tribune* begun in late 1921, Acme Newspictures, a Scripps-Howard company established in 1923, and International News Photos, a division of the giant Hearst company. The development of inexpensive and efficient methods of transmitting photographs by wire finally sealed the fate of the News Service, though the Bain was no longer actively involved when the AP introduced the first truly effective wire system on January 1, 1935.

The News Service collection ultimately reflects not so much the tastes or values or political ideas of its remarkable creator, George Grantham Bain, but rather those of the newspapers and magazines to which he sold pictures. Bain never did believe in using the press as medium of self-expression; indeed, despite his prodigious output of articles

"Big Bill" Haywood leading striking textile workers in Lowell, Massachusetts.

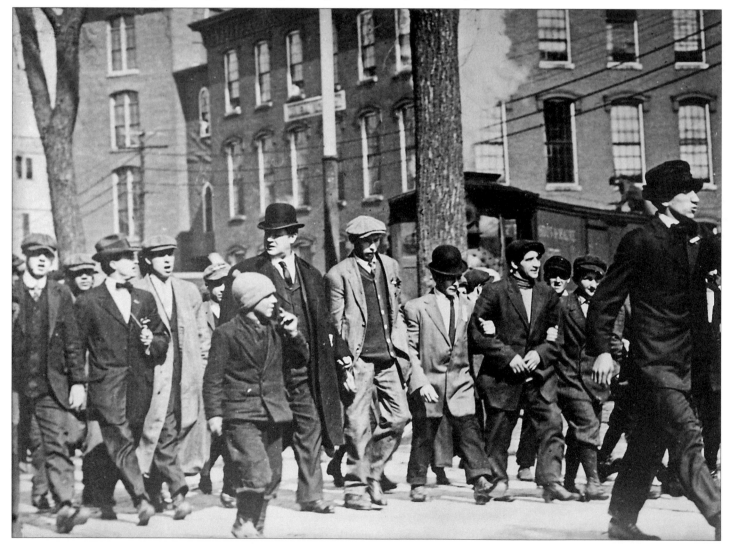

and news analyses over the years, his personal life remains shrouded in mystery. Aside from his public activities—his work as a reporter and at the News Service, his membership in various associations and clubs in New York, a fondness for travel, automobiles, and his fascination with the first airplanes—we know very little about the man. In the end he disappeared almost without notice. A tiny obituary ran in *The New York Times* on April 21, 1944. Mislabeling him as the "father of foreign news photography," the *Times* added "his collection of rare photographs was said to have been very large, possibly worth a considerable sum." Perhaps so, but on the 19th of May that year the Surrogate Court for the County of New York stated that Bain "died possessed of certain personal property…and that the value of all the personal property, wherever situated, or which the deceased died possessed, does not exceed the sum of one thousand ($1000) Dollars." His principal heir was George Vallee Bain, the son of his brother Robert.[41]

The images collected by Bain during the first decades of the twentieth century show us not only what was happening in New York and elsewhere, but also and most significantly what the media felt was important enough to cover. Even the omissions in the file, such as a paucity of photographs depicting African Americans, tell us something, if only of the general indifference of editors and publishers during the early twentieth century in the lives of minorities. If there had been a market for such pictures, Bain would have catered to it, regardless of his personal views. That, after all, was his business.

Because he was based in the heart of New York City, the country's newspaper and magazine capital, Bain amassed an extraordinary visual encyclopedia of the city in the first years of the last century. By a stroke of good fortune, the man who acquired the Bain archive in the early 1940s, David Jay Culver of Culver Pictures in New York, sold almost the entire collection to the Library of Congress in 1946, and it resides there now, the property of all of us. The photographers trained and equipped by Bain were talented and indefatigable, if sadly anonymous, capturing both important moments and everyday life on thousands and thousands of five by seven and eight by ten inch dry-plates. And because American newspapers, wholly ignorant and uncaring of the social and cultural importance of news photographs, even those made by their own employees, thoughtlessly destroyed their photo morgues over the years, filling dumps and landfills with priceless visual history—negatives and all—the Bain News Service pictures in the Library of Congress now stand practically alone to remind us who we were, and whence we came.

MICHAEL CARLEBACH

Caricature of Bain by his friend and fellow Dutch Treat Club member James Montgomery Flagg, creator of the iconic "I Want You" poster of Uncle Sam.

1. W. Joseph Campbell, "1897. American Journalism's Exceptional Year," *Journalism History*, vol. 29, no. 4 (Winter 2004), p. 191. See also John William Tebbell, *A History of Book Publishing in the United States*, vol. II: *The Expansion of an Industry 1865–1919* (New York: R.R. Bowker, 1977), pp. 665–666.

2. "Current Comment. Latter-Day Journalism," *The Illustrated American*, vol. I, no. 12 (May 10, 1890), p. 274.

3. Charles R. McCabe, ed., *Damned Old Crank. A Self-Portrait of E.W. Scripps* (New York: Harper and Brothers Publishers, 1951), p. 146.

4. George Grantham Bain, "Entering Journalism," and "The Subtle Art of Interviewing," unpublished manuscripts, George Grantham Bain Papers, ca. 1895– ca. 1935, Manuscripts and Archives Division, New York Public Library. Hereafter cited as Bain Papers, NYPL.

5. "Editor McCullagh Dead," *New York Times* (January 1, 1897), p. 1; "Gossip of the Capital," *New York Times* (January 3, 1897), p. 3.

6. "The Subtle Art of Interviewing," unpublished manuscript, p. 5, Bain Papers, NYPL.

7. Ibid., pp. 7–8, 12.

8. "I Had to Laugh. Echoes of a Very Busy Life," unpublished manuscript, Bain Papers, NYPL, p. 87.

9. Ibid., pp. 180–181.

10. Thomas Campbell-Copeland, *The Ladder of Journalism: How to Climb It* (New York: Allan Forman, 1889), pp. 122–123; "General Gossip of Authors and Writers," *Current Literature*, vol. IV, no. 4 (April 1890), p. 270.

11. "Stricken Down in His Prime," *Washington Post* (March 13, 1889), p. 2.

12. "Hunting for the Leak," *Hartford Courant* (February 28, 1890), p. 1; "Not With Dolph," *Hartford Courant* (March 5, 1890), p. 1; "Merciless Senator Dolph," *New York Times* (June 1, 1894), p. 4.

13. "Mr. Bain Saw All, *Washington Post* (August 12, 1890), p. 6; "Complimenting Correspondent Bain," *Washington Post* (August 13, 1890), p. 2. See also "Kemmler's Death. Horrible Scenes at His Execution," *San Francisco Chronicle* (August 7, 1890), p. 2.

14. "Changes in the United Press Office," *Washington Post* (January 15, 1891), p. 2.

15. John Rankin Rogers Papers, Box I, folder 37, Manuscripts, Archives, and Special Collections, Washington State University Libraries.

16. "Many Appeals for the Poor," *New York Times* (January 17, 1894), p. 3.

17. Emma H. Little, "The Father of News Photography: George Grantham Bain," *Picturescope*, vol. XX (Autumn 1972), pp. 126–127.

18. "Introduction" in Bishop John H. Vincent, Reverend James W. Lee, and R.E.M. Bain, *Earthly Footsteps of the Man from Galilee* (New York and Saint Louis: N.D. Thompson Publishing Company, 1894).

19. "I Had to Laugh…" Bain Papers, NYPL, p. 71.

20. George Grantham Bain, "The Executive Departments of the Government," *The Cosmopolitan*, vol. X (October 1890), pp. 36–47; "The Executive Departments of the Government, Part II," *The Cosmopolitan*, vol. X (November 1890), pp. 36–47; "The President's Office and Home," *The Cosmopolitan*, vol. X (April 1891), pp. 36–45. Bain's articles on the White House and Cabinet were noted in "Magazine Notes," *The Critic: A Weekly Review of Literature and the Arts* (October 11, 1890, p. 14 and "Magazines and Periodicals," *Zion's Herald* (April 15, 1891), p. 115.

21. Clarence Bloomfield Moore, "Women Experts in Photography," *The Cosmopolitan*, vol. XIV (March 1893), p. 586.

22. Frances Benjamin Johnston, "What a Woman Can Do With a Camera," *Ladies' Home Journal* (September 1897), p. 6.

23. Walter Sprange, "Facts Concerning Copyright and Reproduction," *Wilson's Photographic Magazine*, vol. XXXIV, no. 482 (February 1897), p. 85.

24. George Grantham Bain, "Spain Must Lose All," *Washington Post* (June 5, 1898), p. 20.

25. George Grantham Bain to Frances Benjamin Johnston, Papers of Frances Benjamin Johnston, Manuscript Division, Library of Congress. See also, Amy S. Doherty, "Frances Benjamin Johnston 1864–1952," *History of Photography*, vol. 4, no. 2 (April 1980), pp. 103–104.

26. Emma H. Little, p. 132.

27. "I Had to Laugh…," Bain Papers, NYPL, p. 167.

28. "J. Hal Steffen, A Camera Expert," *New York Times* (April 14, 1937), p. 25.

29. "The Fiasco at St. Louis," *The Photographer,* vol. 1, no. 12 (July 16, 1904), pp. 178–180; "The Fiasco at St. Louis," *The Photographer,* vol. 1, no. 17 (August 20, 1904), pp. 258–259.

30. "$100 for Picture in 'Beauty Book'," *New York Times* (May 8, 1904), p. 1.

31. William Ordway Partridge, *Art in America* (Boston: Roberts Brothers, 1895), p. 38.

32. "The Parker Building Fire," *The American Architect and Building News*, vol. XCIII, no. 1674 (January 23, 1908), p. 34.

33. New York Board of Fire Underwriters, *Report on Fire. January 10, 1908 in Parker Building* (April 22, 1908), pp. 8–21.

34. Emma Little, p. 129.

35. "I Had to Laugh…", Bain Papers, NYPL, pp. 167–168.

36. G.G. Bain (1911), "Printing Apparatus," U.S. Patent No. 1,012,585; D. McDonald (1913), "Timing Device for Photographic Printing Apparatus," U.S. Patent No. 1,054,435, Washington, D.C.: U.S. Patent and Trademark Office.

37. "You Will Like This New Color Service," (May 1921), Bain Papers, NYPL.

38. Peter Bacon Hales, *Silver Cities. Photographing American Urbanization, 1839–1949*, rev. ed (Albuquerque: University of New Mexico Press, 2005), p. 407.

39. Cited by Bruce J. Evenson, "Jazz Age Journalism's Battle over Professionalism, Circulation, and the Sports Page," *Journal of Sport History*, vol. 20, no. 3 (Winter 1993), p. 234.

40. Letterhead in the Bain Papers, NYPL.

41. Surrogates Court, County of New York, Decree Granting letters of Administration, file no. A 1365, 1944, p. 85.

Bain's New York

The City in News Pictures
1900-1925

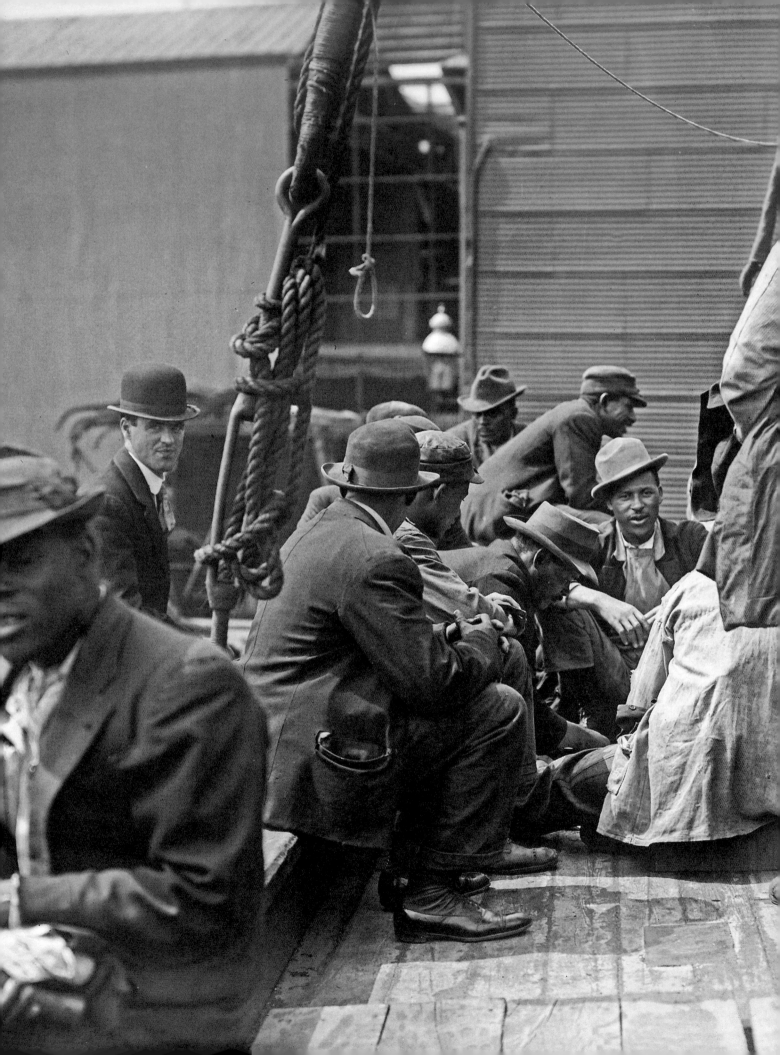

COAL PASSERS
TALK STRIKE

Perhaps the least enviable job on steamships was that of coal passer. Working far below deck in the stygian gloom and oppressive heat of the ship's bunkers and boiler rooms, coal passers worked with trimmers and firemen, the so-called "black gang" because of all the soot, to keep the ship's furnaces stoked. Once in port, coal passers spent their days cleaning inside and around the boilers, removing ash, clinkers, and coal dust. It was brutal and dangerous work for low pay, and occasionally there was talk of a strike.

This photograph made on June 14, 1911, shows a group of coal passers (and one dapper, out-of-place man in a bowler hat) on an unnamed ship. There was considerable discontent on the docks that summer, both here and abroad, much of it directed at the ships owned by America's premier industrial mogul, J. Pierpont Morgan. On June 10, dock workers and seamen struck in England, and on June 18, the International Seamen's Union in New York ordered a strike of its members, demanding an increase in pay of $2.50 a month and unspecified improvements in living quarters and food on board.

Two days later the strike ended with terms favorable to the union. It is not known what became of the men in this picture. Morgan and other shipping magnates were quick to hire strikebreakers, so a work stoppage among menial and unskilled laborers often meant the permanent loss of jobs. *The New York Times* reported on June 21 that a group of black strikebreakers had to be given a police escort to the Morgan pier at the foot of West 11th Street; they may well have been replacements for some of the coal passers in Bain's image.

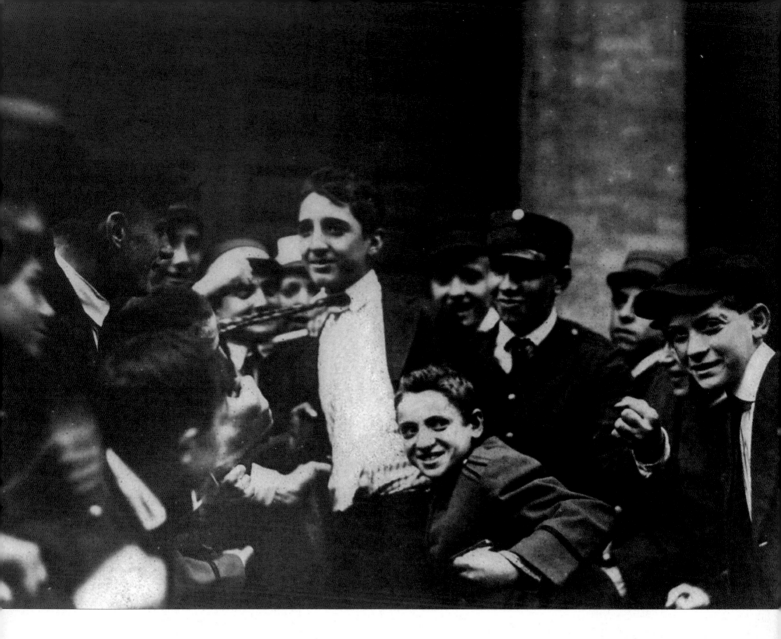

MESSENGER BOYS—SURROUNDING A SCAB

Messenger boys were at once the most visible and least appreciated components of the vast system of electronic telegraphy that developed in mid-nineteenth century America. School-age boys typically worked ten or eleven hours a day, seven days a week, delivering "instant" messages to businesses and individuals, and they did so for a pittance and without the slightest job security. Complaints and even the hint of interest in organizing were met with summary firings. But they struck anyway.

Strikes for better pay, shorter working hours, and lower weekly rent for their required uniforms were frequent but rarely successful. Companies such as Western Union and American District Telegraph (now ADT Security Systems,) often countered the strikers by hiring new messengers at double wages for the duration. Striking boys fought back by harassing, sometimes beating the scabs, but family pressure and the uniform hostility of the mainstream press usually forced strikers back to work after a week or two, oftentimes with little or nothing to show for their efforts. Companies invariably refused to rehire strike leaders or union organizers.

In this photograph, probably taken in late November 1910 during a ten-day strike against ADT and the Postal Telegraph Company that received abundant coverage in New York City newspapers, strikers surrounding a somewhat bemused scab pose for Bain's photographer. Telegraph companies instructed strikebreakers to wear ordinary clothes on the job, hiding message pads and official company badges in their pockets, but pickets like those seen here were adept at spotting scabs. The *New York Times* concluded on November 24, 1910, that the strike was more a joke than an inconvenience "because it has happened so many times before."

GORRIE GUARDED BY POLICE

When members of the International Association of Machinists voted to strike against the E.W. Bliss Projectile Company in Brooklyn at the end of April 1911, every union member and all but one non-union worker joined the walkout. The issue was the company's refusal to adopt the eight-hour workday. The lone holdout was Harry Gorrie, a thirty-year old machinist who lived not far from the Bliss plant on 53rd Street. Gorrie's decision enraged his fellow workers. For several days the strikers merely argued with him, but after about a week he was surrounded by a jeering, threatening mob on his walks to and from work. He sought and was granted police protection.

By May 10, Gorrie's slow treks from his home to the factory and back, accompanied by mounted police and patrolmen, attracted crowds of men and women who pelted the group with bits of street rubble and refuse. Gorrie seemed nonplussed as he walked along, calmly smoking a pipe and occasionally chatting with the patrolmen by his side, which naturally further inflamed the crowd. The air was thick with hurled projectiles and invective. Although in this picture Gorrie appears to be shielding his face from the camera in a manner that is now familiar to anyone looking at news pictures of camera-shy personalities, it may be that he also held the hard little bowler hat over his face as protection from flying objects.

The strike against E.W. Bliss fizzled out without achieving the main goal of a shorter workday, and everyone eventually went back to work with the apostate Gorrie. For the next several years, strikes against the company continued apace, sometimes for the eight-hour day, sometimes for higher wages, sometimes for both, but Harry Gorrie never again took center stage.

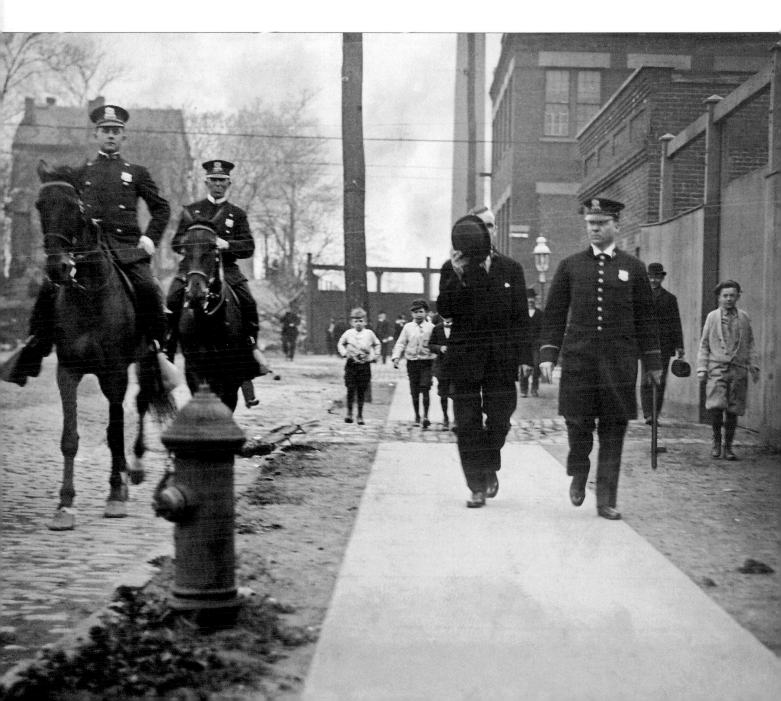

BREAKING GARBAGE STRIKE

There was always an understandable level of discontent among those who collected the city's garbage, but in the summer of 1911 normal dissatisfaction began to give way to talk of a strike. Of central concern was the decision to inaugurate a system of nighttime collection, considered by many to be both cruel and unnecessary. The Commissioner of Street Cleaning, William "Big Bill" Edwards, heard the rumors and, with the support of Mayor Gaynor, informed the workers' union, the International Brotherhood of Teamsters, Chauffeurs, Stablemen, and Helpers, that a strike would be met with immediate termination and the hiring of non-union workers.

Neither Edwards nor Gaynor would rescind the order for nighttime collection, and on November 9, the drivers struck. True to his word, Edwards responded with a mass firing, and the garbage began piling up. There were scattered acts of vandalism and violence as city officials replaced striking workers with several thousand men culled from the Civil Service list and about two thousand scabs supplied by employment agencies. After about a week, the new workers and sweepers, sometimes with a police escort, began to make a dent in the piles of accumulated garbage, and the strike was effectively broken.

On November 20, Commissioner Edwards presided over a Civil Service hearing to determine the futures of those who went out on strike. Each fired worker was given about half a minute to explain to the Commissioner, who acted as sole judge and jury, why he left his job. Two days later, Edwards announced that all but 140 of the strikers were permanently dismissed. With the Street Cleaning Department now functioning well with its non-union drivers and sweepers, Edwards saw no reason to be charitable to union men who left their jobs without his permission.

MAY DAY PARADE

On April 28, 1910, the *New York Times* predicted that the coming May Day parade, actually scheduled to take place on August 30, was likely to attract some 50,000 socialists and union sympathizers. As it turned out, many more than that showed up, among them tens of thousands of women whose struggle for decent pay and humane working conditions in the garment industry was already very much in the news. The manufacture of women's shirtwaists (blouses) was a huge industry in New York, with hundreds of shops and factories employing some thirty thousand workers who often toiled through ten- and twelve-hour days in crowded, sometimes filthy conditions for as little as five or six dollars a week.

In November 1909 over twenty thousand of these shirtwaist workers, most of them young immigrants from Russia and Eastern Europe, launched a general strike that eventually lasted for eleven weeks. Though harassed by the police and threatened, bullied, and beaten by thugs hired by some factory owners, the women persevered and managed to win some concessions, as well as the support of the American Federation of Labor. Those who later chose to participate in the 1910 May Day parade up 5th Avenue from Rutgers (now Straus) Square to Union Square were both energized and triumphant, and many of them (as several of the women in this photograph) wore white shirtwaists adorned with red and blue scarves, much to the delight of the large crowd.

The strike and parade notwithstanding, some of the largest factories in the garment district continued to resist reform, even insisting in some cases that women work longer hours for less pay. A dreadful fire at the Triangle Shirtwaist Company on March 25, 1911, which killed 146 women, caused a flood of anger toward the owners and sympathy for the workers, and led to fundamental changes in the industry.

SYMPATHY PARADE

During the summer of 1916, miners on the Mesabi Iron Range in northern Minnesota stuck against the Oliver Mining Company, a subsidiary of J.P. Morgan's massive United States Steel Corporation. The miners demanded an end to the contract system that paid workers according to the amount of ore produced rather than the number of hours worked, and complained as well that that excessive living costs in company towns like Aurora, Hibbing, and Virginia further diminished their meager earnings.

Both U.S. Steel and Oliver Mining were vehemently anti-union, and refused to recognize or negotiate with the strikers. The union representing the miners, the International Workers of the World or "Wobblies," was equally adamant, accusing the mine owners in particular and capitalists in general of fundamentally criminal and immoral behavior. The walkout devolved into a bitter, violent struggle that eventually produced three deaths, many injuries, and the jailing of several hundred strikers. On September 17 the strike ended with no concessions by Oliver Mining; several miners and organizers remained in jail, accused of murder or complicity in the deaths of a deputy and innocent bystander on July 3.

On December 1, 1916 the Defense Committee of the Minnesota Iron Strikers' Association applied for and was granted a permit for parades in Brooklyn and Manhattan to express concern and sympathy for those still held in jail. The Brooklyn contingent marched over the Williamsburg Bridge and met the Manhattan group in Rutgers (now Straus) Square, then both groups headed uptown to Union Square. There were speeches in several languages, and Bain's photographer moved easily through the peaceful crowd, making at least three pictures of marchers and their mostly hand-printed protest signs.

PROTEST AGAINST
CHILD LABOR

A sudden spring storm complete with snow, hail, and torrents of cold rain blew through New York on April 30, and the forecast for Saturday May 1 was for more of the same. The prediction of foul weather led to the postponement of the annual Automobile Carnival Parade, but the organizers of traditional May Day labor parades and protest meetings were undaunted. Socialists, Wobblies, unaffiliated anarchists, and union members from a variety of trades gathered at various locations in lower Manhattan to protest and parade.

At Union Square there was an angry dispute on the speakers' platform when Socialist organizers denied Alexander Berkman, a prominent and fiery Anarchist, the right to speak. The meeting broke up in some confusion, with Socialists insisting it was all over while Berkman and the Wobblies kept right on talking.

Elsewhere labor meetings and parades proceeded smoothly, though intermittent rain kept the crowds small. The *New York Sun* reported that about 2,000 striking bakers from over three hundred East Side bakeries marched from their headquarters at 127 Delancey Street to Union Square, some of them bearing aloft a six-foot-long loaf of bread studded with small flags. And from the Labor Temple at 242 East 14th Street came thousands of marchers affiliated with the First Agitation District of the Socialist Party and the United Hebrew Trades Council. Among that group were approximately 6,000 women from various unions, marching to protest long hours for low wages, unsafe working conditions, and, as in this photograph, the continuing employment of young children in sweatshops and factories. Not surprisingly, many of the flags, banners, signs, and sashes carried by the marchers were printed in both English and Yiddish, blending the language of immigrants from Eastern Europe with that of their adopted country.

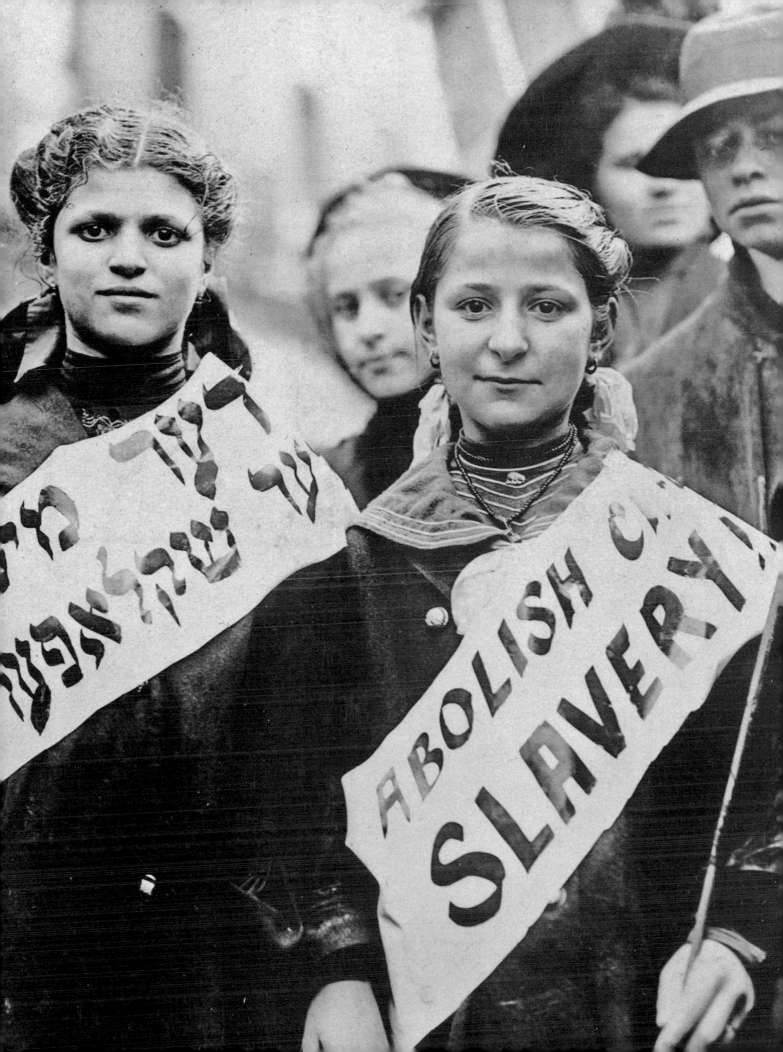

WORK HORSE PARADE

Despite the undeniable impact of motorized transportation during the first decades of the twentieth century, the horse-drawn variety remained a fact of city life, especially in the crowded neighborhoods below 14th Street in Manhattan. The care and feeding of draught animals was a particular concern of the New York Women's League for Animals, established in 1906 by Ellin Prince Speyer as the Women's Auxiliary of the American Society of the Prevention of Cruelty to Animals. Beginning in 1906, Speyer's group organized an annual Work Horse Parade to honor what the New York Times called "suffering horses, the bread winners of the poor."

The May 1908 parade featured over a thousand horse-drawn vehicles, which lumbered up Fifth Avenue from the Washington Arch to the monument honoring General William Jenkins Worth, hero of the War of 1812, the Seminole Wars, and the Mexican-American War, at Madison Square. At a reviewing stand near the Worth Monument, judges, led by Ellin Speyer, awarded ribbons and small cash awards on the basis of grooming, handling, and overall appearance.

In addition to the annual parade, the Women's League established the Free Hospital for Animals at 350 Lafayette Street, and maintained some twenty watering places for horses throughout the City. Two of these stations—at Wall and South Streets and at West and Murray Streets—stayed open twenty-four hours a day to accommodate farmers and manufacturers delivering goods by horse at all hours of the day and night.

JULIA HURLBUT AND
MRS. J. W. BRANNAN

Eunice Dana Brannan, chairperson of the New York branch of the National Woman's Party (NWP), and Julia Hurlbut, vice chair of the group's New Jersey branch, were two of sixteen suffragettes arrested on July 14, 1917, for picketing in front of the White House, though the charge was "obstructing traffic." Washington authorities sought to silence the women with long sentences (thirty to sixty days for what amounted to jaywalking) and harsh treatment at the Occoquan prison in Virginia, but news of their suffering at the hands of Warden William H. Whittaker moved even President Wilson, and he ordered their release.

Though treated like common criminals, the suffragettes were anything but. Eunice Brannan, for instance, was the wife of Dr. John Winters Brannan, president of the Board of Trustees of Bellevue Hospital, and the daughter of Charles Dana, founder and editor of the *New York Sun*, the first penny paper in the United States. She and her fellow protestors were well educated and often from the upper reaches of society, which may explain the brutal enmity of Warden Whittaker and his guards.

After their release, Hurlbut, Brannan and the others continued speaking for the right of women to vote. The banner held by Hurlbut in this photograph announces a mass meeting at Carnegie Hall where the White House picketers planned to describe their trial and incarceration. Brannan was re-arrested at the White House in November 1917, though her sentence of forty-five days at Occoquan was suspended. During World War I, Julia Hurlbut went to France with the YMCA, where she managed an officers' club and enlisted men's canteens at Chatillon-sur-Seine. The nineteenth amendment to the Constitution finally passed in 1920.

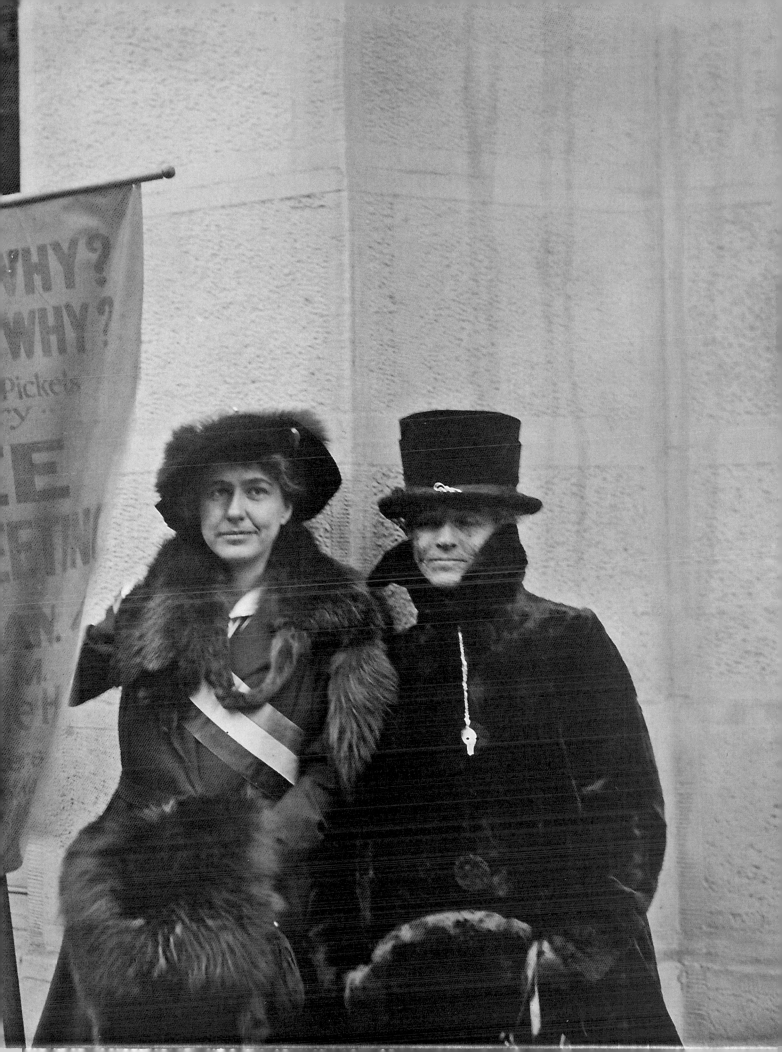

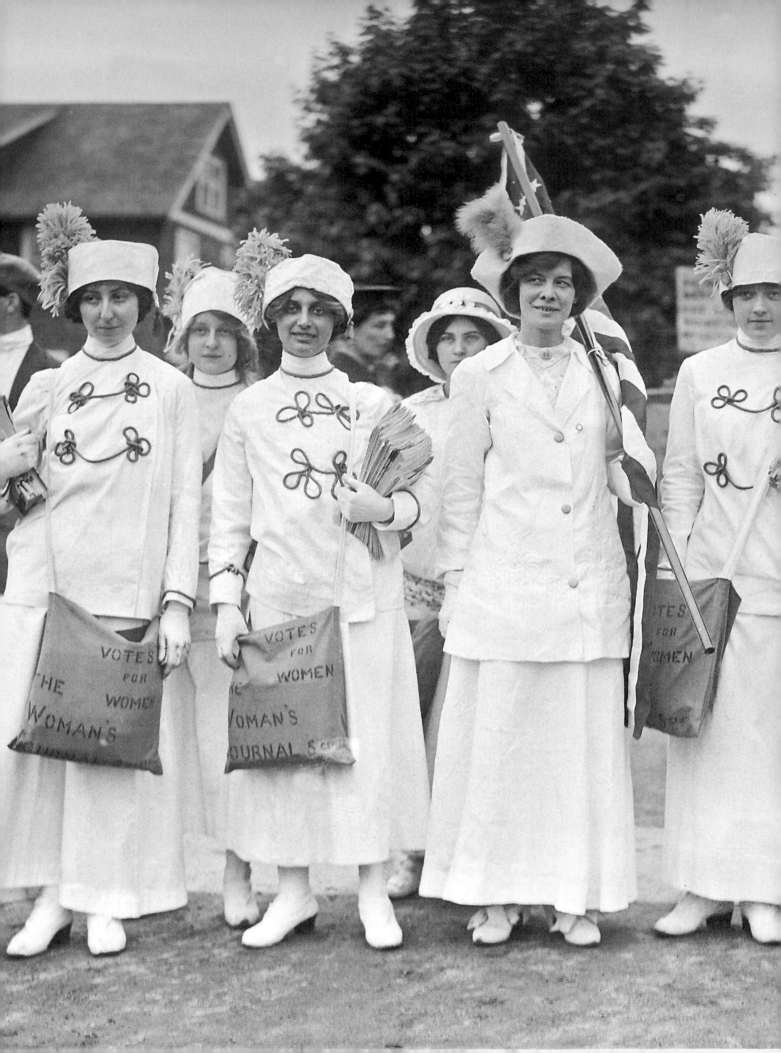

SUFFRAGE NEWS GIRLS

On the afternoon of Saturday May 24, 1913 the public road between Hempstead, Long Island and Mineola was crowded with automobiles moving slowly behind some five hundred marching suffragettes (or suffragists as they were sometimes called). Led by the inimitable John C. "Suspender Jack" McGee in full Rough Rider regalia and a contingent of Boy Scouts, the parade included a lively band, and wagons and buggies decorated with banners, flags, and flowers. Charlie Hild, who later served with the Lafayette Escadrille in France, flew his hand-made monoplane at 800 feet over the marchers.

The "suffrage news girls" seen here, led by suffragette and civil rights activist Elisabeth Freeman (holding the flag), carried newsboy tote bags, each presumably filled with copies of the five-cent weekly illustrated *Women's Journal and Suffrage News*. Founded in 1870 by Lucy Stone and her husband Henry Browne Blackwell, the *Women's Journal* had a circulation of nearly 28,000 in 1915, and provided readers with detailed coverage of the movement, illustrated stories that belied the negative coverage and commentaries run in some mainstream newspapers and magazines.

When the parade arrived at the trolley junction in Hempstead, Rosalie Jones, called General for her organization of the pilgrimage from New York City to Albany in 1912, presented a silver cup to the most effective float, a vehicle filled with children identified as the "Little Twins of the Brookholt Branch." There were speeches by Jones, President Floyd Weekes of the Village of Hempstead, and State Senator Thomas H. O'Keefe from Oyster Bay. When the meeting disbanded, squadrons of suffragettes in automobiles set out for neighboring towns to spread the word.

SPECTATORS AT PLAYGROUND
DANCE–WALDORF ROOF

At the turn of the last century New York badly needed additional parks and recreation facilities. In crowded neighborhoods throughout the city, many children had no real access to open space and play was something that happened on the streets without adult supervision. Progressives like Jacob Riis had deplored the lack of parks since the late 1880s; by 1909 members of the city's elite, even those among Mrs. Caroline Astor's fabled four hundred, were actively involved.

Under the leadership of Eugene Ambrose Philbin, the New York Parks and Playgrounds Association, founded in 1906, began looking for ways to demonstrate the benefits of supervised activities for children. The Association had limited funds with which to purchase land, so Philbin and others considered the possibility of converting the unused rooftops of high rises into instant public playgrounds. George Charles Boldt, proprietor of the original Waldorf-

Astoria Hotel at Fifth Avenue and 33rd Street, agreed to allow Parks and Playgrounds Association to use the recently completed roof garden at his hotel on the afternoon of March 29, 1909, to show New York society what could be done on the roof of a building.

About 100 children played in the rooftop garden that afternoon, and then performed a series of folk dances for an audience consisting mostly of society women. Tea was served in a sunroom on the roof, and the children given their fill of cake and ice cream. Afterward, George Boldt told a reporter for the *Times* that every "roof can be put to good use at small expenditure," adding "there is too much wasted air, and the children do not have enough playgrounds." In the end, the afternoon at the Waldorf-Astoria did not lead to the construction of many new rooftop playgrounds, but it undoubtedly increased public support for the construction and equipping of additional playgrounds at ground level.

MRS. ASTOR'S SOCIETY TABLEAUX

It may not have been clear to the women shown here in furs and fancy hats exactly which Mrs. Astor organized the event at the Plaza Hotel on February 25, 1908. Mrs. Caroline Schermerhorn Astor, widow of William Backhouse Astor, Jr., had long reigned as *the* Mrs. Astor, imperious grande dame of the city's white Protestant elite. However, Caroline's nephew, William Waldorf Astor, felt he was the rightful head of the Astor family, and that therefore his wife, Nancy Langhorne Shaw Astor, ought to be *the* Mrs. Astor, and his aunt merely Mrs. William Astor. Caroline refused the demotion.

The gala was the brainchild of the younger Mrs. Astor who wished to raise money for poor white farmers in her native Virginia. "It is not an appeal for an alien race of the South Sea Islands," she told a reporter for the *Times*, adding that it "is not a call to educate the negroes [*sic*], who are not our brothers in the least." The event featured nine tableaux vivants based on works of art, four dances, and a pantomime called "Le Reveillon de Pierrette" starring Nancy Astor herself. There were changes of costume and scenery and a cast of hundreds of the "best" people of New York; tickets cost between $5 and $25. The highlight was a tableau in which Mrs. James Biddle (Nina) Eustis posed as Gustav Flaubert's Carthaginian heroine Salammbo, standing stock-still on stage with a 6-foot-long python coiled around her.

Nancy Astor's charity event garnered considerable attention from the press, and she sent several thousands of dollars to Albemarle County in Virginia. But her sojourn in New York was strictly temporary. Her husband was a British subject, and Nancy eagerly adapted to life among the landed gentry there, eventually becoming a Viscountess and member of Parliament. Caroline Schermerhorn Astor retained the title of *the* Mrs. Astor until her death on October 30, 1908, less than a year after the other Mrs. Astor's society tableaux at the Plaza.

HENRY GRUBE—LONG BRANCH CIRCUS

In contrast to the occasional newspaper story describing life in the City's crowded immigrant neighborhoods were those that breathlessly considered the lives and lifestyles of the rich and famous. During hot summer months when the fortunate few left the city for weeks or months at the shore or some cool upstate resort, reporters and photographers followed and filed illustrated reports on the fancy doings of the upper class.

Beginning in 1907, in addition to annual dog and horse shows and practically non-stop garden and beach parties, the town of Long Beach, New Jersey organized a circus to raise money for the Monmouth County Hospital and other charities. This would be just like a real circus, except that the participants were members of high society. Thus, in 1909 when this picture was made, the lion tamer was Charles P. Doelger, scion and important New York City brewer. There were, in addition, pretend clowns, jugglers, cowboys, strong men and at least one bearded lady, a Mr. C. A. Arthur.

When he was not exhibiting himself in a dress and bad wig at the circus, Henry Grube, a prominent member of New York's German-American community, sat on the board of directors of the J. M. Horton Ice Cream Company, which had "depots" in the Bronx, Manhattan, and Brooklyn. In 1902, Grube got caught in the middle of the nasty divorce of Merritt Leach and his wife. Both Leaches ended up suing Mr. Grube, he for alienating his wife's affections, and she for reneging on a promise to marry her once the divorce came through. The circus must have seemed like a relief.

DUNCAN DANCERS

In the waning days of the First World War, stateside activities supporting the military and its conduct of the war slowly gave way to efforts to provide aid and solace to injured soldiers and civilians amongst our allies. Thus, in the summer of 1918, the New York Committee of the Italian War Relief Fund of America organized several programs publicizing the urgent need for medical supplies and funds, each event designed to appeal especially to the American business elite and philanthropists.

Newspapers reported in June that George and Helen Pratt would host a garden party (they called it a "fête") at Killenworth House, their grand estate at Glen Cove, Long Island. Pratt's fortune derived principally from his father's role in John D. Rockefeller's Standard Oil Company, and the Pratt's 39-room mansion, with 13 bathrooms, five cellars, and landscaping requiring the services of 50 gardeners, provided an ideal backdrop for an outdoor party. Entertainment for the paying guests (reserved seats at $10, box seats at $100) included a recital by Alda De Luca of the Metropolitan Opera, a reading of poems by the Belgian tragedian Carlo Liten, and a performance by six pupils of the renowned Isadora Duncan. The dancers performed to music supplied by the Little Symphony chamber orchestra, conducted by its founder, Georges Barrere. The program at Killenworth was likely similar to one given at Carnegie Hall in February, when the Duncan Dancers, accompanied by the Little Symphony, interpreted music from Schubert, Glück and André Grétry.

The event attracted several reporters and at least two photographers. The Bain News Service man worked alongside a photographer from Underwood and Underwood, whose own version of the dancers is now part of the Bettmann archive at Corbis Images.

AT BROAD CHANNEL—IN THE LIVING ROOM

In 1916, the impetus for sending a photographer all the way out to Broad Channel, a small island in Jamaica Bay, could have been news reports of a minor building boom on that narrow strip of land. But it is more likely that Bain was working for the developer, Pierre Noel, who leased the island from the City on May 1, 1915 and began building a permanent community there, complete with seaside rental housing, a grid of streets and canals, fresh water, and electricity. The photographs, most of which show a family enjoying various leisure-time activities in their presumably new home on the water, seem more like advertising or public relations than news, and Noel certainly could have used some good publicity.

In September 1916 a flurry of negative stories about Noel and his Broad Channel Corporation appeared in the New York press. There were grumblings about the City's original deal to deliver the island to a private company for development. And the Broad Channel Association, a tenant group, vigorously protested Noel's policies, especially the prospect of rent increases and continuing problems with the water supply. Noel told *The New York Times*, which supported plans to remake Broad Channel as an American Venice, that the tenants' complaints were unfounded. In a letter to the *Times* printed on September 25, Noel listed the many improvements made so far, and promised more in the future. "We have spent in the one year and a half of our lease upward of $180,000 in the development and improvement of the place," he said. "We have filled in a vast area with clean, white sand from the bed of the bay, as anyone one can see in passing on the train." The Bain News Service pictures are the perfect visual accompaniment to Noel's passionate defense.

WORKING ON AN ANGEL

Construction began on the Episcopal Cathedral of Saint John the Divine at 1047 Amsterdam Avenue in Morningside Heights on December 27, 1892, Saint John's Day, and it has never stopped. The original design by the New York firm of Heins and LaFarge envisioned a massive structure with Romanesque and Byzantine features, but after the death of George Lewis Heins in 1907, the trustees hired Ralph Adams Cram who added significant Gothic elements to what had already been built. Construction delays, two world wars, the Great Depression, and a fire in December 2001 that destroyed the still incomplete north transept precluded final completion, and today both construction and restoration projects continue apace, earning for the cathedral the slightly derisive name Saint John the Unfinished.

Conceived as a "house of prayer for all nations," the cathedral welcomed the participation of New York's burgeoning immigrant community, and benefited substantially from the work of skilled craftsmen and artists from Europe. Thus, the great tiled dome over the central crossing of the church is the design and work of Rafael Guastavino, the renowned architect and builder from Valencia, Spain, while many of the cathedral's magnificent stone carvings were produced by Domenico and Clamanzio Ardolino who immigrated from Torre la Nocelle, Campania, Italy late in the nineteenth century. The Ardolino brothers, joined at times by their cousins Rafael and Eduardo, worked for years at the cathedral, often carrying out the designs of British sculptor John Angel.

In this photograph made in 1909, the year work was completed on Guastavino's dome, one of the Ardolino brothers works on the ornate capital of a column

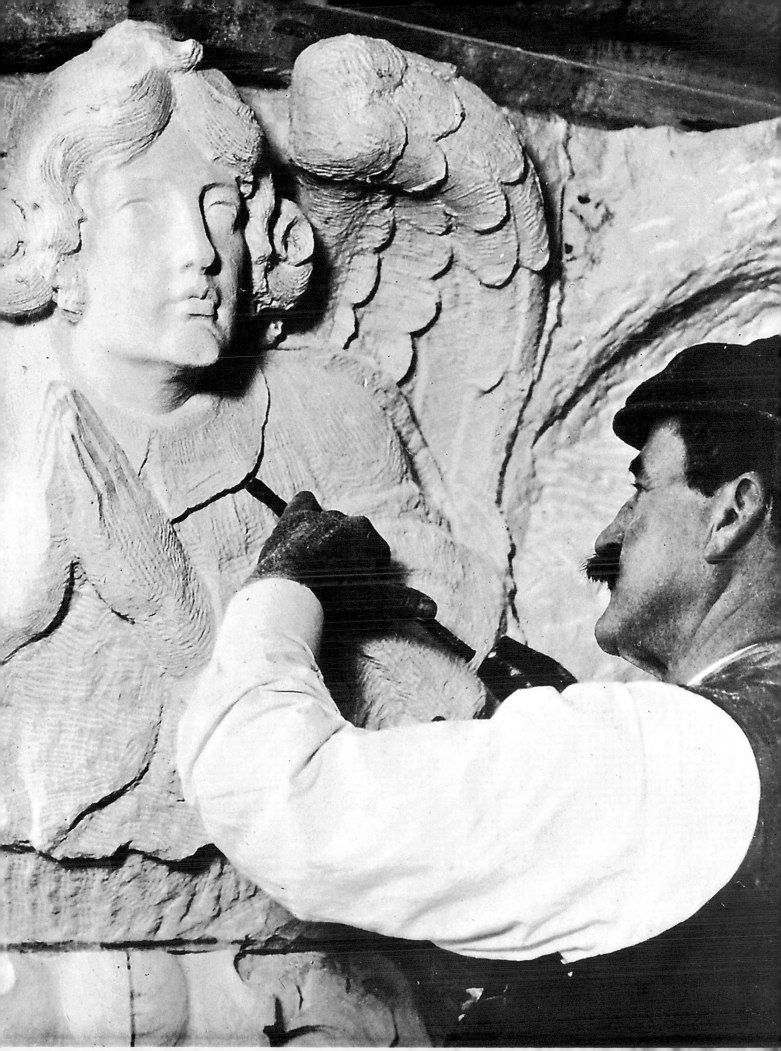

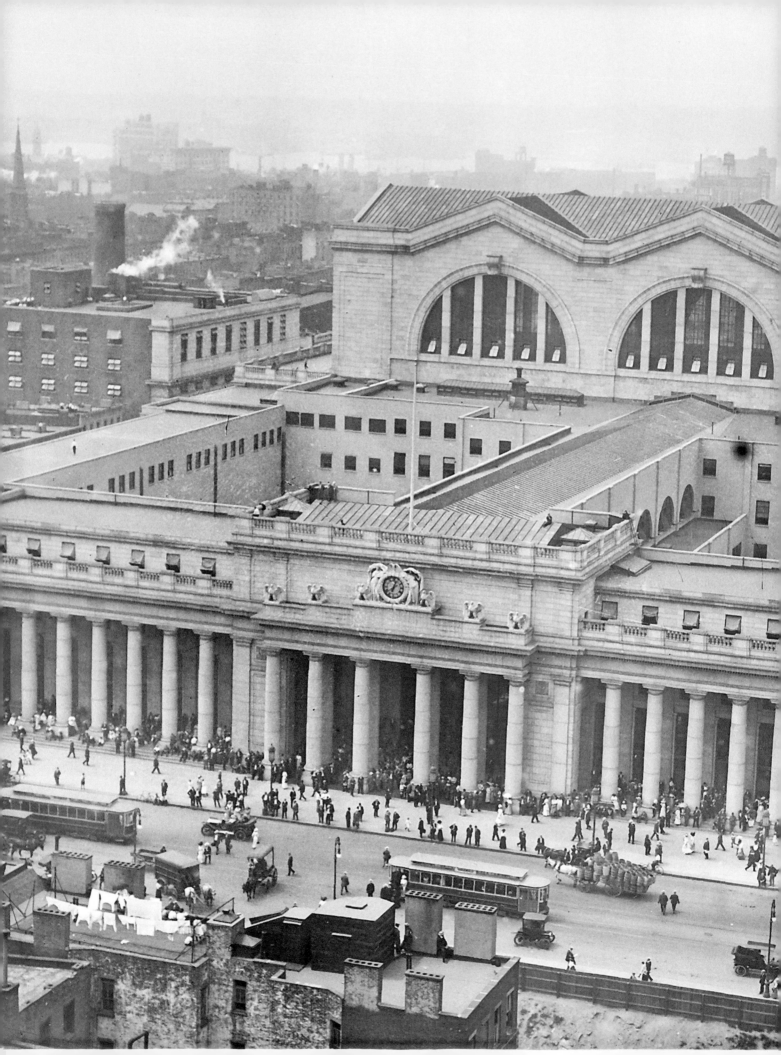

PENN. R.R. STATION

In 1900, the Pennsylvania Railroad (PRR) was an industrial behemoth and the world's largest publicly traded corporation. But the company had a problem. Although Penn. rails ran all over the eastern United States, they did not extend to New York City. Passengers wanting to go there could get only as far as Jersey City, and then had to board ferries for the final push into the city. The president of the PRR, Alexander Johnston Cassatt, brother of the painter Mary Cassatt, vowed to remedy that situation by building tunnels under the Hudson and East Rivers and a flagship station in Midtown. Built on an expanse covering four blocks just south of 34th Street between 7th and 8th Avenues, Pennsylvania Station opened on November 27, 1910, shortly before this picture was made.

The new station, designed by Charles Follen McKim of the firm McKim, Mead and White, was an elaborate Beaux-Arts paean to American rail travel, with soaring interior spaces modeled on the Roman baths at Caracolla and London's Crystal Palace, and an exterior façade clad in pink granite from Massachusetts framed by eighty-four massive Doric columns. It was, wrote Thomas Wolfe, a place "vast enough to hold the sound of time."

Pennsylvania Station was meant to be an enduring monument to American enterprise and greatness, but it lasted less than sixty years. Railroads fell on hard times after World War II, and top management of the PRR began looking for ways to cut costs. Led by the PRR's president, Allen J. Greenough, who viewed the station as a costly, inefficient, and unnecessary albatross, a secret deal was concocted with Irving Felt, president of Madison Square Garden, Inc., to demolish the above ground portions of Penn Station and build in their place an athletic stadium. Despite a torrent of criticism, the deal went through and by 1964 the PRR's magnificent station was gone, torn down and dumped without ceremony into the swamps of New Jersey. Architectural historian Vincent Scully famously concluded that once "One entered the city like a god. Now one scuttles in like a rat."

TUBES FOR SUBWAY UNDER HARLEM RIVER

The first subway tunnel under the Harlem River—which is actually a tidal strait connecting the East and Hudson Rivers—opened in 1905, extending the Interborough Rapid Transit (IRT) into the Bronx. Donald Duncan McBean, a Canadian-born engineer with a penchant for independent thought and little patience for the dictates of bureaucrats, supervised the work. McBean's plan was to build the tunnels on land, then sink them into the riverbed. Despite a minor setback in February 1905 when a persistent leak in one of the two tubes halted work, McBean's tunnels worked well, and he must have thought that more city work would come his way.

A few years later, the Public Service Commission called for bids on additional tunnels under the Harlem River, but McBean's company was left out. Instead, the city awarded the contract to Arthur McMullen and his partner, Olaf Hoff. McBean cried foul, complaining to the mayor, the Public Service Commission, and the press that the contract was an inside job that would ultimately cost the city double what he would have charged, that the proposed tunnels were bound to fail, and that McMullen and Hoff stole his patented ideas. When his protests were ignored, McBean filed suit for one million dollars.

Work on the new tunnels, which extended the Lexington Avenue line into the Bronx, proceeded without incident. In August 1913, when this photograph was taken, two sets of steel tunnels were gently lowered into the dredged out riverbed. Steel air cylinders ten and a half feet in diameter and just over sixty-eight feet long controlled the sinking of the subway tubes; they are the structures seen here. After sinking, the steel tubes were encased in concrete, which stabilized and strengthened the tunnels. The success of the McMullen-Olaf tunnels must have been a bitter pill for Donald McBean; he died in his suite at the Waldorf-Astoria Hotel at the end of February 1918.

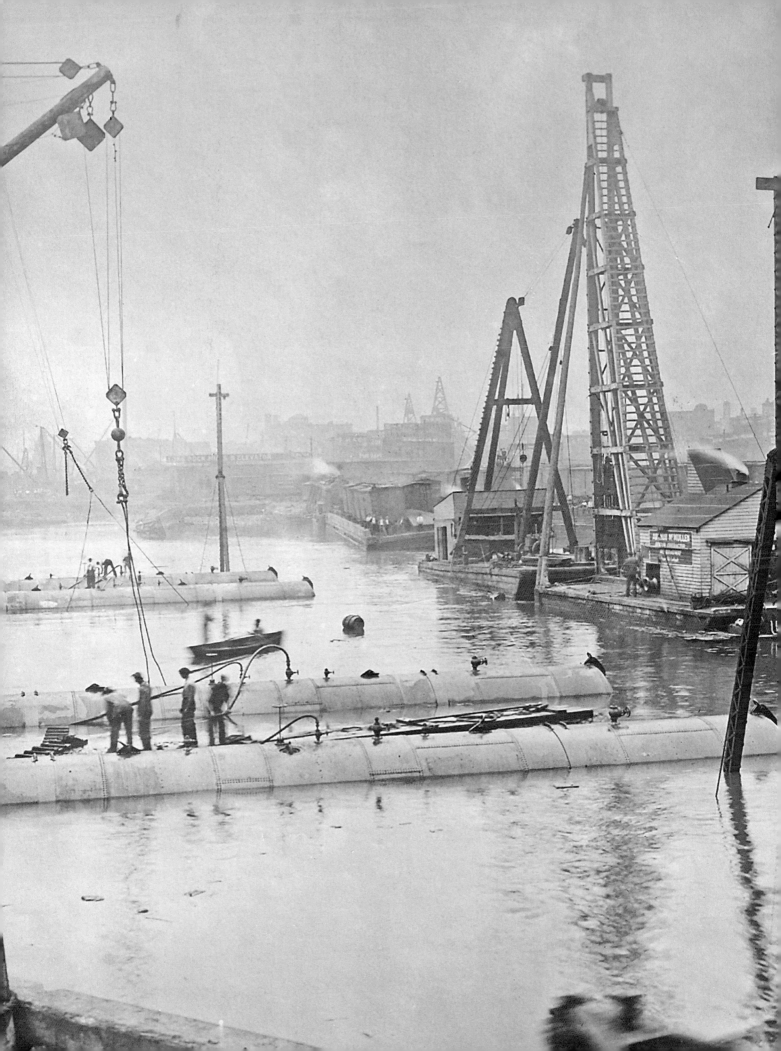

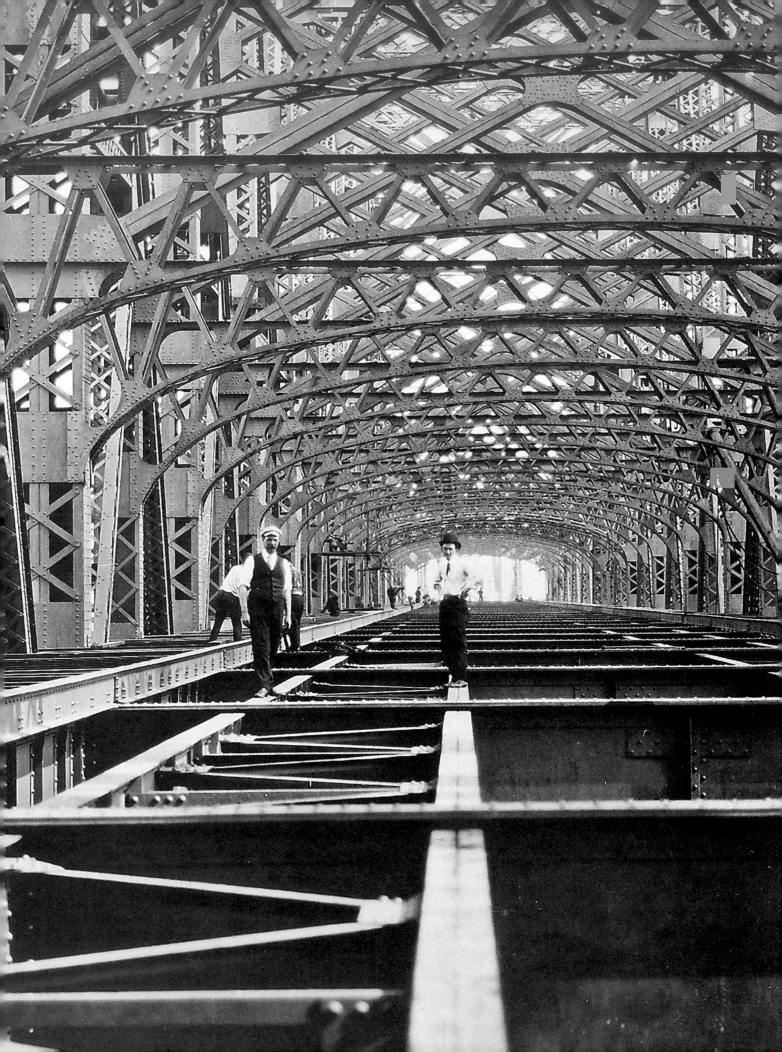

WORK IN ROADWAY, BLACKWELL'S ISLAND BRIDGE

The political consolidation of New York City occurred in January 1898, and over the next dozen years a vast series of public works projects under several administrations provided infrastructure that physically stitched the five boroughs together. Bridges, subways, rail lines and highways built in the first decade and a half of the 20th century revolutionized urban transportation and encouraged residential and industrial development outside Manhattan. The iconic Brooklyn Bridge, completed in 1883, was soon joined by three more giant spans across the East River: the Williamsburg Bridge opened in 1903, and the Manhattan and Queensboro Bridges were completed within nine months of each other in 1909.

Originally called the Blackwell's Island Bridge, the Queensboro, designed by Gustav Lindenthal and architect Henry Hornbostel, stretched from 59th Street in Manhattan to Long Island City in Queens. Early in the twentieth century, Blackwell's Island (renamed Welfare Island in 1923, then Roosevelt Island in 1973) was the notorious site of a prison, a poor house, a lunatic asylum, and a last-resort hospital for victims of smallpox. The island provided land for massive piers supporting the bridge's steel superstructure, but no access to or from the completed bridge.

Despite a work stoppage in July 1905 when ironworkers walked out in sympathy for fellow union members in Harrisburg, Pennsylvania, and controversies concerning the bridge's double cantilever design, its name, and the quality of the steel provided by the Pennsylvania Steel Company, construction proceeded. On March 30, 1909, about a year and a half after this picture was made, New York City mayor George Brinton McClellan, Jr. presided over the opening ceremonics. By that time, the bridge's name had been changed from Blackwell's Island to Queensboro at the insistence of real estate developers in Queens. In December 2010, the State Legislature renamed the bridge once again, this time in honor of former mayor Edward I. Koch. Whether formally called the Blackwell's Island, Queensboro, or Ed Koch Bridge, for many New Yorkers it will always be simply the 59th Street Bridge.

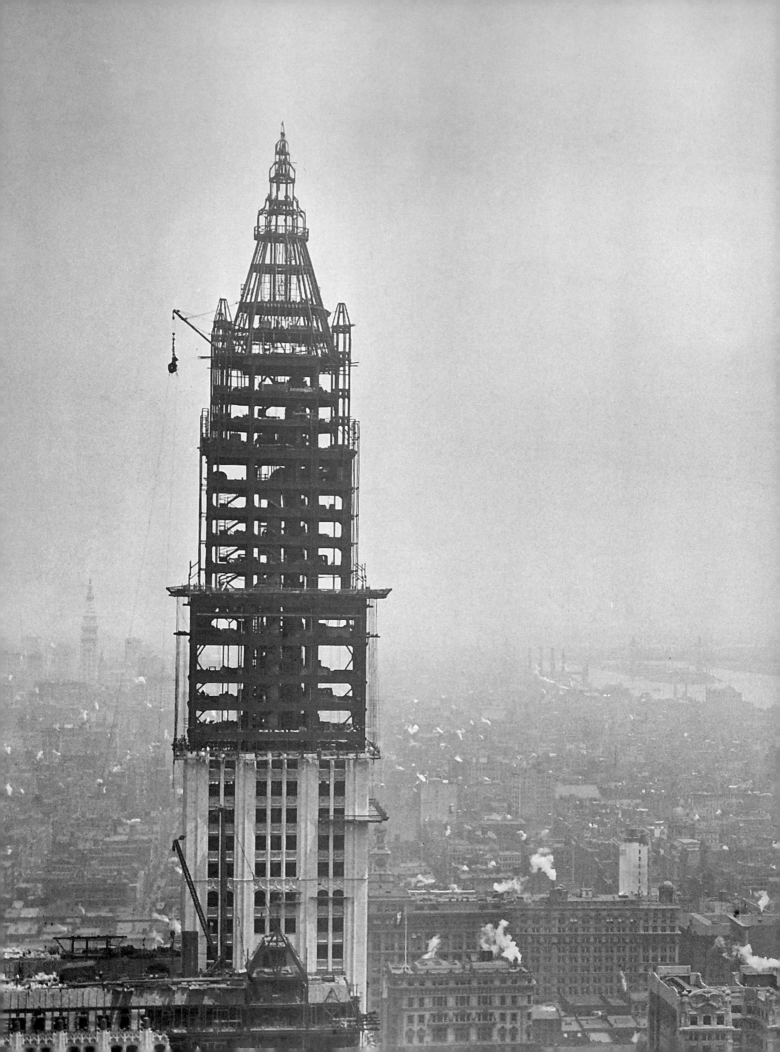

WOOLWORTH BUILDING

Frank Winfield Woolworth, born in 1852 and raised on a potato farm in Rodman, New York, parlayed an early interest in business and merchandising into one of the great retail empires of the twentieth century. His strategy was to offer working class Americans a wide variety of inexpensive goods, in-store dining, and easy access to merchandise displayed throughout the store, not kept behind the counter. Combined with his genius for locating stores in high-volume areas, especially near bus stops, or subway and train stations, the business model worked like a charm and Woolworth amassed a fortune in penny and nickel increments.

Frank Woolworth and his brother Charles formally incorporated the business in 1911, but plans were already underway to erect the company's headquarters on Broadway between Park Place and Barclay Street, opposite City Hall in lower Manhattan. Cass Gilbert designed the building as an elaborate Gothic paean to industry. At 792 feet it was the tallest building in the world, and every cent of the 13.5 million dollar cost came from Woolworth himself. Advertisements in New York newspapers during construction in 1912 emphasized the building's safety, convenience, and location, and New Yorkers (and George Bain) watched with interest as work proceeded.

At its formal opening in April 1913, the Reverend S. Parkes Cadman described the Woolworth Building as a grand "cathedral of commerce," and it began to attract the attention of some of America's most famous art photographers, including Alfred Stieglitz, Alvin Langdon Coburn, and Berenice Abbott. This picture, possibly made in 1912 from a vantage point in the Singer Building (demolished in 1968), was meant merely to document construction progress; however artfully executed, the photograph's purpose and meaning are tied inextricably to the demands and routines of the illustrated press.

PUTTING 46 TON GIRDER IN PLACE—CONSOLIDATED GAS CO.

The Consolidated Gas Company, renamed Consolidated Edison (ConEd) in 1936, began constructing its headquarters building on Irving Place and 15th Street in January 1911. Henry Janeway Hardenbergh, the well-known architect of the Plaza Hotel and Dakota apartments among many others, designed the original building, which combined Classical Revival and Renaissance motifs in a twelve-story structure that was ready to be occupied in late September. But company officials decided in the meantime to move their subsidiaries, especially New York Edison, into the new building, which would thus need to be expanded considerably. Hardenbergh's new plan called for an eighteen-story structure with a nineteenth-story penthouse for the company cafeteria and executive dining rooms.

Since the framing on the original twelve-story middle section would not support the weight of an additional seven floors, Hardenbergh's new design called for an elaborate system of trusses in the form of giant steel girders that would transfer the weight of the floors above the old twelve-story section onto the new additions on either side. By August 1913, when this photograph was made, work on the complicated truss system was well under way, providing Bain's photographer the opportunity to make a dramatic image of a 46-ton girder being slowly hoisted into place.

Milliken Brothers Structural Iron Works and Rolling Mill, a huge plant located on what is now Mariner's Marsh Park on the northwest shore of Staten Island, got the contract to supply the girders used in Hardenbergh's truss system. The ConEd building survives, and is now rightly designated a historic landmark; the Milliken Brothers company lasted only until 1917, when the property was sold to Downey Shipbuilding.

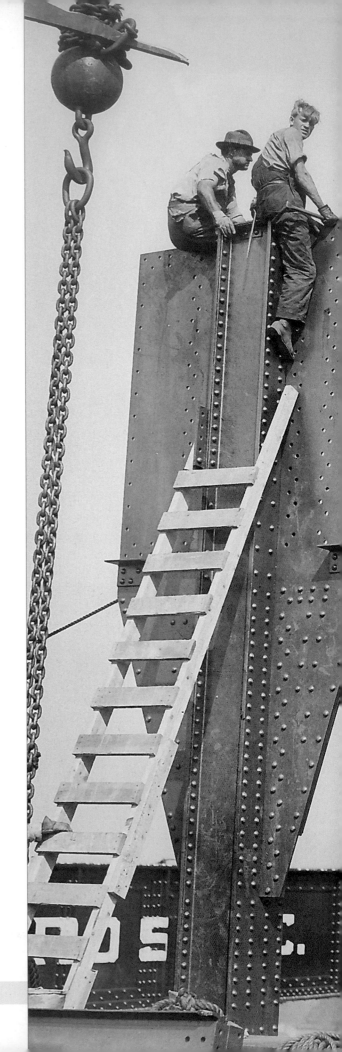

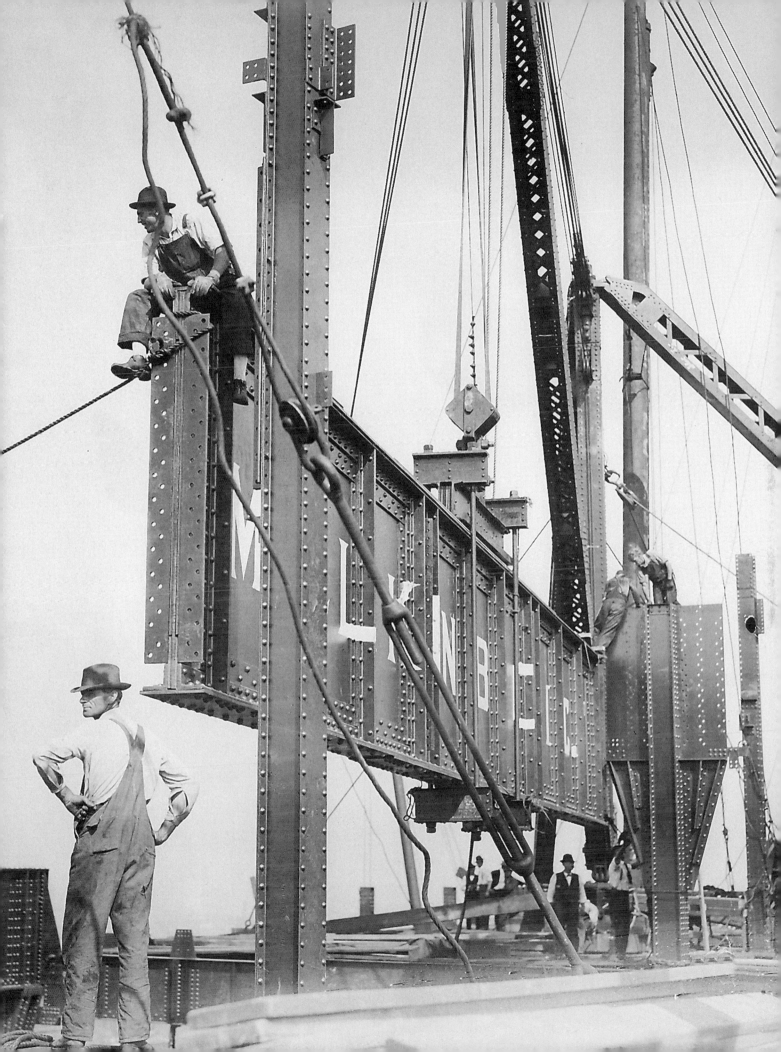

CLEANING SNOW FROM STREET

Snow removal from the streets of the city in the age of horses and wagons was a slow, cumbersome, inefficient process performed by private firms with contracts from the Department of Street Cleaning. Contractors hired temporary workers from among the unemployed, and usually paid them a pittance per wagonload dumped into sewers or directly into the East or Hudson River. Complaints of fraud and incompetence were common, especially after heavy snowfalls.

The most successful firm in the snow-removal business was the Bradley Construction Company, owned by William Bradley and his younger brother James. The Bradley's, described by the *New York Times* as "sturdy, workaday, straight-to-the-point businessmen not afflicted with much sentiment and with an eye to the profit they are accustomed to reap," were involved in numerous construction projects in Manhattan, including building the foundations of high rises and tunnel work on the Lexington Avenue subway. They signed their first snow-removal contract in 1902; by March 1909, Bradley Construction was considered the premier snow-removal firm in Manhattan, with some 600 wagons and drivers operating out of the Department of Street Cleaning stable at Avenue C and 17th Street.

The surprise storm that hit New York in the evening of January 23, 1908—the *Times* called it a "baby blizzard"—dumped over four inches of snow, and the next morning Bradley Company wagons as well as hundreds of white-clad workers armed with shovels and pick-axes from the Street Cleaning Department fanned out across the city. Bain's photographer caught this driver and his load of snow just outside Keith and Proctor's vaudeville theater on 125th Street west of 7th Avenue.

INSPECTOR WALSH
CONDEMNING TAXICAB

Elected Mayor in 1910, William Jay Gaynor turned out to be independent and reform-minded, much to the chagrin of the Tammany Hall politicos who helped elect him. Once in office Gaynor vowed to make changes in several areas, among them the policies and practices of the City's taxicab industry. Complaints about arbitrary fees, malfunctioning meters, company-controlled taxi stands, and gridlock on streets near popular hotels and restaurants led to a rising chorus of complaints, and Gaynor immediately pushed for reform.

On April 18, 1910, Gaynor's Commissioner of Accounts, Raymond Fosdick, inaugurated a formal investigation of the taxicab industry, followed less than a month later by a grand jury investigation led by District Attorney Charles Whitman. On June 1, 1910, Gaynor appointed a new Inspector of Taxicabs, John Drennan, and six deputies (including Thomas F. Walsh, who is seen here), all of whom came from the Civil Service list, not via the usual route of family or political connections. On May 27, the Board of Aldermen passed a new Hack Ordinance by a vote of 65–1, which lowered rates, regularized inspections of vehicles and drivers, and ended the system of company-owned taxi stands.

Despite vehement protests from the industry, led by the formidable Yellow Cab Company, inspections began on August 2, 1910 at a City-owned facility at 248 West 49th Street, and the first results did not bode well for the taxicab companies. According to the *New York Times*, of the first 500 cabs brought in only 17 received unrestricted licenses, while 100, perhaps including this cab with bald tires and no front bumper, were "emphatically rejected" and presumably consigned to the rubbish heap.

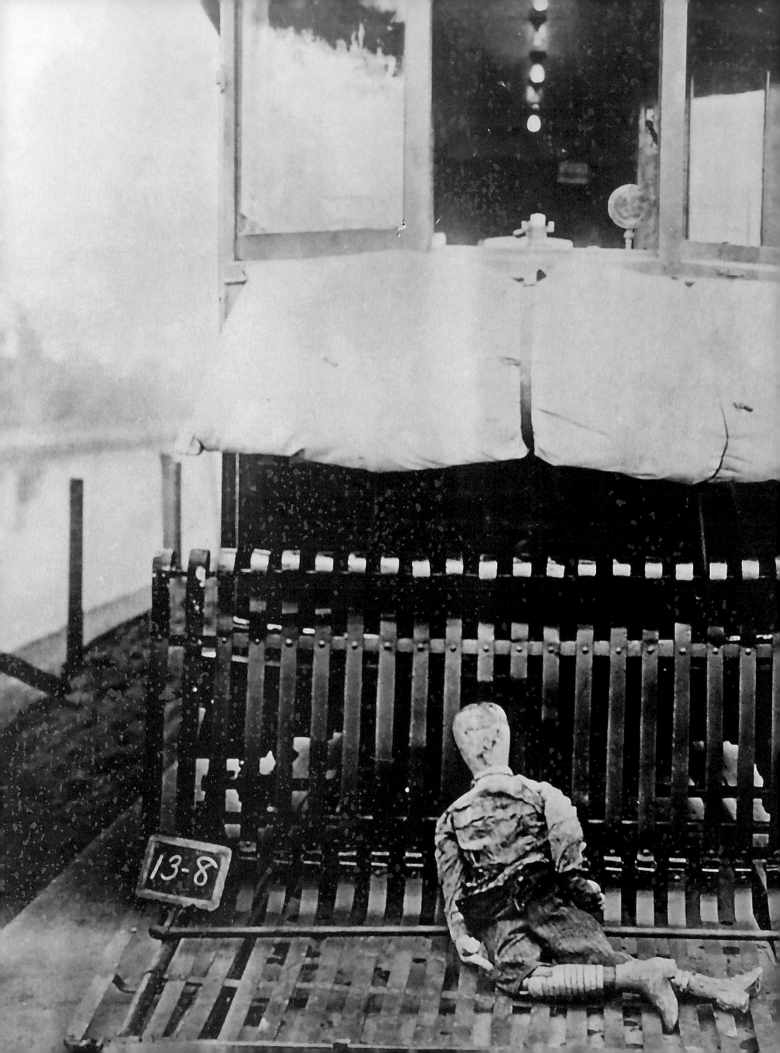

TESTING CAR FENDERS

By 1900, surface rail and subways transformed city life, spurring residential development in the outlying boroughs and providing Manhattanites with quick, low-cost transportation up or downtown. But there was a cost. Most streetcars lacked effective fenders, wheel guards, and brakes, and in a city devoid of electronic traffic lights accidents between surface railcars and pedestrians, horses, carts, and smaller vehicles resulted in a prodigious toll of death and injury. The *New-York Tribune* reported in 1909 that during the previous twelve months 38,000 New Yorkers were killed or maimed by trains or streetcars; and the *Times* dubbed 11th Avenue "Death Avenue" for all the fatal accidents along the New York Central Railroad tracks.

In response, the Public Service Commission (PSC) led by Milo R. Maltbie demanded improvements in fenders and braking systems. In a series of tests held at the General Electric facilities in Schenectady in September 1908 and at the Westinghouse plant in Pittsburg in October, manufacturers demonstrated fenders for streetcars, using dummies dressed as women, men, and children. Some of the devices seemed to work; others, such as this one from the Schenectady tests, seemed somewhat less effective, perhaps even dangerous. The *Tribune* commented acidly that the "ill success of the streetcar fenders in saving dummies dressed as women may be put down as another instance of the perversity of the sex."

In April 1909, the Public Service Commission ordered that cars on all surface lines in the five boroughs be equipped with either wheel guards or fenders. Compliance with the order was spotty; rail companies, especially in Brooklyn, objected strongly to the dictates of the PSC. Eventually, however, they, too, came around and streetcars and people found ways to coexist.

TAKING BERTILLON
MEASUREMENTS—CRANIUM

The Bertillon system for identifying criminals, based upon a complicated array of precise physical measurements taken by trained law enforcement personnel, originated and flourished in France in the late 1800s. In 1887, the warden of the Illinois State Penitentiary at Joliet, Major Robert W. McClaughry, brought the system to the United States, and for several decades, police departments across the country used it to identify and categorize criminals and those suspected of criminality.

Combined with photographic mug shots taken from various angles, Bertillon measurements were a useful tool, but they were not foolproof. The system generated thousands of standardized cards packed with measurements and descriptions, but it was never as reliable as the unique evidence contained in a single finger or thumbprint. In the wake of a much reported case of mistaken identity based on Bertillon criteria at Leavenworth Prison in Kansas in 1907, and news reports in 1908 that New York policemen took Bertillon measurements of women suspects without the assistance or even presence of prison matrons, the system began to lose favor with the authorities and the public. Although New York City police continued to use both systems during the first two decades of the 20th century, fingerprinting was considered to be more accurate and Bertillon measurements eventually became superfluous and unnecessary.

Some remnants of the system devised by Alphonse Bertillon survive, though not the elaborate and complicated physical measuring. Bertillon encouraged police departments to make much greater use of photography, insisting in particular that detailed photographs of crime scenes would yield vital information. On that point at least, he was absolutely correct.

PUBLIC BATHS—MILBANK MERMORIAL

In the early years of the twentieth century, progressives sought to publicize and ameliorate living conditions in poor neighborhoods of the city, especially on the lower east side of Manhattan. Both the Danish-born social reformer Jacob Riis, and Dr. Simon Baruch, a passionate advocate for hydrotherapy and sanitation, described dreadful conditions in the slums of New York, and urged a reluctant Tammany Hall to enact specific reforms, among them the establishment of public baths in neighborhoods where the only running water was in the sewage-clogged East River.

The struggle to build and equip baths received a great deal of coverage in newspapers and magazines, and Bain's collection includes several images that illustrate aspects of the story. This picture, made originally in 1904 by an unidentified photographer for the Byron Company,

a commercial photography studio specializing in maritime and stage subjects, depicts patrons of the public baths at East 38th Street, built with funds supplied by Elizabeth Milbank Anderson, heiress to a founder of the Borden Condensed Milk Company. Bain probably purchased the image some time after January 1908.

The Milbank Memorial Baths, operated by the Association for Improving the Condition of the Poor, cost between $140,000 and $150,000 to build, and could accommodate over three thousand bathers a day. Entrance to the baths was free, but soap and a rental towel cost five cents. The immediate success of the Milbank and other public baths in the city convincingly rebutted those who contended that the poor chose to live in filth and thus were to blame for their own sorry condition.

RANDALL'S ISLAND REFORMATORY

Before it became a park, and a sports and recreation facility in the mid-twentieth century, Randall's Island, situated in the East River between northern Manhattan and Queens and just south of the Bronx, became a repository for some of the City's most neglected and unwanted citizens. In the nineteenth century the small, .85 acre island was first used as a potter's field, but officials soon added an almshouse, a House of Refuge for juvenile delinquents and young vagrants, an asylum for mentally-challenged children (referred to then as the "feeble-minded" or simply as "idiots,") another asylum for inebriates and addicts, and, briefly, a rest home for Civil War veterans.

Treatment of children on the island attracted a great deal of attention in the press, especially during the Progressive era. Eventually the House of Refuge instituted educational and vocational programs, as well as quasi-military training to better prepare their young charges for life in the real world. There may have been an ulterior motive in some of this training, for many of the items produced at the House of Refuge were sold to defray institutional costs.

This carefully choreographed photograph of a teacher supervising the construction of a wooden stairway at the House of Refuge is eerily similar to images made by Frances Benjamin Johnston at Hampton and Tuskegee Institutes and the Carlisle Indian Industrial School. Johnston documented the transformation of people hitherto considered by many to be irredeemable and essentially uneducable. Her photographs offered tangible evidence that the children of former slaves and young Native Americans could be assimilated into American culture. The implication here is the same: these boys may have been sent to Randall's Island for chronic truancy, petty crimes, or even just disorderly conduct, but there they could be saved and transformed into productive citizens.

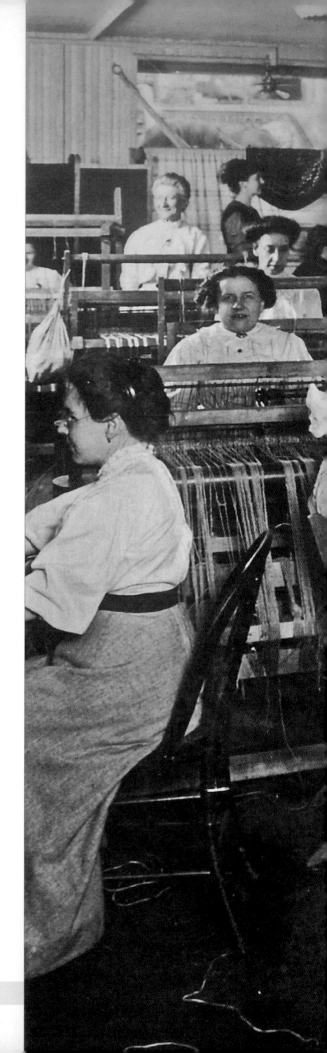

WEAVERS AT WORK

This photograph is one of a series made by Percy Byron of the Byron Company for the New York Association for the Blind, probably in 1912. Byron produced some 160 images for the Association over the years, work that documents the struggle to provide meaningful work for the blind. George Bain purchased this and several other photographs of blind persons from Byron, and sent them out as Bain News photos, though the Byron Company logo on the lower left-hand corner of the negative was left untouched.

Edith and Winifred Holt, daughters of the publisher Henry Holt, incorporated the New York Association for the Blind in 1906. What began as a modest service to provide the blind with free tickets to concerts became in a few years an important and influential agency providing training, recreation, and work to sightless children and adults, as well as research in the prevention of blindness. The sisters raised money to build and equip workplaces for the blind, and at the Association's headquarters, The Lighthouse, items manufactured by the blind were displayed for sale.

This image was probably made at the original Lighthouse head-quarters building on 59th Street. The 1913 annual report of the Association mentions the class and notes the success of the women workers. "We feel confident that the things that are made by the blind can stand competition, and usually surpass in excellence similar articles made by the seeing." In keeping with the Holt sisters' love of music, the weaving room is equipped with an orchestrion, a mechanical music box not often found in workplace or factory settings at that time. At a concert in Florence, Italy in 1903, Winifred Holt had noticed a group of blind children clearly enthralled by the music. It is not surprising that years later she would make sure music was available to blind workers at the Lighthouse.

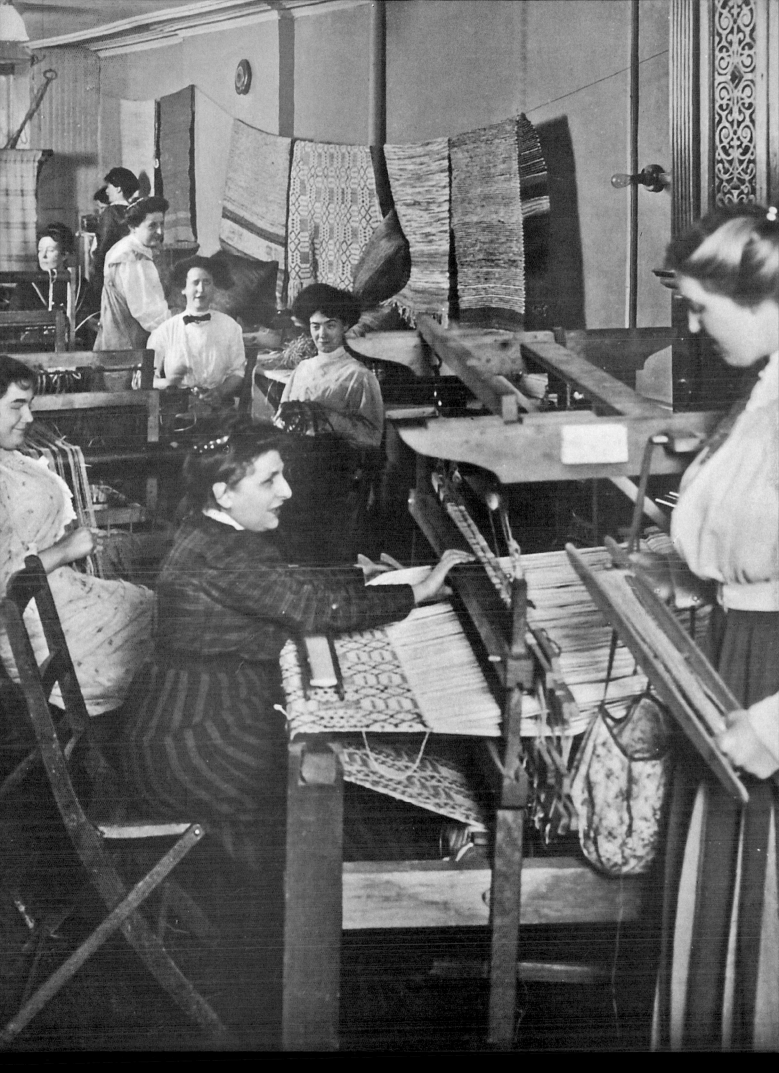

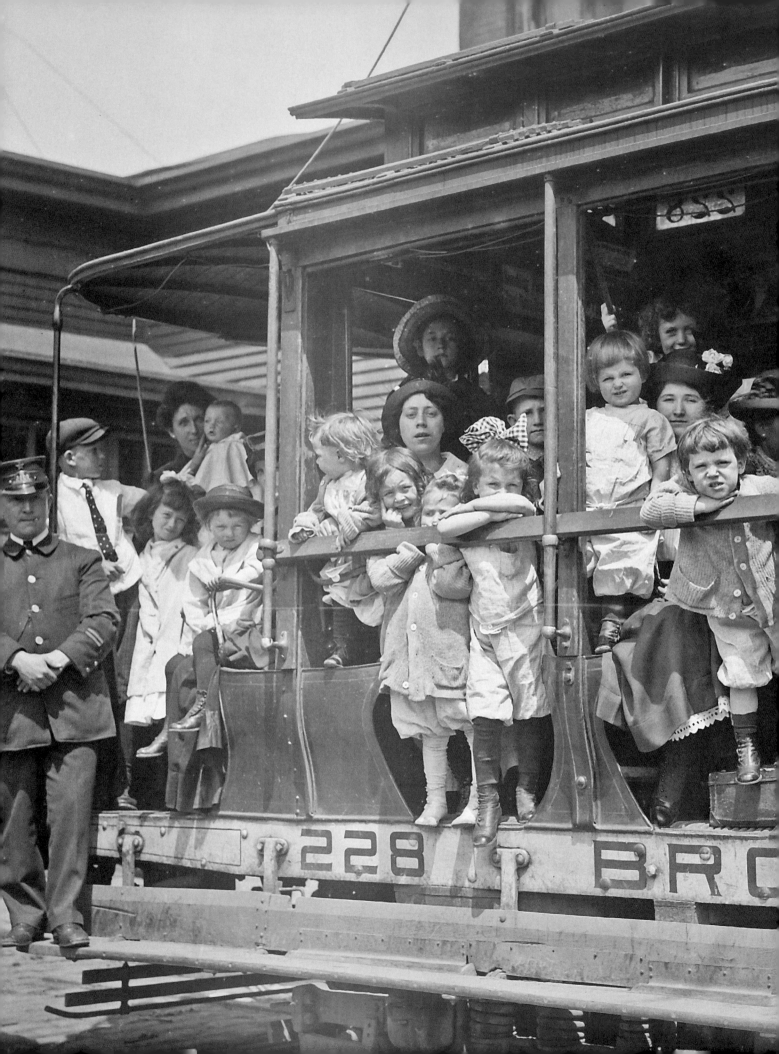

FRESH AIR OUTING

In the late spring of 1913, the Association for the Improvement of the Condition of the Poor began receiving requests from hospitals, nurseries, and settlement houses to participate in one of the Association's summer mini-vacations at the Sea Breeze Fresh Air Home for destitute mothers and their children at Coney Island. The first excursion that summer left the 23rd Street Public Baths on June 2, headed for a two-week stay at the shore. Of the 600 campers in the first group, most adults were recently recovered from some illness, while many of the children came from homes where one or both parents had TB. The stay at Sea Breeze was far more than a temporary respite from an over-heated city. It was instead a vital step in the recovery process: plenty of fresh air and sunlight, not to mention the attention of the Sea Breeze medical staff, would actually save lives.

When the selected campers arrived at the public baths, physicians examined each one to make sure that they were free of contagious disease. The party then went by bus to one of the East River ferries, which took them all to Greenpoint, Brooklyn where they boarded trolleys to take them to Sea Breeze. Bain's photographer caught up with them there, just before they left on a Brooklyn Rapid Transit car.

The Association for the Improvement of the Condition of the Poor provided both weekend excursions and weeklong holidays for adults and children from June to October. The Association's summer programs were important and successful, but they were not alone. The Fresh Air Fund, for instance, established in 1877 by Rev. Willard Parsons, teamed with the *New-York Tribune* in 1888 to provide inner-city children with summer sojourns with host families in the countryside. In the first decades of the 20th century, newspapers and magazines in New York extolled the myriad virtues of fresh air and summer camp for the needy, and they still do.

ORPHANS GOING TO CONEY ISLAND

Planning for the seventh annual Orphans Day Parade began in earnest in early April 1911 under the direction of K. C. Pardee, a prominent New York auto dealer specializing in the Maxwell Company's inexpensive two-cylinder runabouts. Part philanthropy and part public relations for the nascent automobile industry, the parade brought some five thousand children from orphanages and group homes in the city to Coney Island for a day of carnival rides and free food.

The destination of the 1911 parade was Dreamland, the Coney Island attraction created in 1904 by William Reynolds, a real estate promoter and former state senator, and managed by Samuel Gumpertz. Presumably the orphans would have free run of the place, including two of Dreamland's most popular attractions: Lilliputia, a town populated and run by little people, and the Infant Incubators, six live premature babies on display in prototypical incubators. Plans for the orphan parade changed suddenly after a fire swept through Dreamland during the early morning hours of May 27. The place was a total loss, though the little people as well as all six preemies were saved.

Pardee made arrangements for the orphans to go instead to Frederick Thompson's Luna Park, Dreamland's fabulous neighbor and main competitor on Coney Island. Cars, buses, and commercial vehicles gathered at Union Square (where this photograph was made) and at 78th Street and Broadway; each group set out for Coney Island at precisely 10 A.M. After a lunch provided by Benjamin Briscoe of the United States Motor Company, the orphans were allowed to see as many shows as they liked and to sample any or all of the rides. Despite a drenching rain, the kids—described by the *Times* as "wild, smeary, and parentless imps of joy and mischief"—apparently had a great time, and at 5 P.M. they headed back to town, back to the real world.

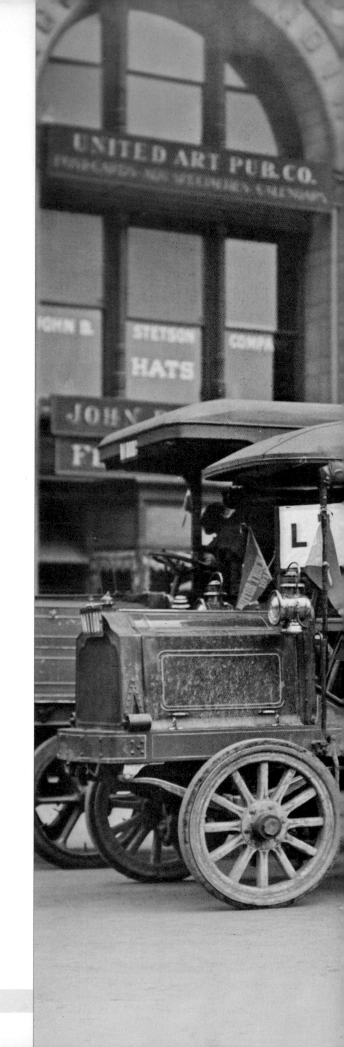

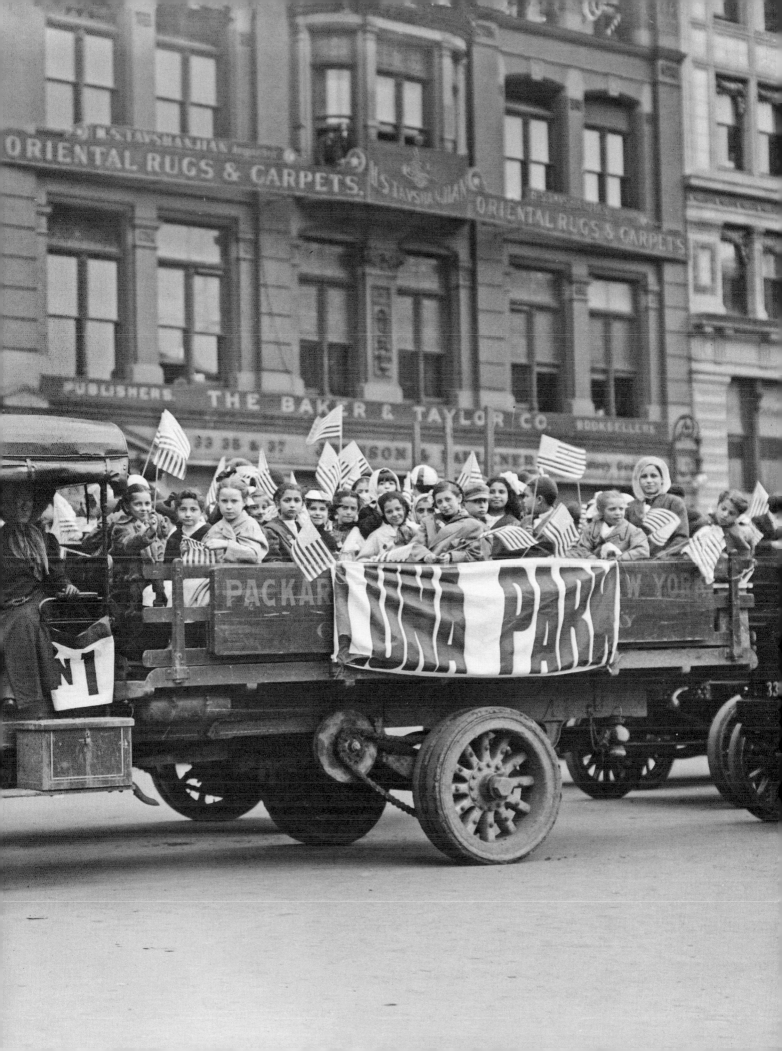

CHILDREN'S AID

Tens of thousands of abandoned children lived precariously on the streets of New York early in the twentieth century, though no official tally of their number exists. In the absence of any governmental safety net, private charities such as the Children's Aid Society (CAS) provided some of them with room, board, medical and dental care, and at least rudimentary education. Many homeless children were eventually shipped out of New York by the CAS on "orphan trains," destined for towns and cities in the Midwest and South for distribution to childless families or those needing extra hands on the farm.

Founded in 1853 by Charles Loring Brace, who ministered to the poor at Five Points Mission in lower Manhattan and on Blackwell's (now Roosevelt) Island, the Children's Aid Society provided parentless children with both sustenance and job training. Brace believed that church-affiliated orphanages inculcated a psychology of dependency, thus robbing children of a chance to succeed in life. At CAS schools and institutes established by Reverend Brace throughout the city children received rigorous vocational training in addition to traditional education.

It is not clear precisely what news story impelled Bain to compile photographs of infants at one of the City's CAS facilities, but both the *New York Sun* and the *Times* ran stories in March 1910 about the successful transfer of children to New Orleans from the New York Foundling and Orphan Asylum at 68th and Lexington, a Catholic orphanage. There apparently was considerable demand for northern babies in New Orleans and surrounding villages, and a train bearing what the *Times* called "choice baby freight" headed south, accompanied by two Sisters of Charity and several adoption agents and nurses. Even after this delivery, demand for healthy white babies remained strong.

LICKING BLOCKS OF ICE ON A HOT DAY

What appears to be a routine hot-weather picture to modern viewers may have meant much more to readers early in the twentieth century, for the manufacture, cost, and availability of ice were subjects of numerous investigative stories in New York papers from May 1900 to late summer 1913. William Randolph Hearst's *New York Journal* was the first to go after the so-called Ice Trust, but others soon followed suit with charges that the firms delivering ice to the City from upstate engaged in illegal price-fixing. Lack of serious competition between the American Ice Company and the Knickerboker Ice Company drove up prices, making ice prohibitively expensive in poor areas of the city.

High prices charged to independents and peddlers led to shortages in areas not served by firms associated with the Ice Trust. On the lower East Side, for instance, people depended on peddlers willing to dispense ice in small quantities; few tenement dwellers had the means to store the kind of large blocks used in uptown iceboxes. When street venders were forced out of the ice market, these people suffered.

Stories in the press regarding restraint of trade began to take a toll on the ice industry, and not surprisingly, the industry fought back. Wesley M. Oler, president of the Knickerbocker Ice Company, defended his practices in letters to the editor of the *New York Times* and in a bold two-column paid advertisement in the July 19, 1911 edition of the *New-York Tribune* titled "FAIR PLAY FOR THE ICE MAN." In 1913, Harold W. Cole of the Natural Ice Association of America stated flatly that except in a few "special emergencies...the poor do not need or even desire ice," an idea refuted by this Bain News Service image made on July 6, 1912.

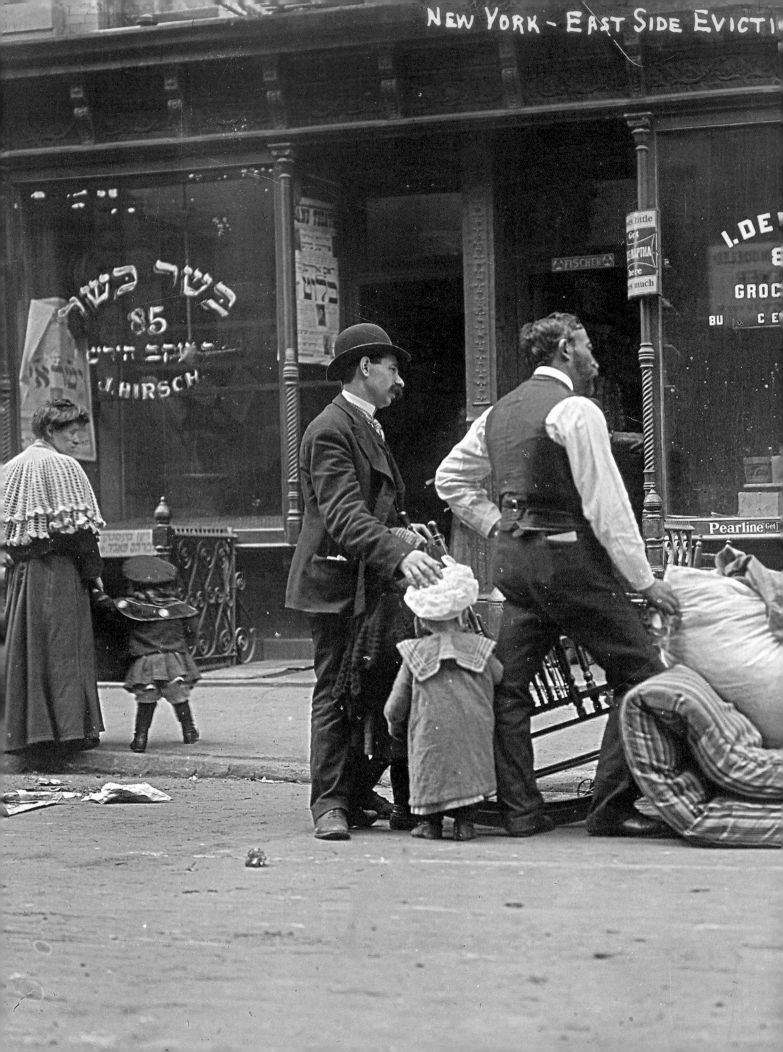

NEW YORK - EAST SIDE EVICTI[ON]

NEW YORK—EAST SIDE EVICTION

In the spring and summer of 1904 and again in 1907–8 tenants on the lower East Side were beset by soaring rents for their cramped apartments as well as the eagerness of certain landlords to use the courts to evict those behind in their monthly or weekly payments. There were public demonstrations and threats of violence as tenants (many of them Jewish immigrants from Eastern Europe) sought to retain their tenuous foothold in the City. The Courts were usually no help. Though some municipal judges expressed sympathy for families facing eviction, most felt compelled to follow the law, and the law favored the owners.

Newspapers published sympathetic photographs of families with small children huddled near meager piles of belongings piled on sidewalks. The protests, demonstrations, and press coverage did little to ameliorate the situation, though a few landlords reluctantly rescinded some of the increases. In time, many families found far more reasonable accommodations in Brooklyn. In fact, according to the *New York Times*, the exodus from the East Side, usually by way of the Williamsburg Bridge, actually created a glut of vacancies in the area by 1913.

J. Hal Steffen likely created this image in 1904 on or near Columbia Street. Steffen joined the Bain News Service that year as an apprentice, remaining for two years. His status in the Bain organization may explain the use of an unwieldy 8 by 10 inch camera instead of the more common press camera that produced 5 by 7 inch plates. It may also explain the inclusion of Steffen's initials on the plate. Bain never credited his full-time photographers for their work, but he may have allowed apprentice Steffen this slight acknowledgment.

HOTEL DE GINK—PREPARING MULLIGAN STEW

The outbreak of World War I devastated the American labor force as European markets dried up, and unemployment and homelessness increased dramatically. In response, New York and other cities pursued a variety of public and private approaches to provide work and minimal shelter. One of the most successful of these, and the one that garnered the most enthusiastic attention from the press, was the establishment of refuges in abandoned and derelict buildings. Named Hotels de Gink (for common man) by Jeff Davis, the charismatic and highly entertaining leader of Hoboes of America, Inc., the places were fixed up and run by unemployed men, providing a temporary, low-cost, and politically palatable solution to an endemic problem.

The New York Hotel de Gink, a five-storey building at the corner of Center and Worth Streets that was once a button factory, officially opened on January 21, 1915 with a gala celebration attended by city officials in evening dress and silk hats, vaudeville performers claiming an ancient affinity for the hobo way of life, and even a small orchestra. Jeff Davis surveyed the festivities from a throne decorated with a giant horseshoe made of carrots, onions, cabbages and potatoes—essential ingredients of a mulligan stew.

The Hotel de Gink flourished during the early years of World War I, but closed shortly before America entered the war. In 1919, the city renovated the building and used it briefly as a detention facility for material witnesses in pending court trials. Two years later, the old Hotel de Gink, once a last-chance haven for the homeless and unemployed, housed the employment division of the Industrial Aid Bureau, a city-run effort to combat unemployment among veterans of the war in Europe.

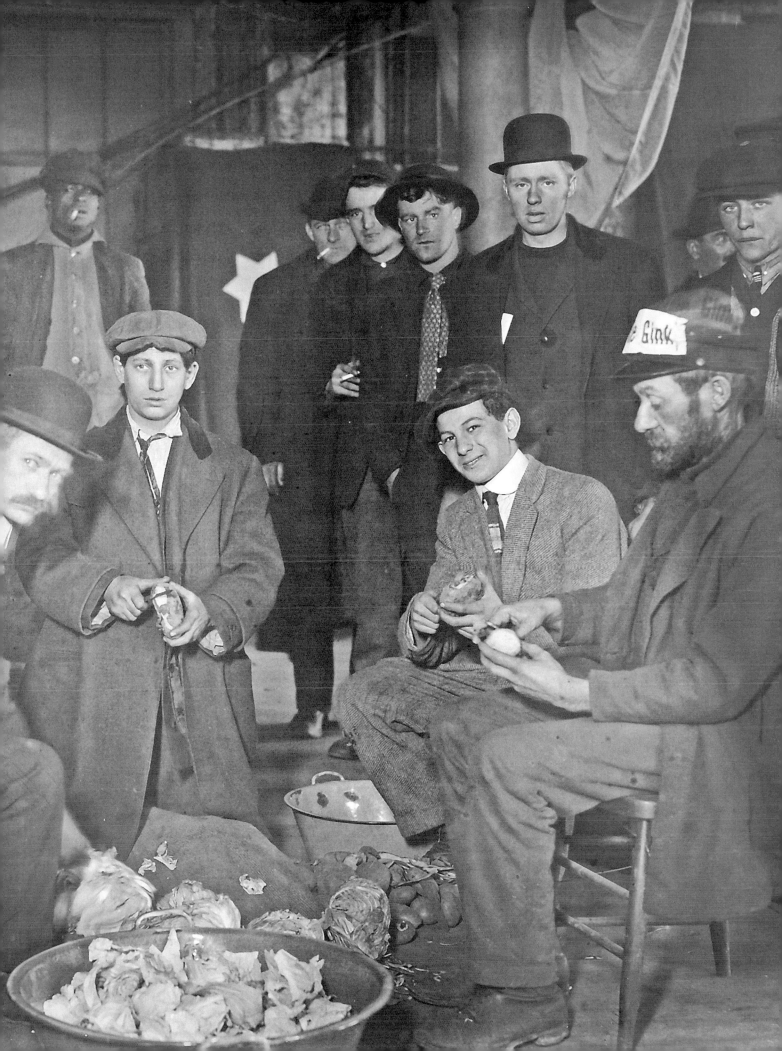

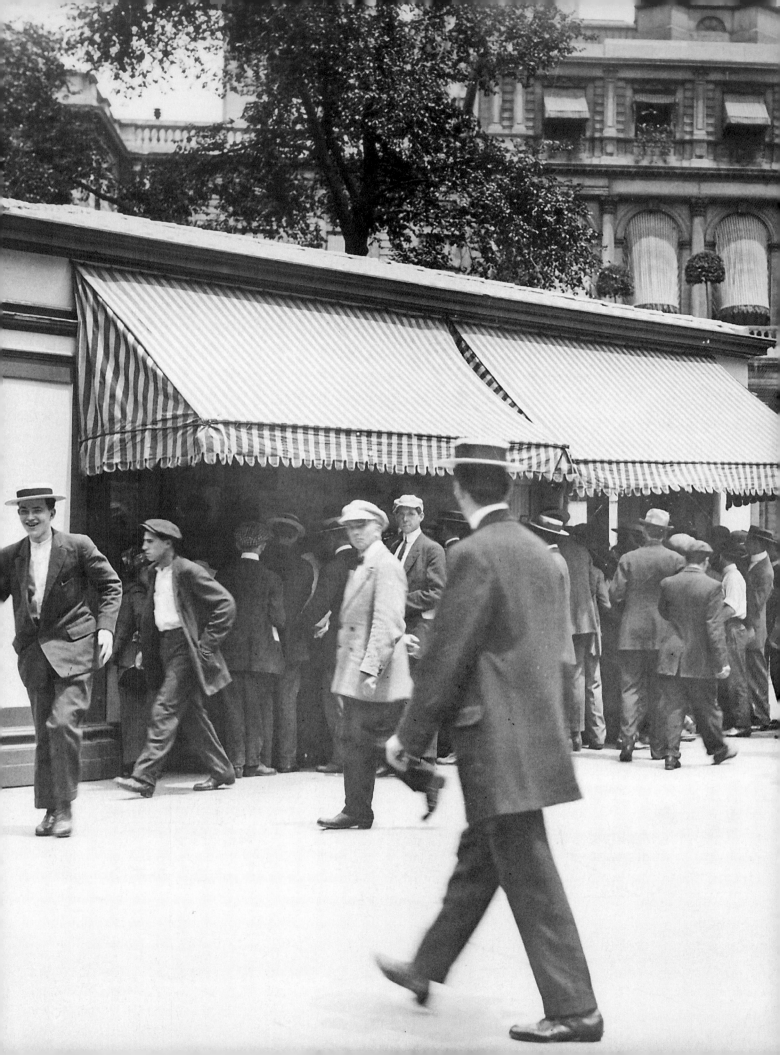

MILK 1 CENT—CITY HALL PARK NEW YORK

The phenomenal growth of New York in the decades after the Civil War seriously affected the ability of dairy farmers to supply unspoiled milk to the City's population, especially in poor and working class districts. The high rate of infant mortality—in 1841 one of every two children under the age of five died, many of them from intestinal infections—convinced a coalition of doctors, scientists, and social reformers that regulating the milk supply could save lives. One group led by Dr. Henry Coit urged the establishment of strict standards for milk producers. An alternative to Coit's certified raw milk movement was pasteurization, a process that removes impurities in milk by heating.

Nathan Straus, co-owner of Macy's department store, spent more than three decades working to improve milk supplies in the City. In 1893, he built the first of his "milk depots" at the Third Street Recreation Pier on the East River, which supplied pasteurized milk at just a penny per glass. Mothers unable to afford even that could obtain vouchers from various charitable organizations to cover the cost. By October 1894, the death rate among infants on the Lower East Side decreased by a tenth, and Straus and others credited pasteurized milk for the decline. Straus built many more depots, including the one pictured here at City Hall Park, as well as a pasteurization laboratory at 151 Avenue C to ensure a steady supply of fresh milk.

On June 6, 1921, Mayor John ("Honest John" to his supporters) Hylan and the City's Health Commissioner, Dr. Royal Copeland, officially opened Milk Week at the Straus depot in City Hall Park. As photographers made their pictures, the mayor raised a brimming glass of milk and said he hoped "every baby in New York will have plenty of milk for the rest of the year and in all the years to come."

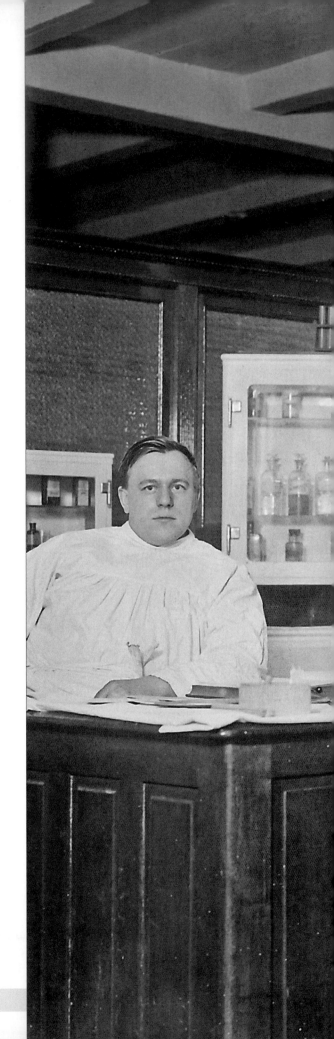

N.Y.C. LODGING HOUSE–VACCINATING

The Danish-born social reformer Jacob Riis spoke passionately of homelessness and poverty in New York, describing in words and photographs the horror of life in the grimy, dangerous lodging rooms run by the police. "These vile dens," he wrote in 1902, "in which the homeless of our great city were herded, without pretence of bed, of bath, of food, on rude planks, were the most pernicious parody on municipal charity...." Eventually, city officials took note, and in 1909 a new six-story Municipal Lodging House opened. Designed by Raymond F. Almirall and situated at 25th Street between First Avenue and the East River, it offered safe accommodations and three meals a day for as many as nine hundred persons, mostly men and women.

The bed and board were free, but staying at the Municipal House came with a price. Each new lodger had to strip naked while attendants took their clothing to be fumigated. After showering with green soap strong enough to kill any resident vermin, clients received clean nightshirts and socks, and then traveled by elevator to an upper floor (separate floors for men and women) where a physician from the Board of Health examined them. The merest sign of contagious disease led to swift transfer to Willard Parker Hospital at 16th Street and the East River, which specialized in the treatment of infectious disease. Anyone requiring a smallpox vaccination got it—no exceptions.

This image was probably made for Bain in early 1909, shortly after the facility opened. The lodger receiving the vaccination, identified by a number on the brass tag hanging from a cord around his neck, his hair still showing the effects of the shower, sits quietly while another waits his turn. The new Lodging House, however encumbered by rules and regulations, was a distinct improvement over the disgusting places described by Riis, and the first city-run institution to do something about endemic homelessness.

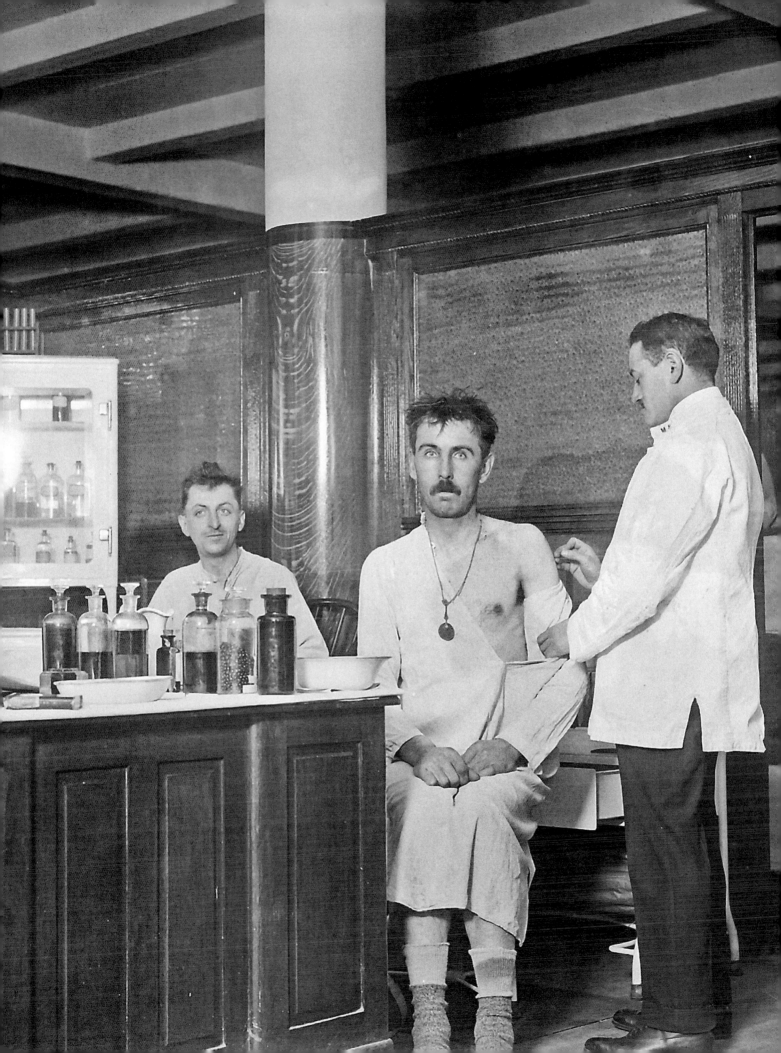

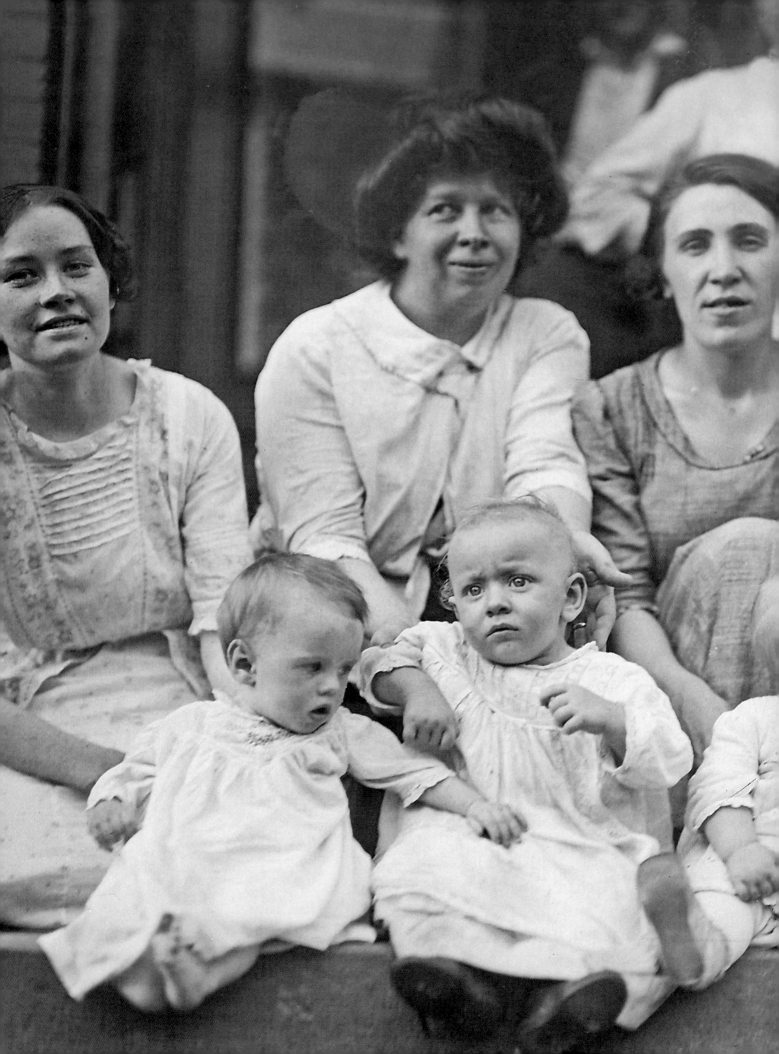

EAST SIDE BABIES

Better Baby and Healthy Baby contests were popular diversions for young parents in American cities in the first decades of the twentieth century. Usually judged by physicians and other health professionals, the contests sought to encourage healthful child-rearing practices and to identify children in need of medical attention. The May 1913 contest in New York, organized by the University Settlement in the heart of the Lower East Side and judged by doctors on the staff of the Babies' Hospital at Lexington and 55th Street, promised modest financial rewards, and, most importantly, a chance for babies to be thoroughly examined by a physician. It was an opportunity too good to be missed.

To ensure the event did not devolve into a contest for the cutest or most fetchingly dimpled, candidates underwent testing and measuring by nurses and physicians who meticulously noted each child's height, weight, head and chest circumference, abdominal and sensory development, and disposition. Babies received a numerical score in each category; in order to make the first cut they had to receive a score of at least 975 out of a possible 1000. Rejection was a bitter pill for parents to swallow, though one perhaps softened by a souvenir photograph.

On May 17, the judges announced the winners, and by design or coincidence their choices reflected the extraordinary diversity of lower Manhattan. Sixteen-month old Sussman Starvisky, the child of Jewish immigrants from Russia, was first in Class A (the oldest babies); Mollie Pallas, the eight-month old child of Turkish parents won Class B; and four-month old Francis Motto of Little Italy took the first prize in Class C, the youngest babies.

DOCTOR WORKING ON RECREATION PIER

The 720 foot-long double-decked recreation pier at 24th Street and the East River, opened by Mayor William L. Strong on September 25, 1897, was a vital resource for residents in the crowded neighborhoods of the lower East Side, especially during the summer months. According to Maurice Featherson, Commissioner of Docks and Ferries, over 10,000 people a day visited the pier during the hot months. Most came for a respite from oppressive heat, a chance to see friends, perhaps, or even listen to music (there were free concerts at night), but others came with their children, hoping for a chance to see one of the physicians or nurses supplied by the Health Department.

With prodding from Sara Josephine Baker, director of the Bureau of Child Hygiene, the Health Department assigned one doctor and several nurses to each of the city's recreation piers. Their main purpose was to provide education about the proper care and feeding of infants. Child mortality from gastro-intestinal diseases and tuberculosis increased dramatically during the summer, and public health officials believed that by instructing young mothers about the need for cleanliness, pure (pasteurized) milk, and plenty of fresh air and ventilation, they could reduce the terrible toll of infant death.

The lack of medical care in the city's poorest districts made summertime visits to doctors on the recreation piers vital. For tenement dwellers on the lower East Side, the free clinic on the 24th Street pier, where this picture was made, provided their only real access to medical care, and they came in droves. Despite problems in communication between medical personnel and their immigrant patients, there was steady improvement, and in July 1911, Ernst J. Lederle of the Department of Health announced that infant mortality would likely decline by 1,000 by the end of the summer.

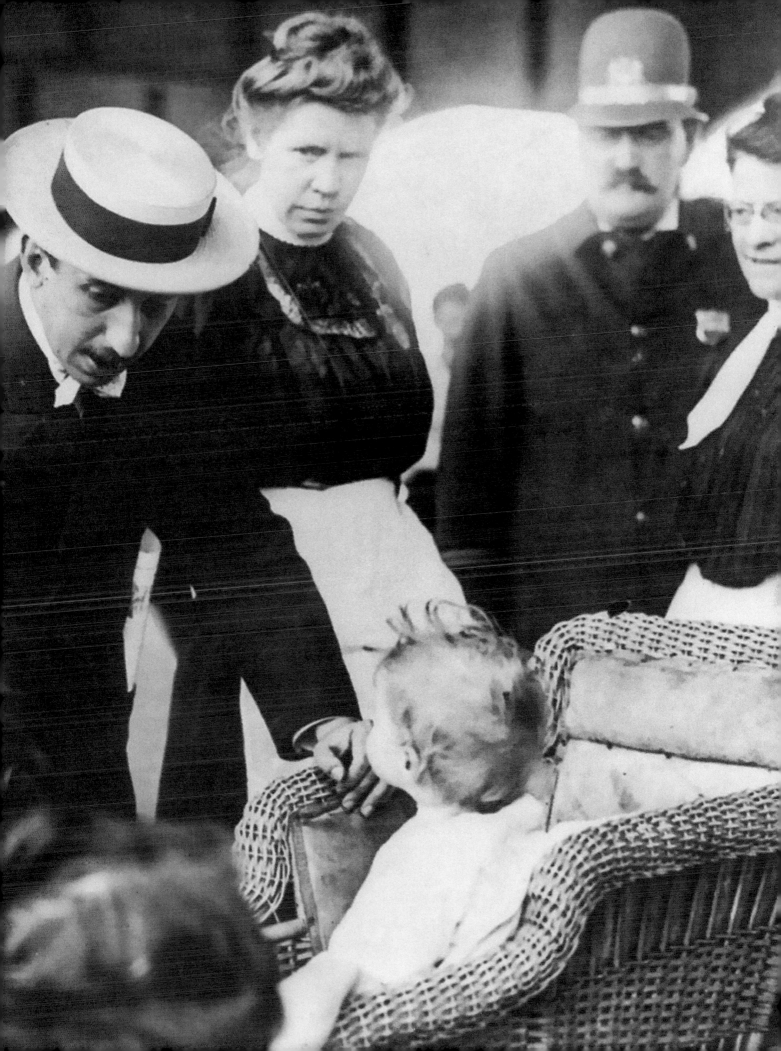

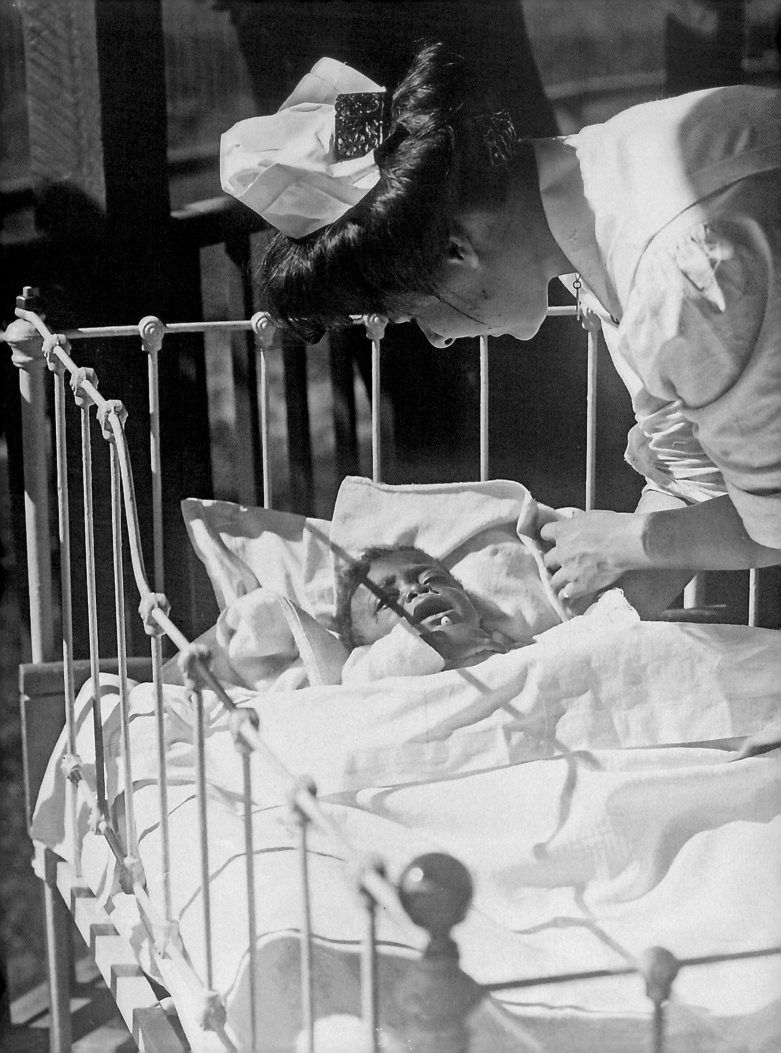

NURSE & PATIENT—"JUNIOR SEA BREEZE"

In July 1905, Theodore Roosevelt spent over two hours touring Sea Breeze Home, a newly constructed hospital for children with all forms of tuberculosis, located on the shore in Coney Island, but separate from the area's raucous amusement park. Newspapers across the country reported on the President's visit as well as his observation that sick children "can't help getting well here." Roosevelt's enthusiasm was contagious; the following year John D. Rockefeller contributed $125,000 to enhance and expand the facilities at Sea Breeze.

Rockefeller did more. On land situated on a bluff overlooking the East River at 64th Street, once part of a grand eighteenth-century estate owned by the Schermerhorn family, Rockefeller built Junior Sea Breeze Hospital where, according to the *New York Times*, "babies suffering from Summer complaint or other infant diseases may be brought at any hour of the day or night for treatment." Operated by the Association for Improving the Condition of the Poor, Junior Sea Breeze had cribs for approximately sixty-five infants, and there was no charge for treatment. In 1910, when this photograph was taken, Junior Sea Breeze had a staff of two physicians, twenty-two nurses, and two dieticians.

Though much publicized and undoubtedly well meaning, Sea Breeze and Junior Sea Breeze did little to stop the spread of TB. The movement to provide New York City children and infants with pure, pasteurized milk, spearheaded by Nathan Straus, helped a great deal, and the development of antibiotics in the 1930s and 40s ultimately did even more to combat infection, though TB continued to take its dreadful toll in the poorest areas of the city.

CONSUMPTIVES ON "SUSQUEHANNA"

Tuberculosis, called "the white plague" for the pallor it causes, or consumption for the way it slowly consumes the bodies of the afflicted, was and still is a deadly scourge. Ancient Egyptians wrote of it; so did John Bunyan, who described TB as "the Captain of All These Men of Death." In the years before the development of antibiotics, standard treatment included plenty of fresh air and sunlight, proper ventilation, and sanitation, none of which was readily available in over-crowded and impoverished urban neighborhoods.

The disease thrived in the dank, airless sweatshops and tenements of New York City, infecting working men and women in the prime of life, then spreading inexorably to their families. The youngest and most "innocent" victims were children, and their plight attracted the attention of charitable organizations, progressives, and some health professionals determined to treat those with no other access to medical care.

In 1909, Mary Harriman, daughter of the railroad baron Edward Harriman and founder of the Junior League for Promotion of the Settlement Movement in New York (now simply the Junior League), together with the Brooklyn Bureau of Charities and the Brooklyn Tuberculosis Committee purchased an old ferryboat, the *Susquehanna*, anchored her in the Erie Basin on the Brooklyn waterfront, and refitted her as a floating school and clinic for children with TB. The *Susquehanna* and other hospital ships treated a relatively small number of consumptives, but press coverage of their operations helped educate the public about the disease and suggested ways to limit its spread.

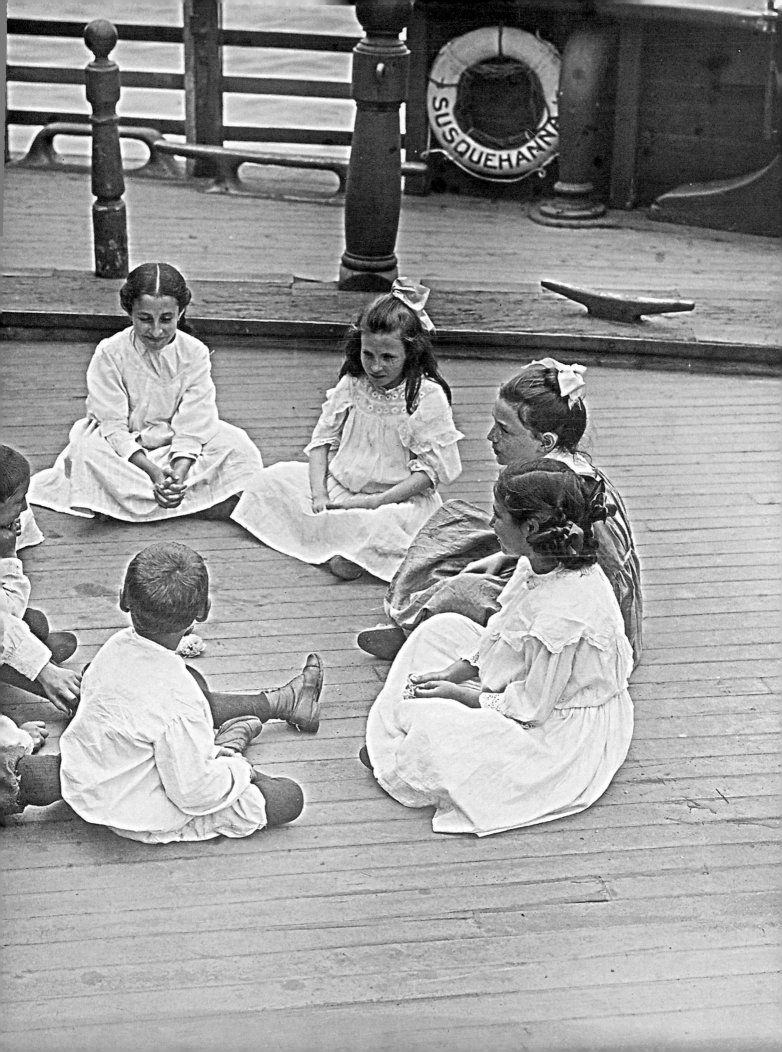

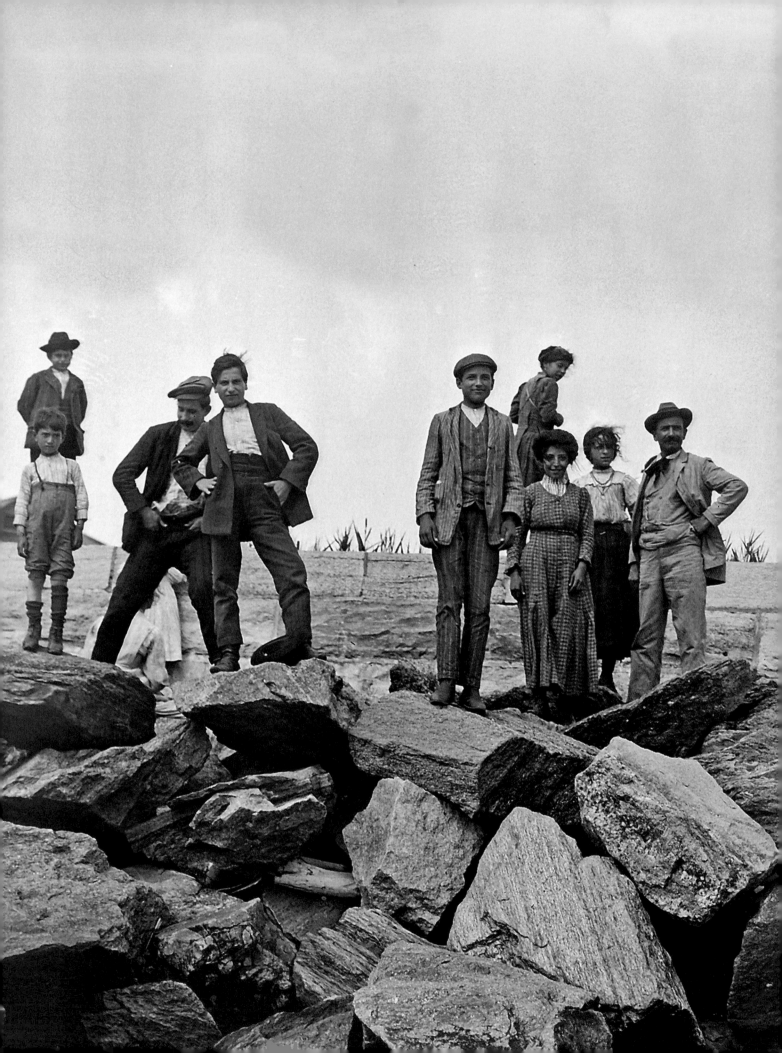

QUARANTINED ON HOFFMAN ISLAND

Ellis Island is a national icon, the most important component of the idea of America as melting pot. Between 1892 and 1954, over twelve million immigrants entered the United States after first being examined and approved for entry by federal officials on the little twenty-seven acre island in New York Harbor. Much less is known about two nearby man-made islands, Hoffman and Swinburne, which housed immigrants who arrived at Ellis Island ill with disease. Those identified as contagious and the family members traveling with them received immediate transport by quarantine or "plague" boat to Hoffman where medical treatment was available. Those desperately ill, perhaps with cholera, yellow fever, or smallpox went directly to Swinburne Island, which also housed a handy crematorium.

Dredged from shoals off South Beach on Staten Island, Hoffman Island covers about eleven acres protected by a sea wall and heavy riprap. Accommodations, while hardly commodious, were comfortable, especially compared to the fetid conditions in steerage class. Healthy family members were free to roam the island while their loved ones received treatment. Immigrants with diseases considered incurable, such as trachoma, a bacterial infection of the eyes, eventually received deportation orders; those who managed to recover from diseases like measles and scarlet fever were released.

Officials prohibited non-essential visits to Hoffman and Swinburne, which may explain why Bain's photographer stayed off shore. Even today, long after the state closed the quarantine facilities for good, the islands remain off-limits, because as essential components of the Gateway National Recreation Area, they now provide vital nesting sites for gulls and wading birds.

QUARANTINED CHILDREN OF CHOLERA VICTIM

In the summer of 1911 the prospect of a cholera epidemic on American soil suddenly seemed imminent. Cases of cholera proliferated in Naples, Italy throughout 1910 and 1911, and perhaps inevitably, immigrant ships arriving in the Port of New York had sick persons aboard. The quarantine system run by Dr. Alvah H. Doty, was supposed to identify those ill with cholera and isolate them on Swinburne Island. In July, however, it appeared that the deadly scourge might have escaped the confines of quarantine.

Patrick F. Cushing, hired temporarily to guard passengers from the *SS Moltke*, a Hamburg American Line ship that arrived from Italy on July 5 with infected persons aboard, returned to his home at 14 Fingerboard Road, Clifton, on Staten Island after being laid off. The 37-year old man became desperately ill shortly afterwards and was rushed to nearby St. Vincent's Hospital where tests proved he had cholera. Cushing was taken to Swinburne Island where he died on July 15; meanwhile, authorities placed his wife and children under guard at their home. An inspector from the Board of Health regularly visited the house, and everyone was examined for traces of the disease. None of them became ill.

The fact that Cushing left Hoffman Island to go home though he was known to have had contact with sick immigrants led to bitter denunciations of Dr. Doty and his procedures. The governor of New York, John Alden Dix, called for an investigation of the Quarantine Service, and the subsequent report was highly critical. In February 1912, seven months after the death of Patrick Cushing, Doty voluntarily left his job as Health Officer of the Port of New York. By then, of course, the epidemic was old news.

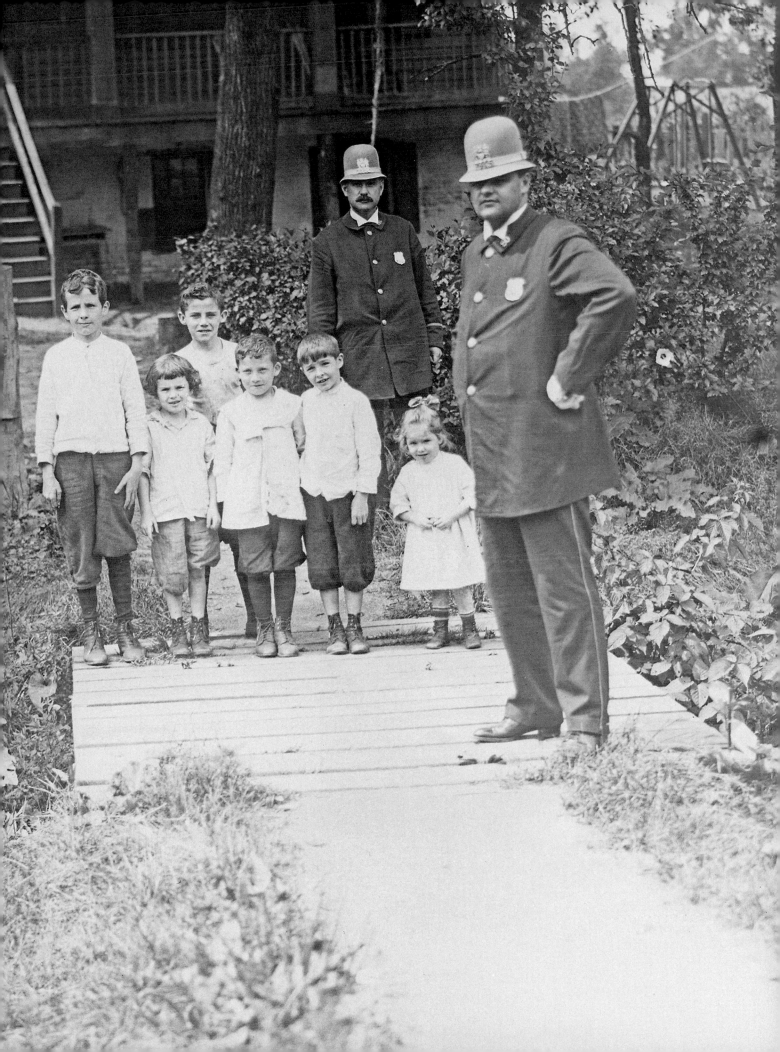

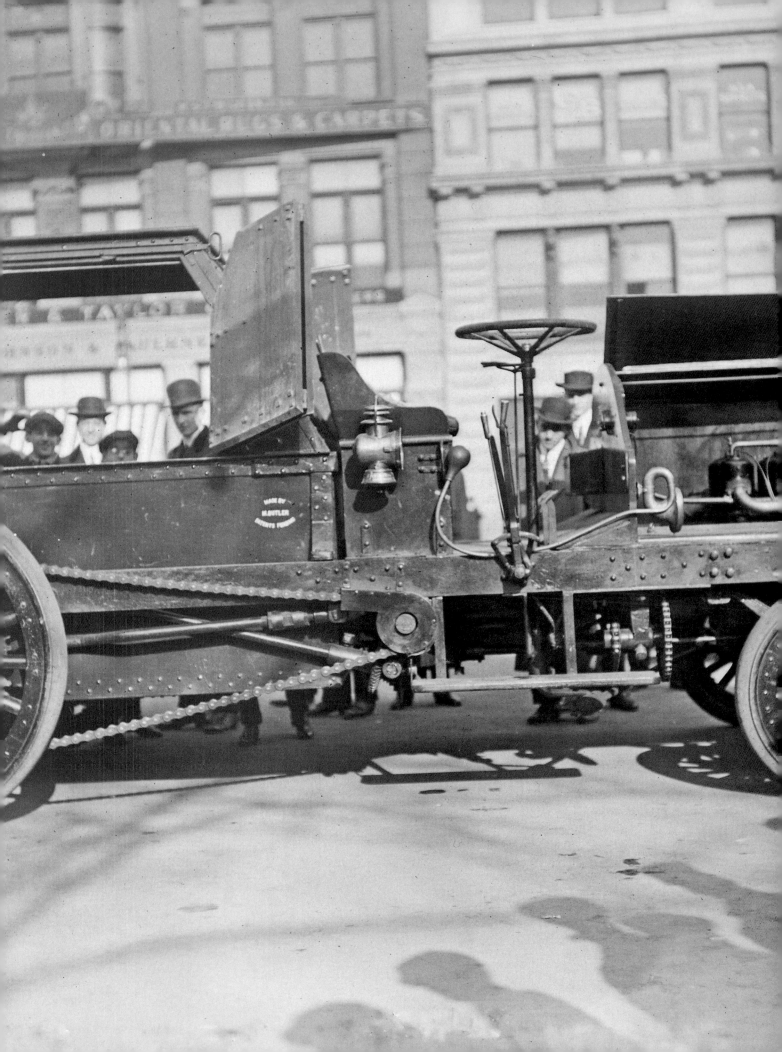

AUTO STREET CLEANER

Inadequate and inefficient garbage collection and removal from the streets of New York was long recognized as an impediment to economic progress and a threat to public health. Especially as the city's population grew rapidly early in the twentieth century, the accumulation of waste far outpaced the city's mostly meager efforts to get rid of it. In 1914, the new commissioner of Street Cleaning, John T. Fetherston, noted that New York ranked well below other major cities in its commitment to sanitation, and vowed to change things. In particular, he called for funds both to hire and train additional sanitation workers and to replace decrepit equipment

During the last week of November 1914, Fetherston's Department of Street Cleaning conducted a series of public seminars on sanitation, as well as exhibitions of new and used street-cleaning appliances and entertainments including a parade featuring the Department of Street Cleaning marching band. Fetherston invited manufacturers of waste hauling equipment to attend, and several, including one Magnus Butler, showed up with impressive mechanical devices. At a time when men with push-brooms and shovels were responsible for cleaning streets by piling refuse into wagons hauled by horses, (which naturally produced abundant waste of their own) the idea that garbage could be picked up and disposed of "automatically" must have seemed miraculous, and Fetherston's week-long exhibition attracted over 27,000 New Yorkers.

Butler's machines, similar to the street sweepers patented in 1909 and 1915 by Charles H. Butler, an inventor from Oakland, California, attracted a large crowd, as well as Bain's photographer. Since his trucks carried the letters DSC, for Department of Street Cleaning, it is safe to assume that Mr. Butler had a contract with the city.

RAT CATCHER AND FERRETS

Rats have always been an unpleasant fact of life; disease-ridden, destructive, voracious, yet—as a species—indestructible. Still, people attempt to exterminate, or at least control them using vast amounts of poison, setting traps along rat runs and at the entrances to their burrows and dens, and sharing homes and apartments with notorious rat-killers like cats. Still, the rodents persist and, not surprisingly, so do professional rat-catchers. Early in the 1900s exterminators in New York and other American cities began importing thousands of ferrets, long known to European professionals as efficient and indefatigable rat assassins.

However necessary and competent, rat-catchers elicited little public admiration apart from an occasional prize given in the late 1880s to one of their profession by Richard K. Fox, editor and publisher of the *Police Gazette*. Perhaps they still carried the taint of the legendary Pied Piper, who first rid the town of Hamelin, Germany of its rats, then returned to lure away and presumably kill all but three of the town's children in retaliation for the town's refusal to pay for the original extermination. In any event, aside from images made for the George Bain News Service in 1920 by an unidentified photographer, both ferrets and their handler generally kept a low profile.

That is, they did until June 29, 1999 when the New York City Board of Health included ferrets on a list of prohibited animal pets, alongside gorillas, wolves, and tigers. Ferret-lovers protested long and bitterly, but Mayor Rudy Giuliani and the Board of Health held firm. In New York City's five boroughs, pet ferrets are now illegal.

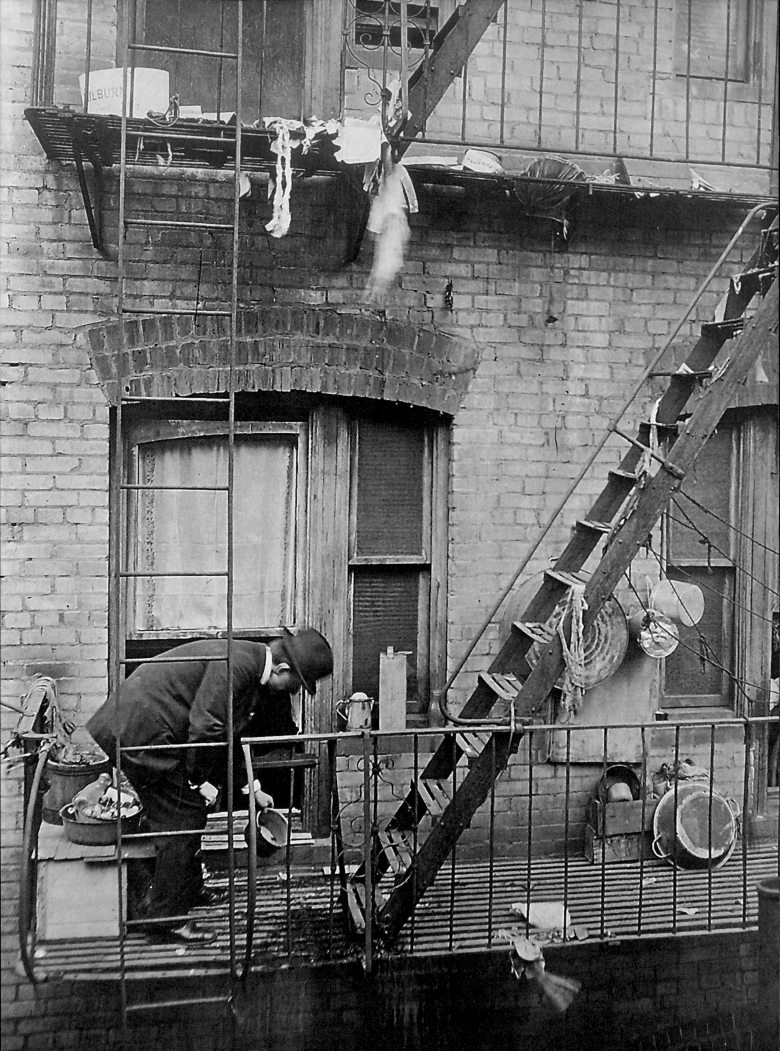

LOOKING FOR MOSQUITO BREEDING SPOTS

The well-publicized efforts of Dr. William Crawford Gorgas to combat malaria and yellow fever by exterminating mosquitoes during the construction of the Panama Canal from 1904 to 1914 encouraged state and city health officials in New York and New Jersey to establish similar programs. Despite occasionally fervent opposition from those who scoffed at the very idea of mosquito-borne illness as well as those objecting to the cost and scope of the programs, considerable progress was made during the first two decades of the twentieth century.

The largest and most fecund breeding grounds were marshes that covered much of the Jersey shore and sections of Staten Island, Brooklyn and Queens. Landfill operations in some of these areas both eradicated mosquitoes and created new land for development. Health and Sanitary officials also mandated the construction of ditches and canals through coastal wetlands, thus effectively draining them, and the Department of Street Cleaning dumped ashes, sweepings, and garbage into low-lying areas that tended to collect and hold water.

In addition to these large-scale eradication programs, Health and Sanitation Department workers fanned out across the city in search of smaller breeding sites, such as uncovered or unscreened barrels, tanks, catch basins, or other containers on rooftops or, as in this photograph, on fire escapes. The usual method of extermination was to either overturn and empty the receptacle or spread a thin layer of oil or kerosene over the surface of the standing water, which effectively suffocates the mosquito larvae. In heavily infested areas such as cellars, outhouses, cesspools, or stables, Health Department officials recommended the judicious use of fumigants such as carbon disulphide.

ONE OF THE "1000 MARRIAGEABLE GIRLS" ON THE BALTIC

Early in the twentieth century, newspapers in New York and elsewhere published many stories describing aspects of American immigration policy and the impact of new arrivals on American life. The enormous influx of foreigners sparked both vicious nativist reactions and urgent calls for progressive reforms; controversy surrounding the issue helped sell a lot of papers.

In September 1907, a decidedly positive story about immigration hit the papers when it was announced that the steamship *Baltic*, due to arrive in New York on September 27 from Queenstown, Ireland and Liverpool, England, carried amongst its passengers over a thousand comely, single women who, it was said, wanted nothing more than to find an American husband. According to the *Washington Post*, "Each one of the fair consignment was handsome, and sturdy and buxom…. They were all sizes, ages, and complexions, but each knew her mind." Bain's photographer, most likely

Henry Raess, made several pictures of women leaving the ship for the examination rooms at Ellis Island, though it would be a full twenty-four hours before any of them was permitted to leave and, presumably, begin sifting through marriage proposals.

Officials of the White Star line, which owned the *Baltic*, denied the women were coming to America in search of marriage, suggesting instead that most were maids and nannies in the employ of wealthy American families, returning to the United States after visiting their own families during the summer. "We always have a good summer business of this sort," said the White Star spokesman. Exactly how many of the one thousand were actually single and intent on marriage is unknown. As for the two in this photograph, we know only that Raess identified the woman as a "marriageable girl." He may or may not have been correct.

IMMIGRANTS FROM "PRINZESS IRENE"

The Barbarossa-class ocean liner *Prinzess Irene*, built for the North German Lloyd line and launched in 1900, specialized in the lucrative trans-Atlantic passenger trade. From 1903 to the outbreak of war in 1914, she provided passage for thousands of immigrants from ports in southern Europe to New York, her third class and steerage decks crammed with folks eager to pursue the American Dream.

The six to eight crossings made each year by the *Prinzess Irene* and other immigrant ships rarely caught the attention of the New York press. However, in 1906 and again in 1911, the ship briefly made news. According to the *New York Times,* during the November 1906 eastward crossing, an electrical fire in one of the steerage compartments caused "a panic among the excitable Italian immigrants who [had] boarded the steamer at Naples." The crew quickly extinguished the fire but it took hours to persuade the passengers that the ship would not suddenly explode and sink. Five years later, in April 1911, the *Prinzess Irene* ran aground on a sand bar off Fire Island and remained stuck there for over eighty hours. An unnamed Bain photographer made pictures of a cheerful Sunday holiday crowd from Sayville and other Long Island towns watching efforts to tug the great ship out of the sand. When the liner's passengers finally arrived the next day at Ellis Island, more photographs showed immigrants standing with their luggage, presumably awaiting processing. The image perfectly encapsulates at least some aspects of the Ellis Island experience. The men in the picture are a bit ragged and their luggage somewhat rough and threadbare, but they stand unbowed, facing the photographer. Perhaps they assume he is an official, and the image simply another required step toward admission.

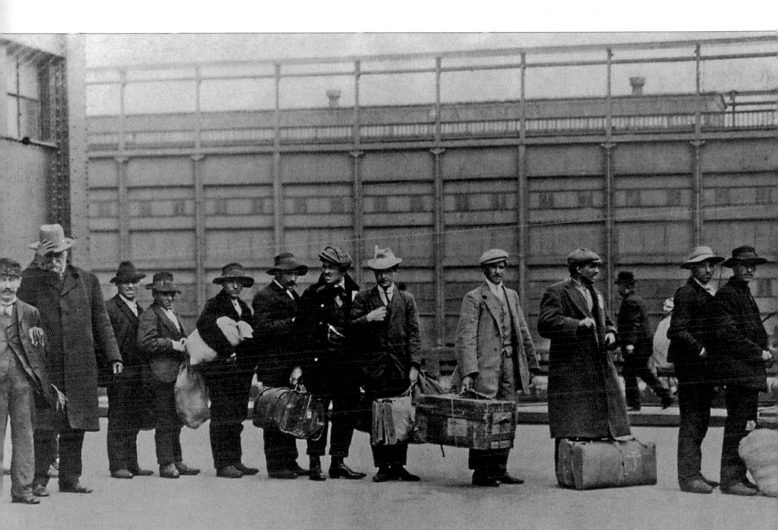

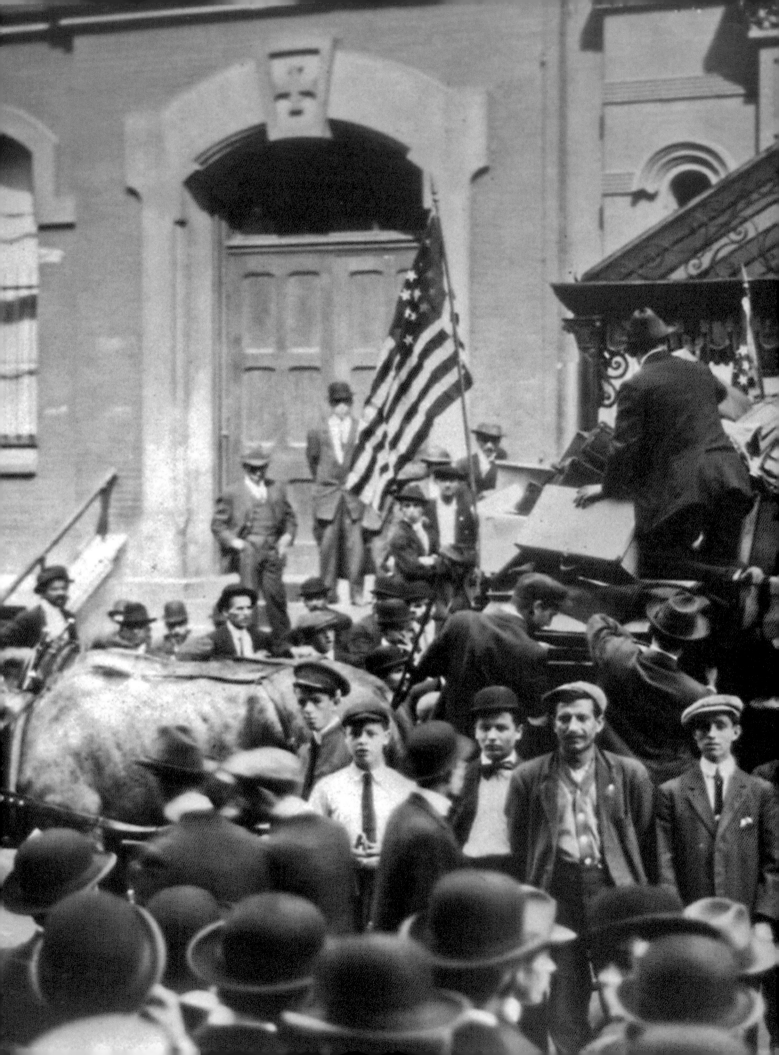

GREEKS IN NEW YORK, GOING BACK TO FIGHT

The First Balkan War pitted members of the Balkan League (Greece, Serbia, Bulgaria, and Montenegro) against the Ottoman Empire in a bloody three-month long prelude to World War I. Hostilities began officially on October 8, 1912, when Montenegro declared war on the Turks; within two weeks everyone was involved. Well before the shooting began, Greece's King George called up the reserves—including those living abroad—and in early October a sizeable portion of the Greek community in America made arrangements to return home to fight.

On October 5, the first contingent of some 600 young men boarded the National Greek Line ship *Macedonia*, scheduled to depart for Piraeus from pier 30 in Brooklyn at 6:00 PM. But the would-be soldiers were on board just a few minutes before being notified that steerage passengers must transfer to another ship, the *SS Martha Washington*. United States regulations prohibited ships from carrying both explosives and 3rd class passengers, and the *Macedonia*'s hold contained guns, ammunition and four field artillery pieces purchased from the Bethlehem Steel Company.

That momentary setback did little to dampen the enthusiasm of Greek Americans from heeding the King's call to arms. During October and early November, Greeks in New York City and elsewhere made their way to the East and North River docks to book passage, usually in steerage class, on ships headed to Europe. Bain's photographer made a series of photographs of returnees gathered in front of Webster Hall at 125 East 11th Street, their luggage piled high onto a horse-drawn wagon. Other images showed reservists on board various ships, a kind of pictorial paean to immigration in reverse. None showed the departure of the French liner *Niagara*, which left New York for Le Havre on November 2 with both Greek and Turkish reservists aboard, all headed to war but on opposite sides.

PRAYERS—WILLIAMSBURG BRIDGE

Two short films made in December 1903, one shot by James Blair Smith for Thomas Edison, Inc. and the other by G.W. "Billy" Bitzer for the American Mutoscope and Biograph Company, depict opening ceremonies for the Williamsburg Bridge connecting lower Manhattan to Brooklyn. The footage shows a gaggle of reporters and news photographers with press cards stuck into their hatbands, followed by a host of dignitaries including New York's lame duck mayor, Seth Low, all marching along the bridge's flag draped roadway. It was by all accounts a brilliant affair, ending at night in a grand fireworks display that lit up the bridge.

Despite all the pomp and promise, however, the Williamsburg Bridge never struck the American fancy like its famous neighbor to the south, the Brooklyn Bridge. Just four months after the grand opening, the *New York Tribune* noted snidely that New Yorkers now referred to the bridge as "the Jews' Highway." The new span over the East River did indeed facilitate an exodus away from the over-crowded immigrant neighborhoods of the lower East Side to Williamsburg, but neither lower Manhattan nor the Williamsburg section of Brooklyn was then (or is now) populated by a single ethnic group.

Still, since the bridge opened, religious Jews ventured onto it during Rosh Hashanah to participate in a ceremony called Tashlich, which involves prayer and the symbolic casting off of sins into moving waters. Though in this picture the bridge is misidentified as the Brooklyn Bridge, whoever titled the photograph correctly notes that the people are Jewish and praying. The actual event, however, was and is much more about the river than the bridge.

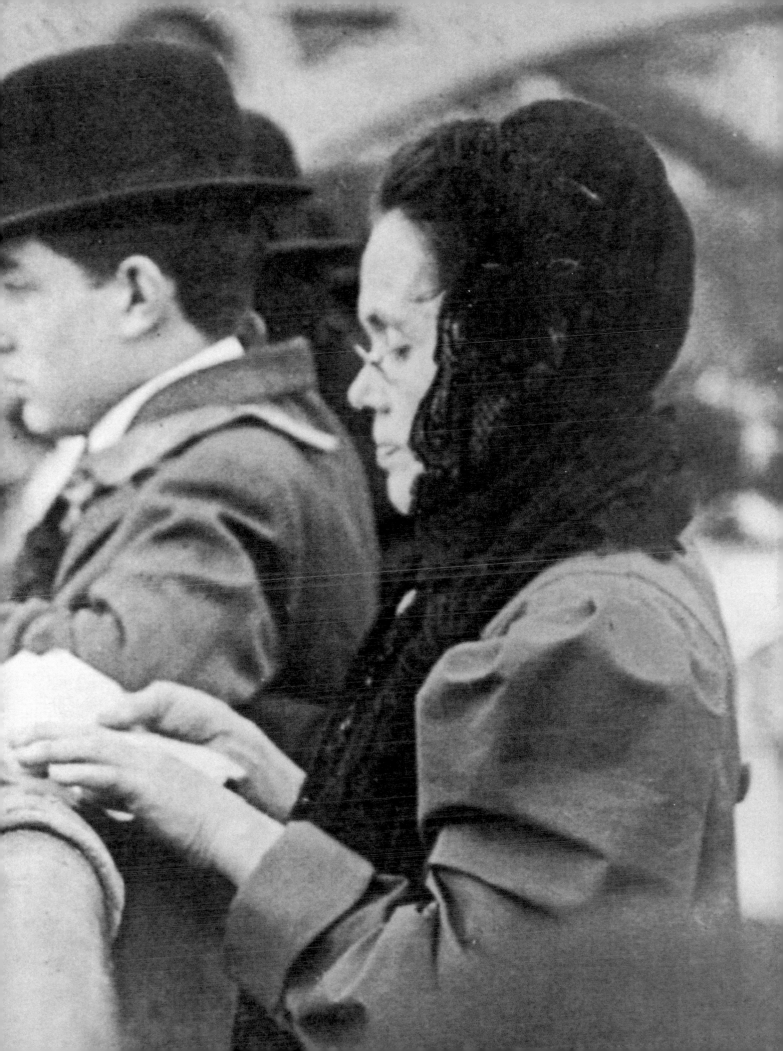

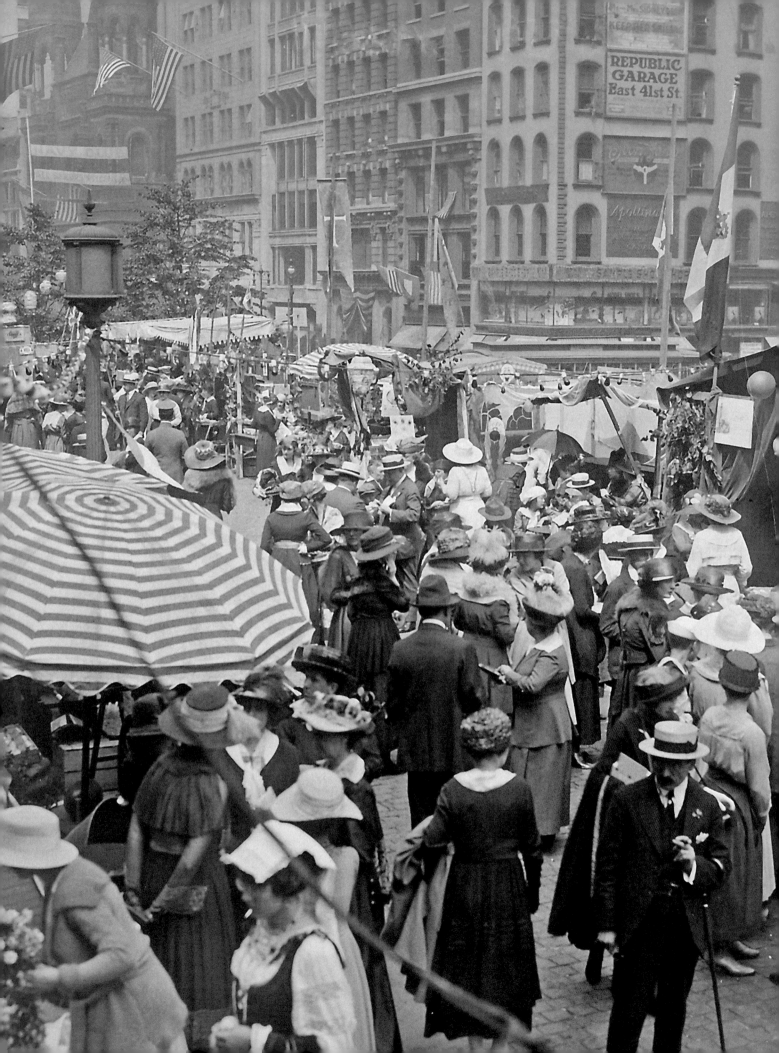

ITALIAN FESTA

In the late nineteenth and early twentieth centuries, there was never a single, monolithic Little Italy in New York; rather, Italian immigrants settled in neighborhoods throughout the city, from Mott and Elizabeth Streets in lower Manhattan to Harlem and all the other boroughs. And at various times during the year, each Little Italy celebrated one or more patron saints in festivals that attracted local inhabitants as well as sightseers and shoppers from other districts. In mid-August, for instance, Italians on the lower east side and in Brooklyn organized street fairs, parades, and services honoring San Rocco, the fourteenth century martyr who protects against the plague and other contagious diseases.

The annual Feast of San Rocco, which was (and still is) celebrated in Manhattan, Brooklyn, and elsewhere, attracted considerable attention from the press, which usually described the festivities as colorful and slightly exotic outdoor street fairs. "There were American and Italian flags galore," the *Times* reported in 1899, while "paper lanterns hung from windows and fire escapes and festoons of little glass lamps were strung across the streets." The decorations were "of the cheapest character, but a few cents spent in bunting and colored paper go a long way..."

The city's newspapers usually steered clear of discussions of the religious significance of the festivals, preferring instead to emphasize the events' carnival-like atmosphere. In 1906, however, a dispute between rival organizations, the Societa Mutuo Succorso di San Rocco and the Confraternita di San Rocco, caught the attention of the *Sun* and other papers, as the effigy of San Rocco was taken from its original home in San Giaocchino's Church on Roosevelt Street to the basement of St. James church two blocks away. For a time there was talk of dueling parades and even separate effigies, but within weeks San Rocco was back at San Giaocchino's for good.

SELLING COOL DRINKS IN SYRIAN CORNER

Little Syria was a vibrant immigrant neighborhood along Washington and Rector Streets on the lower west side of Manhattan, a few blocks south of the future site of the World Trade Center. The neighborhood consisted mostly of Christian Arabs from Greater Syria, an area that roughly included the modern boundaries of the Palestinian territory, Israel, Lebanon, Jordan, and Syria. From about 1880 through the first decades of the 20th century, "Syrians" came to America in search of religious freedom and economic opportunity, both of which were in short supply in the waning days of the Ottoman Empire. They built at least three churches and many businesses along Washington Street, and got the news of the day from one of several Arab-language newspapers. Construction of the Brooklyn-Battery tunnel in the 1940s destroyed most of little Syria, but by that time many of its inhabitants had already moved out to Brooklyn or Queens.

George Bain knew the allure of photographs describing the immigration process as well as those of immigrant enclaves scattered throughout the city. It is possible, in fact, that the original file, the one created prior to the January 1907 fire, contained additional pictures of Little Syria, since the *New York Times* and several other papers ran extensive profiles of the community around the turn of the century, and Bain would have made sure he could supply his clients around the country with timely images.

In this photograph, made between 1910 and 1915, the man selling drinks to passersby may be Turkish; he wears a fez and his large, ornate dispenser is decorated with the star and crescent moon, emblems of the Ottoman Empire. Like other ethnic neighborhoods, Little Syria was fertile ground for peddlers and other nomadic entrepreneurs (a boy selling newspapers stands nearby,) and the picture presents the people and the place as exotic, but without menace.

FINGERPRINTING
A GERMAN

In 1914 and 1915, pressure mounted for America to side with the British and French against the Central Powers, and, not surprisingly, hostility toward immigrants, especially Germans, increased exponentially. Suddenly all things German were suspect: sauerkraut became liberty cabbage, German books and music banned, and the teaching of German in schools and colleges suspended for the duration. Into this mix of enmity and suspicion strode Teddy Roosevelt, who insisted in a 1915 speech at Carnegie Hall that America begin preparing for war, and that what he called "hyphenated Americans" return to their home countries. "A hyphenated American," he said, "is not an American at all."

On April 6 and November 16, 1917, shortly after Congress declared war, President Woodrow Wilson issued proclamations severely restricting the activities of German and Austrian non-naturalized immigrants, and requiring them to register with authorities, provide officials with five photographs, and submit to fingerprinting. One agent in the Enemy Alien Registration Section stood out as an especially zealous and effective compiler of dossiers on aliens and others suspected of ignoring or flouting federal law: J. Edgar Hoover.

In New York City the ten-day registration process for German males over the age of 14 began on February 4, 1918. (Mandatory registration of German women took place later in the year.) During that initial registration period nearly 40,000 Germans filled out forms and supplied authorities with photographs and fingerprints. However, since that number was approximately 7,000 short of the estimated total number of German men in the city, authorities made plans to round up aliens who failed to comply and send those found guilty of willfully flouting federal regulations to internment camps.

NAVAL-MILITIA GUARDING A
NEW YORK BRIDGE

In the months preceding America's official entry into World War I in April 1917, activities and events in New York clearly foretell the country's shift from neutral observer to active participant in the war. Beginning in 1916, for instance, preparedness parades marched through New York and other cities urging immediate American involvement, supported by notables such as Teddy Roosevelt and General Leonard Wood.

A massive explosion on July 30, 1916 of the munitions depot on Black Tom Island, a small spit of land in New York Harbor connected to the New Jersey shore by a man-made causeway, was felt as far away as Philadelphia, and New Yorkers began preparing for war in earnest. Civil and military authorities blamed German saboteurs for the attack, and state and city officials in New York began looking for ways to protect persons and property. In February 1917, the military sent units of the New York Naval Militia to guard East River bridges, a difficult task due to a general lack of supplies and the severity of the weather, and ordered Army guard units to protect the Croton aqueduct all the way from John D. Rockefeller's estate to the City.

On February 5, when this picture was made, policemen finally replaced the Naval Militiamen on the roadways leading to the bridges, though navy men continued to guard the undersides of the bridges. Commander William Bell Wait, Jr., executive officer of the First Battalion of the Naval Militia, complained bitterly of the treatment of his men, noting that long-term service in the militia caused undue hardships for family men and those with steady jobs. He urged the country to institute universal service.

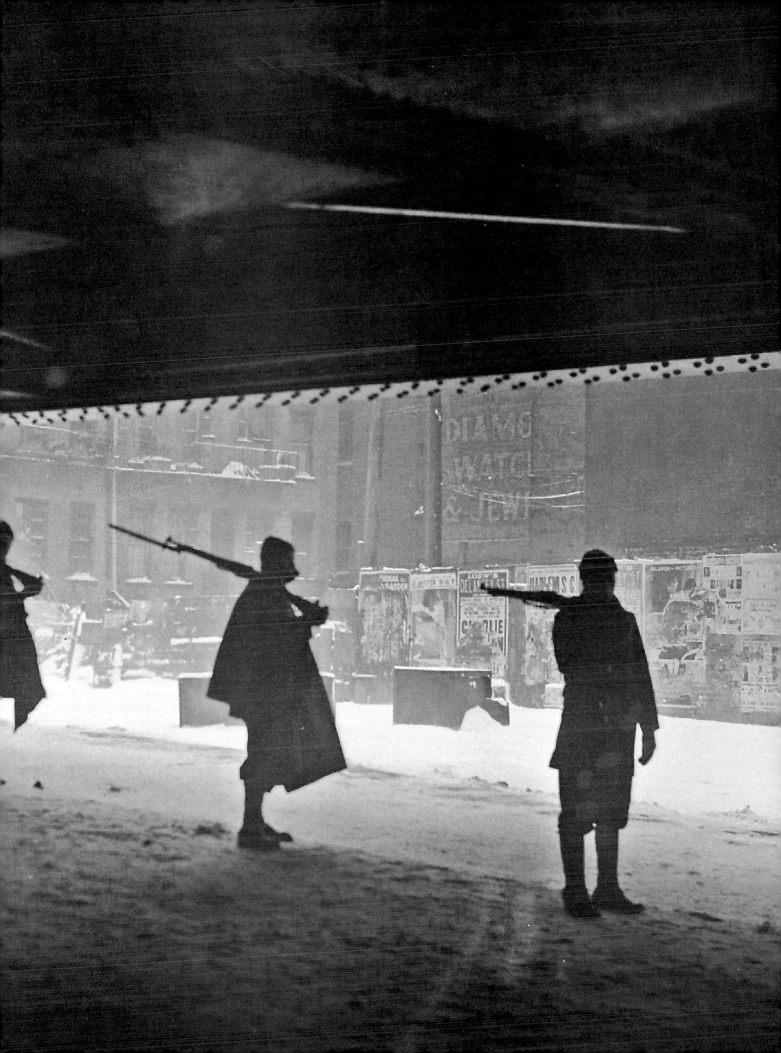

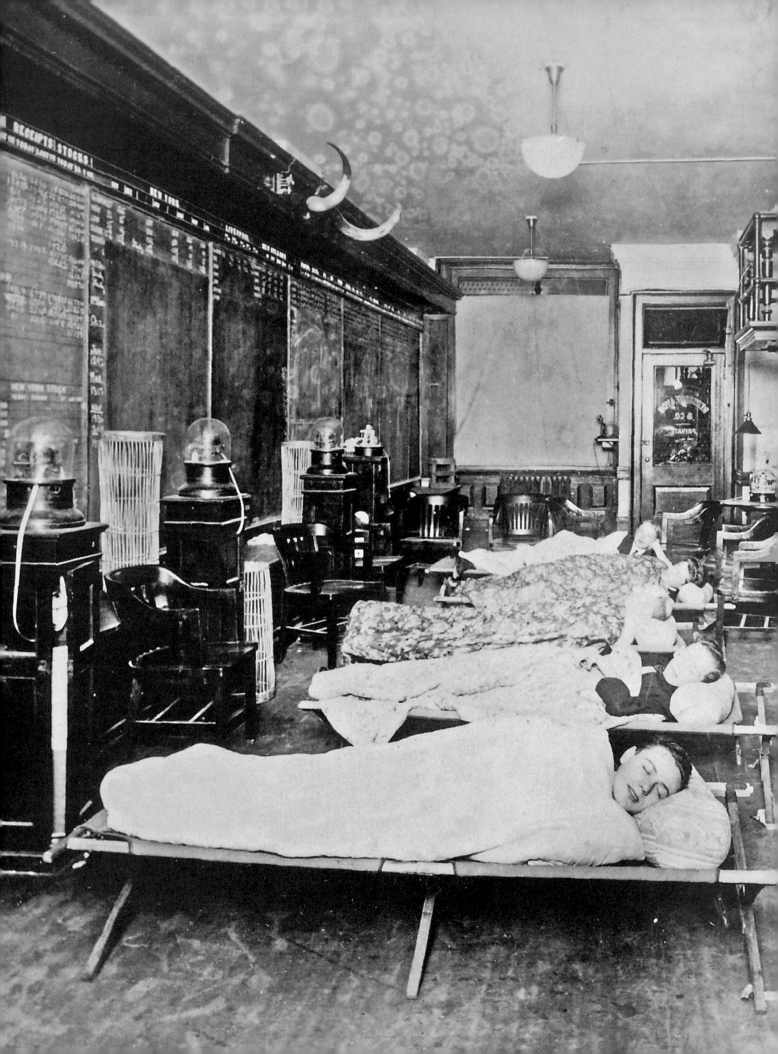

2 A.M. IN WALL STREET BROKER'S OFFICE

The swift descent of Europe into war in the summer of 1914 was a human tragedy, but eventually it turned out to be very good for the American economy. The New York Stock Exchange closed down for three months when the war began, but by early in 1915 a vibrant bull market took hold, propelling huge gains in stocks across the board, with steel and ordinance issues leading the way. Thus, Bethlehem Steel, which sold for about $30 a share at the end of July 1914, soared to $600 a share by October 22, 1915. Speculation in what came to be known as "war stocks" produced windfalls for old-line traders as well as for those buying stocks for the first time. *The Financial World* magazine noted that "newspaper accounts of the enormous trading, together with many stories of sudden fortunes made by plungers or even novices...only served to advertise the ...exciting speculation now on."

The high volume of trades (million-trade days were commonplace) caused brokerage houses to struggle just to stay even. In a world without computers, brokers depended on messengers and clerks to effect trades, which meant that when volume was especially heavy, it sometimes took several hours to execute orders to buy or sell. Brokerage houses began demanding that employees stay into the night, or even all night, in order to keep up.

Many of the clerks and messengers who worked on Wall Street, including, perhaps, one or more of the fellows in this picture, were school age, a fact that rankled Progressives determined to put an end to all forms of child labor. The first national child labor act passed and was signed into law by President Woodrow Wilson in 1916, though the Supreme Court overturned it in 1918. As a result of that decision, children continued to clerk on Wall Street until the 1930s.

SIGNALLING TO OFFICES, CURB MARKET

The New York Curb Market was precisely what the name implied: an outdoor stock market on the sidewalk and in the street in the center of the city's financial district. It operated for five hours a day in all kinds of weather, specializing in the buying and selling of stock in new industries as well as companies preferring the unfettered swirl of curbside trading or unwilling to meet the more stringent requirements for listing on the Big Board of the New York Stock Exchange. After the discovery of gold in California in 1848, mining companies proliferated on the curb, and for years John D. Rockefeller's Standard Oil Company, the Allis-Chalmers farm-equipment company, and Otis Elevator, among many others, traded there.

To sightseers and passersby the Curb Market must have seemed both chaotic and highly entertaining, as traders in the street communicated with arcane hand signals to clerks (some of them mere children) perched in the second- and third-storey windows of buildings lining the street. Brokerages telephoned orders to their clerks sitting in windows who then communicated to their brokers in the street below, identified by brightly colored hats or coats, who signaled back when the trade was completed.

Though occasionally beset by bad press when schemers and stock manipulators caused sudden booms or busts, the Curb managed to hang on. The market moved indoors in the early 1920s to a fine new building at Trinity Place at the west end of Wall Street, and in 1953, the Curb finally took a new name: the American Stock Exchange.

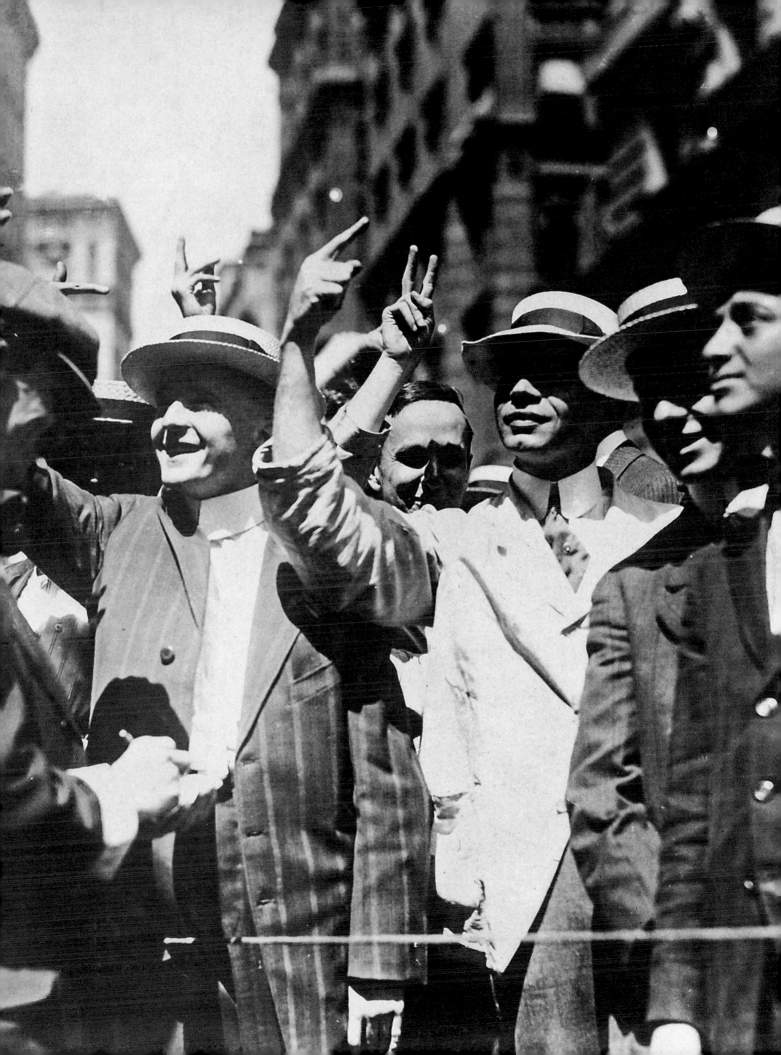

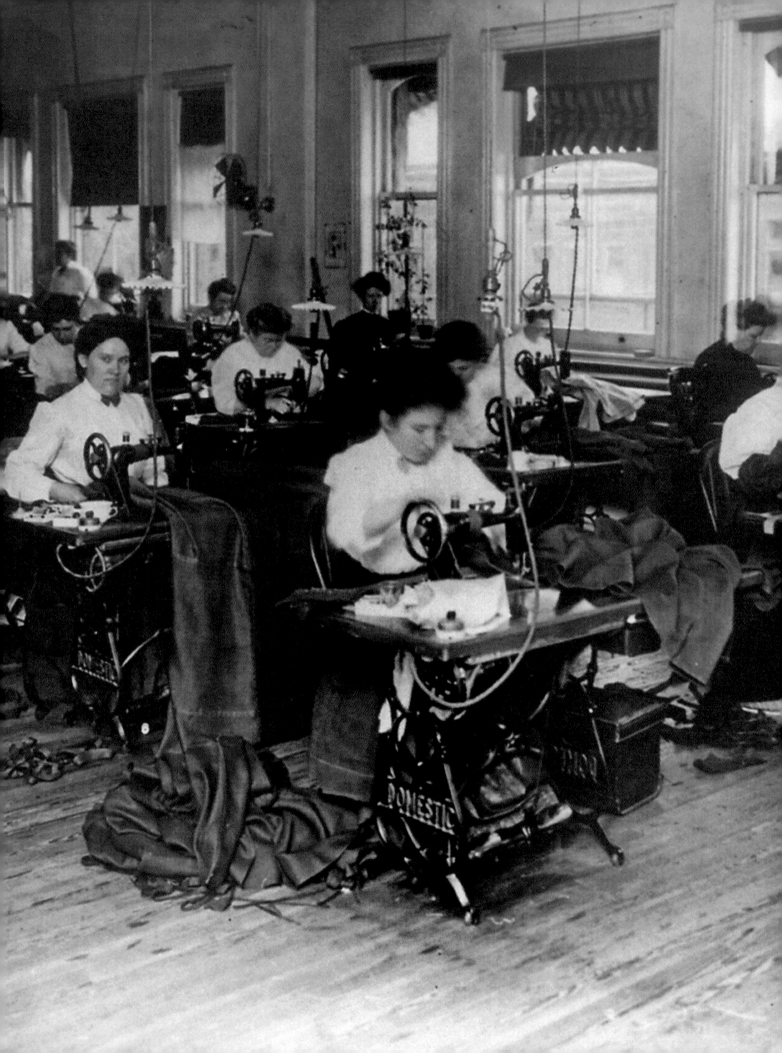

FLAG-MAKING—BROOKLYN NAVY YARD

The decision in 1907 by Theodore Roosevelt to send a fleet of sixteen battleships and their auxiliary vessels—the famous Great White Fleet—on a grand two-year circumnavigation of the world generated abundant press coverage and public interest here and abroad, and George Bain made the most of it. The News Service collection includes shots of battlewagons both under construction and under way, each ship suitably festooned with flags and pennants. Bain may have wondered about the origin of all those flags, or perhaps he remembered news stories printed at the end of the Spanish-American War about the manufacture of naval regalia. In any event, in June 1909, he sent a photographer out to the Brooklyn Navy Yard to make pictures of the Navy's principle flag-making operation.

On the third floor of the main equipment building at the Navy Yard, several men and approximately fifty women worked five to eight hours a day, five days a week, to produce the forty to fifty flags carried on board each ship. Besides various sizes of American flags, the ships also carried the flag of every country visited by the fleet. Mary A. Woods, designated Quarter Woman Flag-maker by the Navy (instead of quartermaster), was in charge of design and day-to-day operations. The women sewers and seamstresses used electric-powered Domestic sewing machines with cast iron cabinets and treadles, and were paid between $1.50 and $2.50 a day. In July 1913, a reporter for the *Lewiston* [ME] *Sun Journal* wrote, "the majority of the women who work in this department are cultured and refined," though having suffered some "misfortune, have been forced to earn their living in this way...."

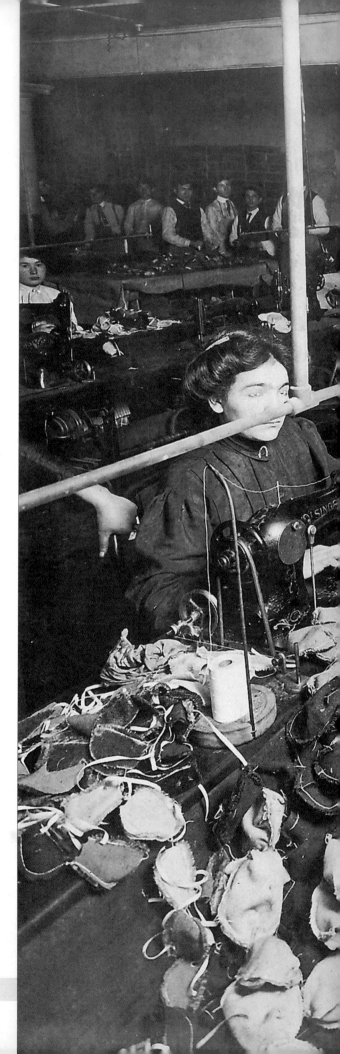

PEOPLE MAKING TEDDY BEARS IN FACTORY

The history of the American teddy bear begins in 1902 with President Teddy Roosevelt and a well-publicized trip to settle a boundary dispute between Louisiana and Mississippi. During the excursion, Roosevelt—a formidable hunter—announced his intention to hunt for black bears, but after five days near the Little Sunflower River in Mississippi he had nothing to show for his efforts. However, unbeknownst to the President, his guide caught and clubbed a bear, then tied it securely to a tree as an easy target. Roosevelt declined the offer and ordered the animal's release.

The story of Roosevelt's demurral received the enthusiastic attention of the press, and Clifford K. Berryman, cartoonist with the *Washington Post* immortalized the moment in a widely reproduced illustration, "Drawing the Line in Mississippi." The cartoon inspired Russian immigrants Rose and Morris Michtom to make a replica of the pardoned bear, which they called "Teddy's bear" and placed in the window of their small candy and novelties store in Brooklyn. It sold almost immediately, so Rose made more, and they did just as well. At the same time, the Stieff Company in Germany created its own bear cub toy, and it, too, flourished.

The popularity of the teddy bear led the Michtoms to establish the Ideal Novelty Toy Company in 1903, and by 1906 there was intense competition from other firms in this country and in Europe. Teddy bears became one of the first great consumer fads of the twentieth century, popular with adults as well as children. Roosevelt used the bear as a mascot in his re-election campaign, children's books centered on the antics of cute bears proliferated, John Walter Bratton composed "Teddy Bear's Picnic," and in 1914 the city of Hartford, Connecticut tied teddy bears to local trees to scare away flocks of starlings; all this from a failed hunting trip and the skill of a political cartoonist.

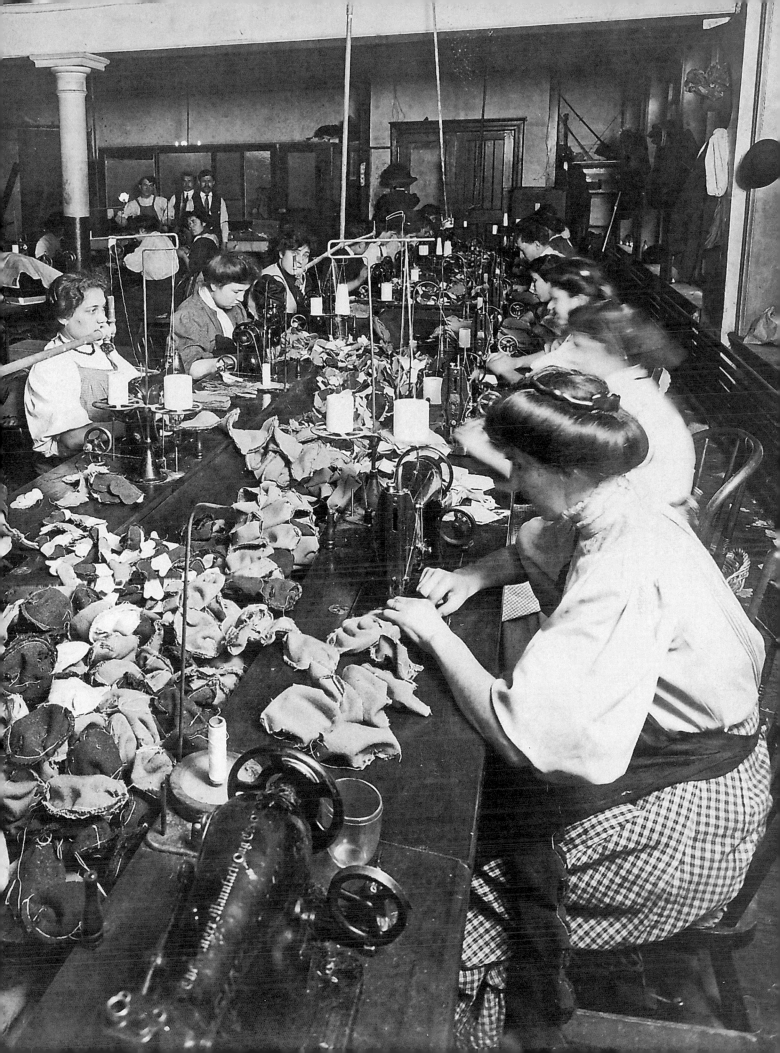

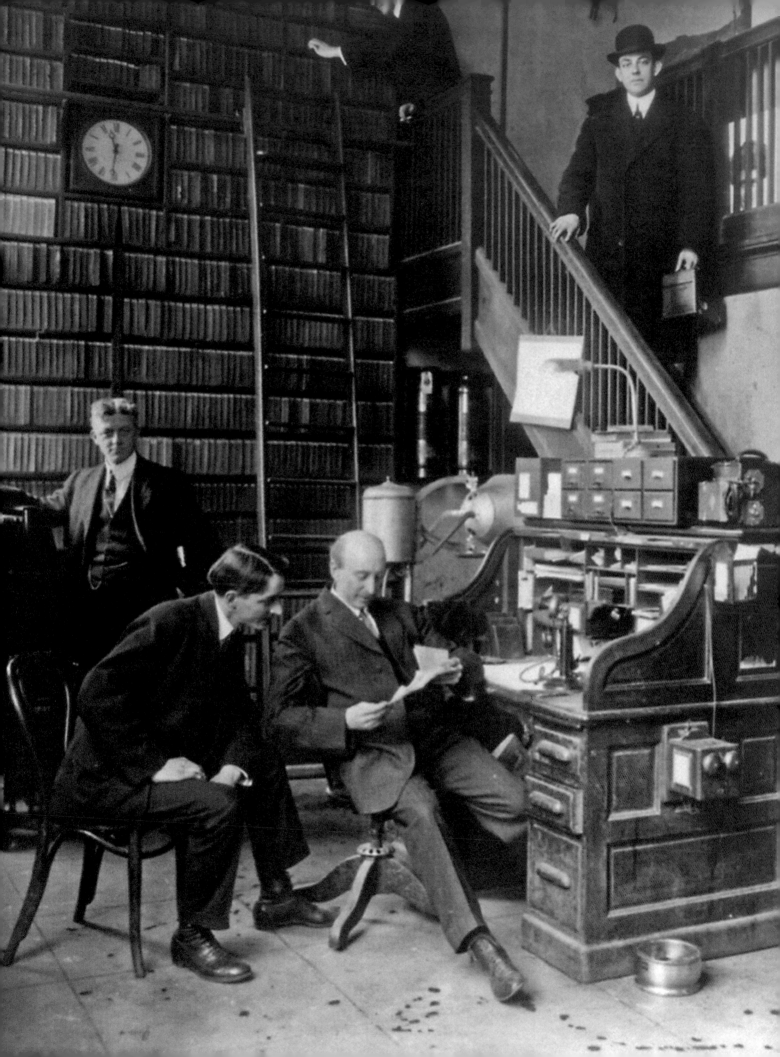

NEWSPAPER PUBLISHING— PHOTO DEPT. NEW YORK WORLD

In 1883, Joseph Pulitzer bought the *New York World* from the notorious speculator Jay Gould, who was anxious to unload his little morning newspaper with the paltry readership. By the turn of the century Pulitzer transformed the *World*, creating in the process one of the first great newspaper empires and a new and dynamic approach to daily journalism. The *World* was written and designed for the masses, especially the urban working class, and at the center of the enterprise were illustrations— thousands of them—from photographs to fanciful drawings and cartoons.

Despite a chorus of criticism from those believing that pictures on the printed page degrade the journalistic enterprise, Pulitzer was undaunted. He knew the value of pictures, knew they could enhance and clarify the written word. In an editorial printed in February 1884, Pulitzer explained that there was always extra demand for the paper when "it is illuminated, so to speak." The *World* hired staff photographers and graphic artists, and their work embellished nearly every page of the newspaper.

The men shown here comprise all or part of the *World's* photography staff in 1909. There is a metal spittoon on the floor next to a roll-top desk in the foreground and a large portrait camera at the back of the room. Most significant however, is the vast, floor-to-ceiling bookcase holding what appears to be thousands of cases of 5 by 7 glass-plate negatives, an early version of the modern photo morgue. Those negatives documented the social and political history of New York City at the turn of the last century, and they were a major reason for the success of Pulitzer's newspaper, but eventually they were discarded. However important photographs were on a daily basis, their value as history was neither understood nor appreciated, and in the end someone decided that saving all those latent images was simply not worth the effort.

MILLION DOLLAR CORNER

During the first decade of the twentieth century, the little 30 by 50 foot building at the corner of 34th Street and Broadway changed hands several times, all the while eluding every attempt by the Straus brothers, owners of R. H. Macy and Company, to buy it. The block between 34th and 35th Streets from Broadway to 7th Avenue was supposed to be the site for Macy's new Manhattan emporium, but in 1901 Alfred Duane Pell, an Episcopal minister who owned the brownstone on the corner, sold instead to Robert S. Smith, who may have been fronting for Henry Siegel, owner of the vast Cooper-Siegel department store on 18th Street and 6th Avenue.

Smith, who owned a dry-goods store near Macy's original 18th Street store, put the little building at 34th and Broadway up for sale, but the Straus brothers considered the asking price exorbitant and Smith sold to Siegel instead. Macy's architects, the firm of DeLemos & Cordes, built a corridor around the rear of the hold-out parcel, creating in the process a huge department store with a notch at the corner of 34th and Broadway. Siegel eventually tore down the original brownstone and erected in its place a five-storey building that he sold back to Robert Smith in 1907 for an astounding $375,000.

Smith may have had grand designs for the little building at the corner of Macy's, but in the end the place was more profitable as a rental property. For several years the United Cigar Stores Company leased the first two floors for $40,000 a year, and firms such as the Hippodrome Theatre, the Edison Company, and Sun-Ray Ginger Ale rented advertising space on the façade and roof of the building. After World War II, Macy's rented, for an undisclosed sum, space on the little building and erected there its giant, red Macy's sign.

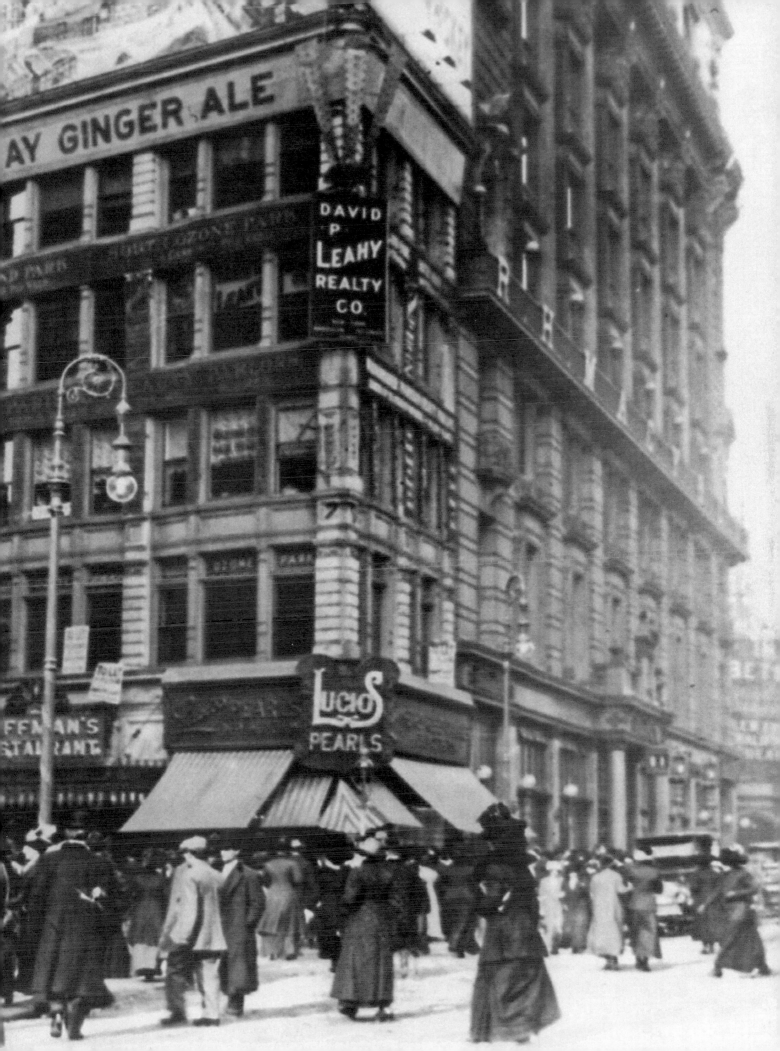

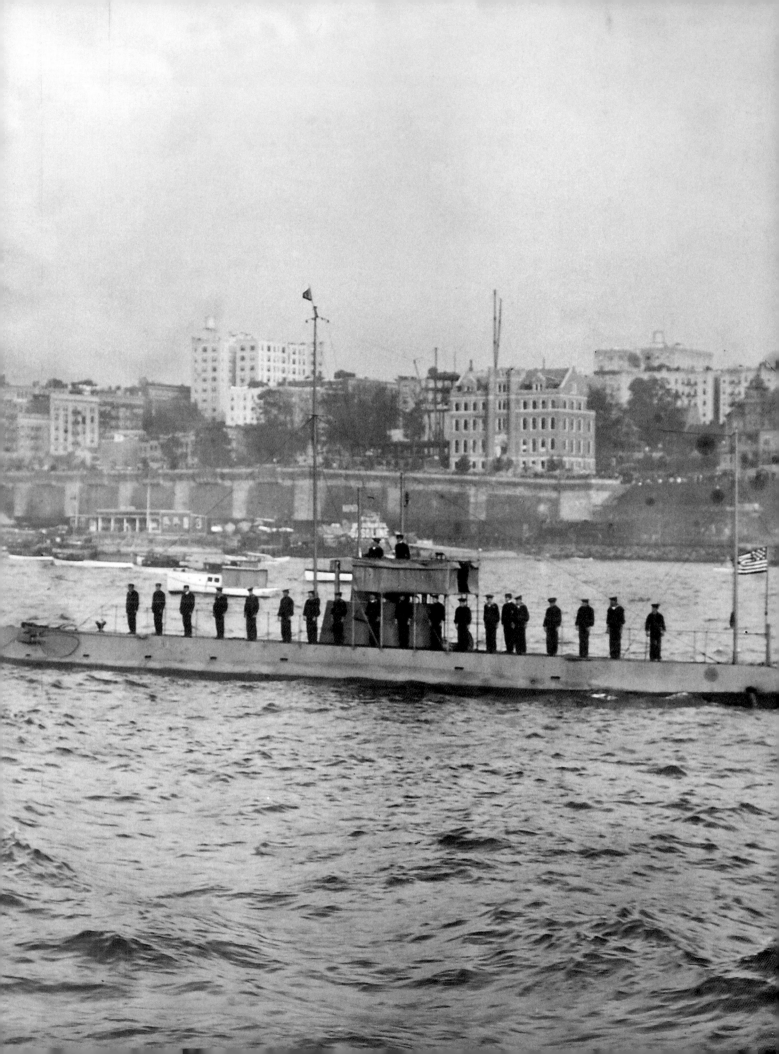

SUBMARINE

In the midst of his ultimately disastrous re-election campaign in 1912, President William Howard Taft spent at least two very good days on the presidential yacht *The Mayflower*, reviewing 123 ships of the United States Navy on the New York side of the Hudson River. On October 14, thousands of spectators lined the shore from about Seventy-ninth Street to Washington Heights as *The Mayflower* steamed slowly past the formidable collection of warships. Thunderous salvos rent the air and military bands played the Star Spangled Banner in what was both a grand display of military might and an effective presidential photo-opportunity. The only ships that did not participate in the firing were submarines of the Atlantic flotilla (due to the absence then of deck guns), anchored between 135th and 145th Streets. Instead, the sailors and officers on each sub stood at attention on the deck and conning tower, saluting smartly as the President went by. The next morning the fleet left New York, once again firing their guns as they passed the President's yacht.

The ship in this photograph is the *USS E-1 (SS-24)*, which was launched on May 27, 1911 in Quincy, Massachusetts and originally named *Skipjack*. Her commander, one of the two men visible on the conning tower, was Lieutenant Chester W. Nimitz, a 1905 graduate of the Naval Academy and future Commander in Chief of the Pacific Fleet during World War II. In 1944, Nimitz attained the newly created rank of Fleet Admiral, and on September 2, 1945, he signed the instrument of surrender as the United States Representative aboard the battleship *USS Missouri* in Tokyo Harbor. After retiring from active duty, Nimitz remained an active and effective participant in naval affairs, with a special fondness for the submarine service, until his death in February 1966.

IMPERATOR

The 52,000-ton *Imperator*, briefly the largest passenger ship in the world, was built at the Vulcan Shipyards for the Hamburg America Line and launched on May 23, 1912. She made her first transatlantic voyage from Cuxhaven on the shore of the North Sea to New York on the sixth of June 1913, just over a year after the sinking of the *Titanic*. *Imperator's* arrival in New York on June 19 received enthusiastic press coverage, though a few reports mentioned a persistent 10-degree list to starboard. Readjusting the ship's ballast tanks during her layover took care of that problem.

With a Roman swimming pool, Ritz-Carlton restaurant, and ballroom measuring sixty by one hundred feet, the *Imperator* offered state-of-the-art accommodations, at least for those traveling first-class, and four giant turbine engines assured swift passage across the Atlantic. When the great ship left her berth in Hoboken on June 25 on her return trip, some five thousand visitors and well-wishers thronged the Hamburg-American pier, and others watched her stately exit down the Hudson from along the Battery.

Following that first glorious voyage, little went right for the *Imperator*. After docking in Hoboken on August 28, 1913, an officer discovered a fire on board as the last of the first- and second-class passengers disembarked, and for five hours the ship's crew and fire crews from New York and Hoboken fought the flames, using in the process several million gallons of water, causing another sharp list to starboard. A year later the German government sent the ship back to Hamburg for the duration of the war. After the Armistice, the *Imperator* served briefly as a troop ship for the Americans, and then was given to the British as repayment for the sinking of the *Lusitania* by a u-boat in May 1915. After series of electrical fires broke out in the 1930s, in 1938 the Cunard line sold the ship, now named the *Berengaria,* for scrap.

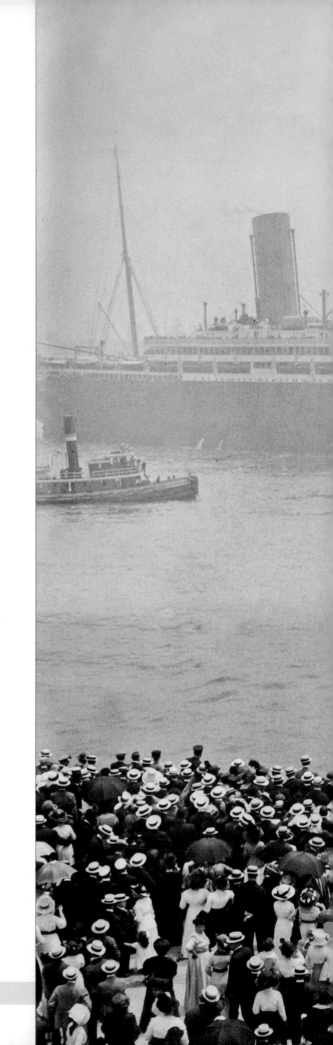

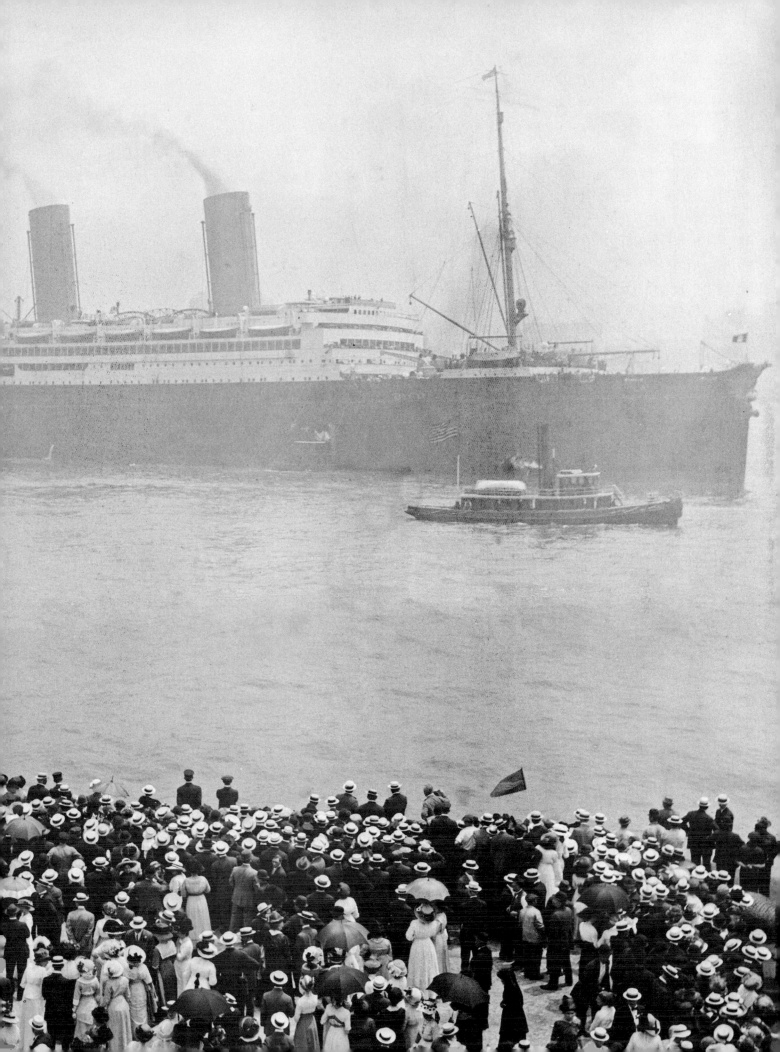

BATHING IN RIVER, NEW YORK CITY

By 1900, free public bathing facilities were available in some of New York's poorest neighborhoods, but many children opted instead to swim and wade in the Hudson or East Rivers, often unencumbered by bathing attire and free from the rules and regulations enforced at city-run baths and pools. Apparently nonplussed by a shoreline littered with industrial debris and rotting garbage, and tidal water that stank from the tons of sewage poured into it, boys flocked to this spot near the Recreational Pier at Fiftieth Street and the Hudson in spite of the fact that one of the City's many 95 by 60 foot floating pools was anchored nearby.

In order to accommodate the maximum number of users, city officials enforced strict time limits at the floating pools (twenty minutes during peak hours), and kept a watchful eye on the bathers. The boys no doubt preferred an unrestricted approach to the water, even water that smelled. Jacob Riis noticed this behavior in his *The Battle with the Slum* (1902).

The river is "less and less a place fit to bathe in," he wrote, "though the boys find no fault." And the *Times* noted "all the police in New York could not keep these amphibious dock rats on land when the desire for a swim takes possession of them."

Years after this photograph was taken, Lewis Wickes Hine photographed children playing in the same fetid lagoon for a study of West Side children funded by the Russell Sage Foundation and published in 1914 by Survey Associates. Hine titled his picture "Wading in Sewage-Laden Water," a much more pointed and critical title than the one supplied by Bain. The text accompanying Hine's image describes the scene: "Here along the river front he bathes in the hot weather, encouraged by the city's floating bath which anchors close by, and regardless of the fact that the water is filthy with refuse and sewage."

LOUIS AND LOLO?–TITANIC SURVIVORS

The George Bain News Service collection has many photographs relating to the *RMS Titanic* disaster, from portraits of notable survivors such as Margaret "Unsinkable Molly" Brown, to views of the great ship under construction and pictures of anxious crowds at the White Star Line offices in Manhattan awaiting news following the sinking on April 15, 1912. But the Bain photographs that ultimately generated the most human interest, and perhaps the most sales as well, were simple portraits of two surviving children who came to be known as the "Titanic waifs."

Four-year old Michel Marcel and his two-year old brother Edmond Roger sailed with their father, Michel Navratil, who booked second-class tickets under the name Louis M. Hoffman. He and his wife Marcelle had separated early in 1912 after four stormy years of marriage, and during his regular visitation with the boys over the Easter weekend Navratil absconded with them and boarded the *Titanic* at

Southampton. After the ship struck the iceberg, he placed Michel and Edmond in a lifeboat (Collapsible D), though Navratil himself later perished in the sea. The boys' mother, Marcelle, had no idea of her children's whereabouts until she saw news pictures of them a week or so after the ship went down. The White Star Line agreed to take her to America to reunite with her boys.

Michel and his brother, who were called "Louis and Lolo" by the newspapers, were the only children to survive with no accompanying relative or friend. Another survivor, Margaret Hays, spoke fluent French and cared for the boys at her home on West 83rd Street until their mother arrived. After their tearful reunion on May 16, Marcelle and her boys returned to France aboard the *Oceania*. Later, Marcelle sued the White Star Line for the loss of her husband, and may have received part of the $664,000 settlement finalized in December 1915.

LITTLE PEOPLE–
THEATRICAL PARTY IN
CENTRAL PARK

This picnic in Central Park, presented as a kind of impromptu spring celebration, was in fact carefully organized by Nicol Gerson, manager of a troupe of little people billed as the "Lilliputian Circus" at the New York Hippodrome, the grand theater on 6th Avenue between 43rd and 44th Streets. The thirty-five performers in Gerson's company enacted a complete two-ring circus with clown acts, tumbling, jugglers, equestrians riding tiny ponies, sleight-of-hand artists, and singers and dancers. Gerson and the Hippodrome management assured sell-out crowds by advertising freely and organizing catchy photo opportunities like the gathering in the park.

In an article printed in the *New York Times* less than two weeks after the troupe's arrival on March 1, 1910, the manager took pains to explain his relationship with his employees. "It took me some time to learn how to treat them," he admitted. "They have all the feelings of normal-sized men and women, and to be treated as children and called 'cute' is the greatest of insults." Though Gerson admitted to making many mistakes early on, he insisted that his approach had changed. "Now," he said, "I treat them as any manager would treat his company and we get along splendidly." Still, he occasionally used the word "midget" to describe little people. Even in 1910 that word gave offense.

Despite Gerson's professed sensitivity to his diminutive performers, there is evidence of a less than cordial relationship. In late April, for instance, just before the picnic in the park, one of the stars of the show, George Laible, who stood less than three feet high, sued Gerson in Municipal Court for failure to repay a promissory note of $190. The case was postponed and may ultimately have been settled amicably, but it indicates that the circus was far more a business than one big happy family.

THANKSGIVING MASKERS

The tradition of children masquerading in makeshift costumes through town begging for treats or coins occurred more often on Thanksgiving than Halloween early in the twentieth century. Though most middle and upper class families celebrated the holiday quietly and at home, many New Yorkers spent the better part of the day parading through town in raucous counterpoint to the staid family celebrations described in mainstream newspapers and magazines.

The writer and editor William Dean Howells neatly described Thanksgiving revelry in his 1907 utopian novel *Through the Eye of the Needle*. "The poor recognize the day largely as a sort of carnival," he wrote. "They go about in masquerade on the eastern avenues, and the children of the foreign races who populate that quarter penetrate the better streets, blowing horns and begging of the passers." Although some protested that encouraging children to "beg" would lead inevitably to life on the dole, most, like Howells, viewed it as benign. In fact, it is now clear that not all those who paraded were destitute, orphaned, or the sons and daughters of immigrants. Children from wealthier families, usually dressed as ragamuffins, often joined in and cavorted down the streets just like everyone else.

The Thanksgiving masks, costumes, and begging gradually disappeared, but the parades evolved from impromptu gatherings to grand commercial spectacles complete with casts of thousands, mechanized floats, exotic animals, all with giant helium-filled balloons hovering overhead. The legendary Macy's parade began in 1924 and is still going strong, an annual spectacle viewed by millions. There is still begging, of course, but now it is in the form of corporate logos and a host of 30-second advertisements on television.

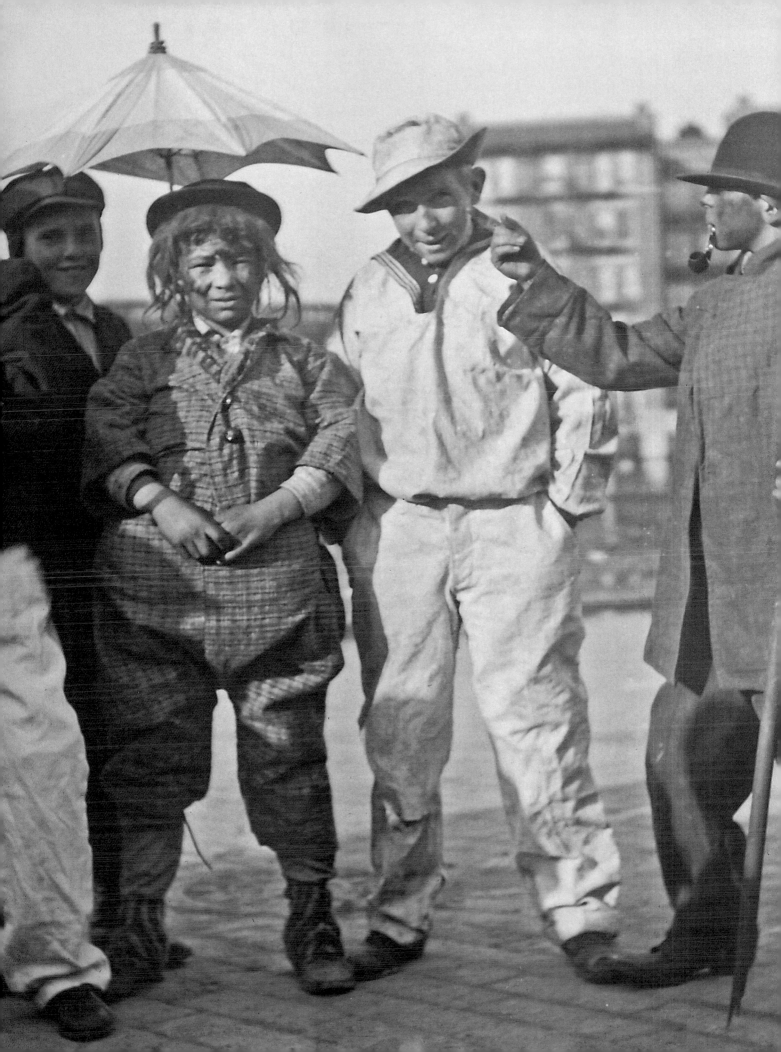

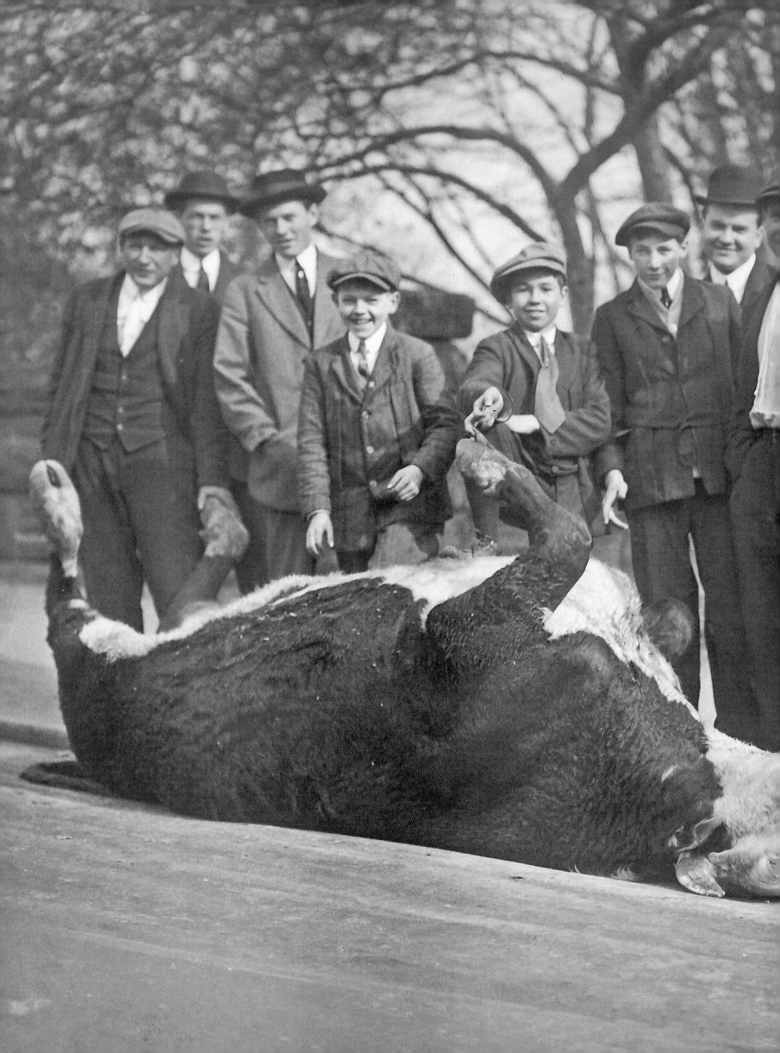

SHOOTING BULL—
CENTRAL PARK

At the turn of the last century meat intended for the dinner tables and restaurants of New York came into the city in the form of live animals. Hogs, sheep, and cattle were held at one of several stockyards located along the Hudson and East River waterfronts, then transferred to one of over two hundred slaughterhouses for rendering. The process was relatively inefficient and often unsafe; rotting offal befouled entire neighborhoods, and animal wastes were usually dumped untreated into the rivers.

Every once in a while one or several animals would make a break for it and run panic-stricken through city streets until corralled or killed. On October 12, 1911, a steer stampeded through the city from 60th Street and the Hudson all the way to the plaza in front of Pennsylvania Station where a volley of police bullets finally brought him down. It happened again in the pre-dawn hours of November 3, 1913, when eight shorthorn steers escaped from the Union Stock Yard at 61st Street and the Hudson during their transfer to the new five-story abattoir of Joseph Stern and Sons on West 40th Street. One frenzied animal managed to get all the way to Fifth Avenue and 59th Street, where it attracted the attention of policemen who immediately began shooting. The first fusillade had little effect on the steer, but one stray bullet hit and killed George Beattie, the night watchman of a nearby building under construction and another wounded Walter Wangerheim, headwaiter at the Hotel Gotham at Fifth and 55th. The steer, though hit several times, ran on, undaunted.

Officers from the 51st Street precinct commandeered several taxis and gave chase, leaning out of the windows to shoot. The wounded animal finally dropped to its knees and was dispatched by a patrolman with three quick shots into its forehead. For the next several hours, passersby and the curious examined the fallen beast and posed for pictures.

HOT DOG, CONEY ISLAND

Historians of the venerable hot dog contend they originated in ancient Babylonia, but reached perfection in Germany and Austria where they got the names frankfurters and wieners. In Coney Island, however, hot dogs became legendary. In the early 1870s, Charles Feltman, a young German immigrant making a modest living hawking pies from a wagon pushed along the shore in Coney Island, decided to expand his business by selling hot sausages in milk rolls. The little meaty delicacies seemed the perfect treat in the relaxed and playful atmosphere of Coney Island, and Feltman did very well by them. By 1900, his original pie wagon was long gone, replaced by a massive complex of restaurants selling hot dogs and shore dinners, beer gardens, and carnival rides along West 10th Street from Surf Avenue to the beach. He employed over a thousand waiters and served as many as eight thousand meals at a time.

In 1916, a Feltman employee named Nathan Handwerker, whose job was splitting hot dog rolls, took $300 dollars saved from his salary and opened his own emporium in a rented building at the corner of Stillman and Surf Avenues. He sold his dogs for a nickel a piece, half the price of Feltman's, and he prospered, especially after the Stillwell Avenue subway station opened in 1919 right across from his place. He inaugurated an annual hot dog-eating contest in 1916, advertised heavily, and eventually his hot dogs became synonymous with Coney Island itself.

Charles Feltman died in 1910, before Nathan's even began, but his fabulous complex lasted until 1954 when Astroland replaced it. Nathan's is still going strong.

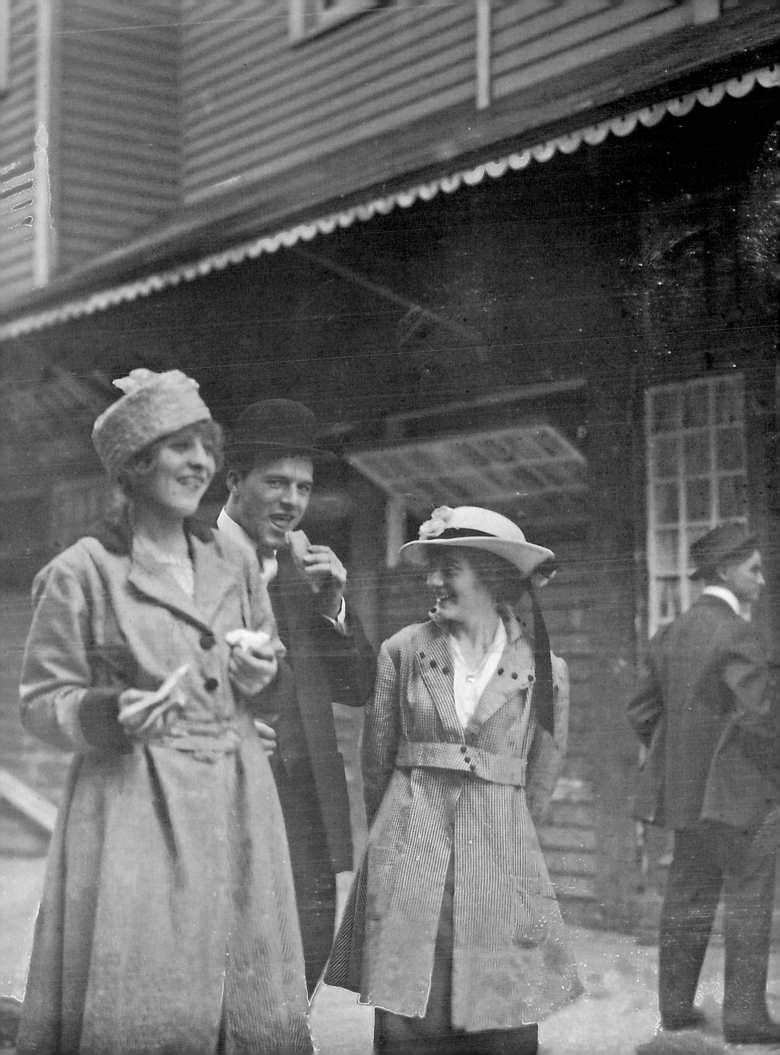

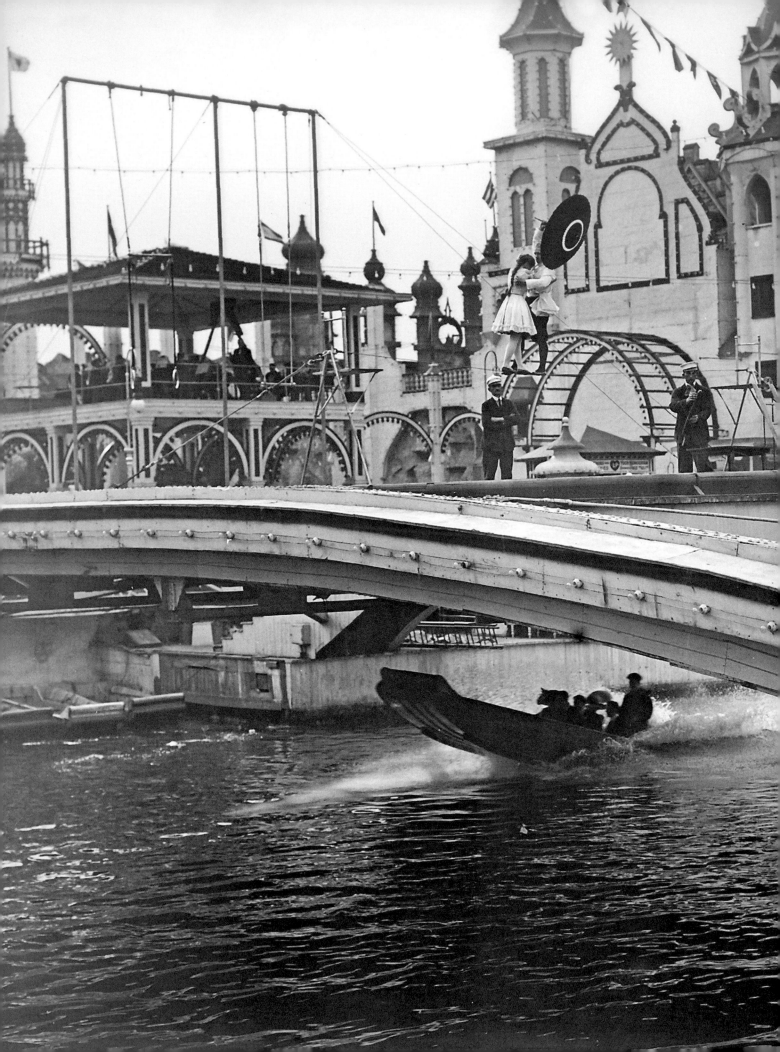

CONEY ISLAND—WIRE WALKERS AND THE CHUTE BOAT

Frederic Thompson and his business partner, Elmer S. Dundy, creators of Luna Park in Coney Island and the vast Hippodrome Theater on Sixth Avenue between 43rd and 44th Streets in Manhattan, knew exactly how to attract and please a paying audience. The key is to create a permanent carnival spirit, Thompson wrote in *Everybody's Magazine* in September 1908. "In big amusement enterprises…the spirit of gaiety is manufactured just as scenery, lights, buildings, and the shows generally are manufactured." Thompson's Coney Island extravaganza, originally built on 22 acres along Surf Avenue between West 8th and 12th Streets, placed rides, concessions, and exhibits into a fantastic city crammed with exotic buildings with brightly-colored domes and spires, each festooned with thousands of electric lights.

The "Shoot-the-Chutes" ride seen here was actually a hold-over from Paul Boyton's Sea Lion Park, which opened in 1895 and closed after the disastrously rainy 1902 summer season. Flat-bottomed chute boats were hauled by cable up a long ramp, and then released to slide rapidly down into a lagoon in a great spray of water. Overhead, tightrope walkers and tumblers performed without a net on a dazzling array of rings and trapezes. According to the *New York Times*, the acrobats would occasionally be joined in this free open-air circus by bears on bicycles, performing horses, and of course, clowns.

In addition to the "Shoot-the-Chutes" ride, Luna Park attractions included a wild animal exhibit, an Infant Incubators display identical to the one at Dreamland, an Eskimo village, and a cyclorama ride called "A Trip to the Moon" that offered a simulated rocket flight. Upon "landing," customers received pieces of green cheese from little people dressed as moon men: all this for just a dime a ride, or perhaps quarter for the really spectacular ones.

JAMES SIMCOX, MASCOT OF SPANISH WAR VETERANS

Almost immediately after the fighting ended in the Spanish-American War, veterans established associations and societies across the country to commemorate their participation and to honor the lives of the fallen. The groups included the Spanish War Veterans, the Spanish-American War Veterans, Service Men of the Spanish-American War, Legion of the Spanish-American War, and the Veteran Army of the Philippines. The proliferation of groups diluted their message, however, so in 1904 most of the groups combined forces as the United Spanish War Veterans.

One of the most successful and well-reported veterans' events was the Catholic Mass celebrated annually at the Brooklyn Navy Yard beginning in May 1902. By 1908, when this picture was made, the event attracted tens of thousands of participants. May 23 of that year was hot and breezeless, and in the crush of people in front of the altar several women and children and perhaps a dozen uniformed guards had to seek some shade inside the Marine barracks.

The celebrant of the mass was Father William Henry "Ironsides" Reaney, who served with Admiral Dewey aboard the *Olympia* in the Philippines. Known as the "fighting chaplain" for his fondness and facility for boxing (it was said that he once beat Tom Sharkey, the future heavyweight champion), Father Reaney spoke of the importance of both religion and patriotism in the life of the country.

Nothing at all is known about young James Simcox, the group's mascot, but the sword he holds suggests he is the son or nephew, perhaps, of an officer.

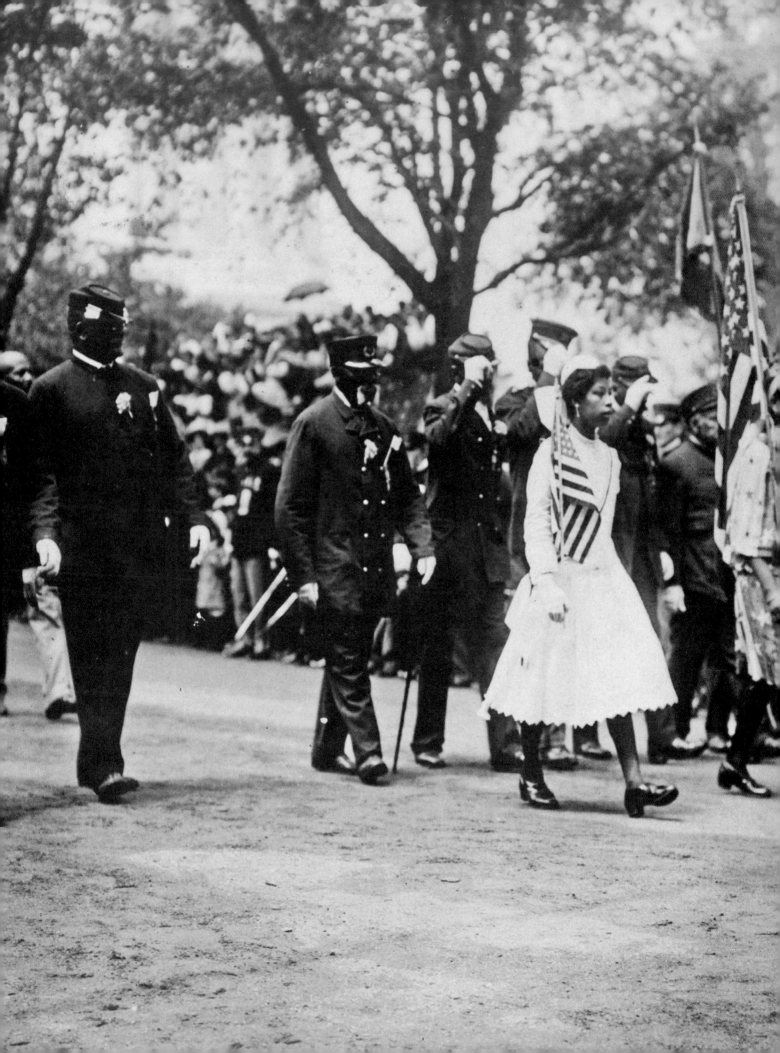

NEGRO G.A.R. VETERANS PARADING

The 1912 Memorial Day parade in Manhattan covered seventeen blocks, from 72nd Street to the Soldiers' and Sailors' Monument at 89th Street and Riverside Drive—a tall order for the aging Civil War veterans who marched that day. Four years earlier some 2,500 veterans took part in the May parade; in 1912, fewer than a thousand showed up. Though the Union Army veterans made up only a tenth of the parade, they were the centerpiece and principle draw for an enthusiastic audience that stretched along Riverside Drive.

Captain Franklin S. Huntoon commanded the G.A.R. contingent made up of some sixty separate posts or camps. Some units consisted of several rows of soldiers though most were like the group seen here, a single line of old men, some using canes or crutches for support. According to the *New York Times*, the girls or young women in white dresses that accompanied many groups were "their own or some dead comrade's children or grandchildren." On the tunic of each G.A.R. veteran was a simple white boutonnière, supplied each year by Mrs. Sarah Loomis, stalwart of the Lafayette Circle of the Ladies of the Grand Army of the Republic.

Though the Manhattan Memorial Day procession was by far the city's largest, and the only one with significant participation by Civil War veterans, both Brooklyn and the Bronx celebrated the day with parades and speeches. In addition, Mrs. Ellen Speyer, the wife of banker James Speyer and president of the New York Women's League for Animals—not to be outdone by the martial parade uptown—hosted the sixth annual Work Horse Parade, honoring the city's draft animals and the men and women who cared for them.

ONE-LEGGED RACE

At the end of World War I the government suddenly had to consider how to treat and, if possible, rehabilitate and retrain several thousand returning veterans who lost one or more limbs in combat. The Federal Board for Vocational Education, established in 1917 by an act of Congress, proved wholly inadequate to the task. Complaints from veterans and a series of investigative reports in the *New York Evening Post* showed the Bureau to be mired in bureaucratic inefficiencies that by 1920 prevented all but a few amputees from receiving aid.

In New York City a division of the Red Cross called the Institute for Crippled and Disabled Men stepped in and began working with veterans at their headquarters at Fourth Avenue and 23rd Street. Under the guidance of Douglas C. McMurtrie, the Institute helped train amputees in a variety of trades, from typewriter repair to stenography to motion picture camera operation. An active public relations program distributed brochures such as "Your Duty to the War Cripple" as well as an illustrated magazine called *Carry On*, and staged athletic events that demonstrated the physical prowess of disabled veterans.

According to the *New York Tribune*, disabled men took part in daily baseball games on the vacant lot next door to the Institute. In addition, the public was encouraged to attend regularly-scheduled "field days," during which one-legged races such as the one seen here, boxing matches, and other feats of strength offered proof that men with missing limbs were fully capable of rejoining society. The point, as one Institute brochure claimed, was to put men who suffered catastrophic injuries during the war right "back in the game, make them useful, and, in consequence make life worth living again."

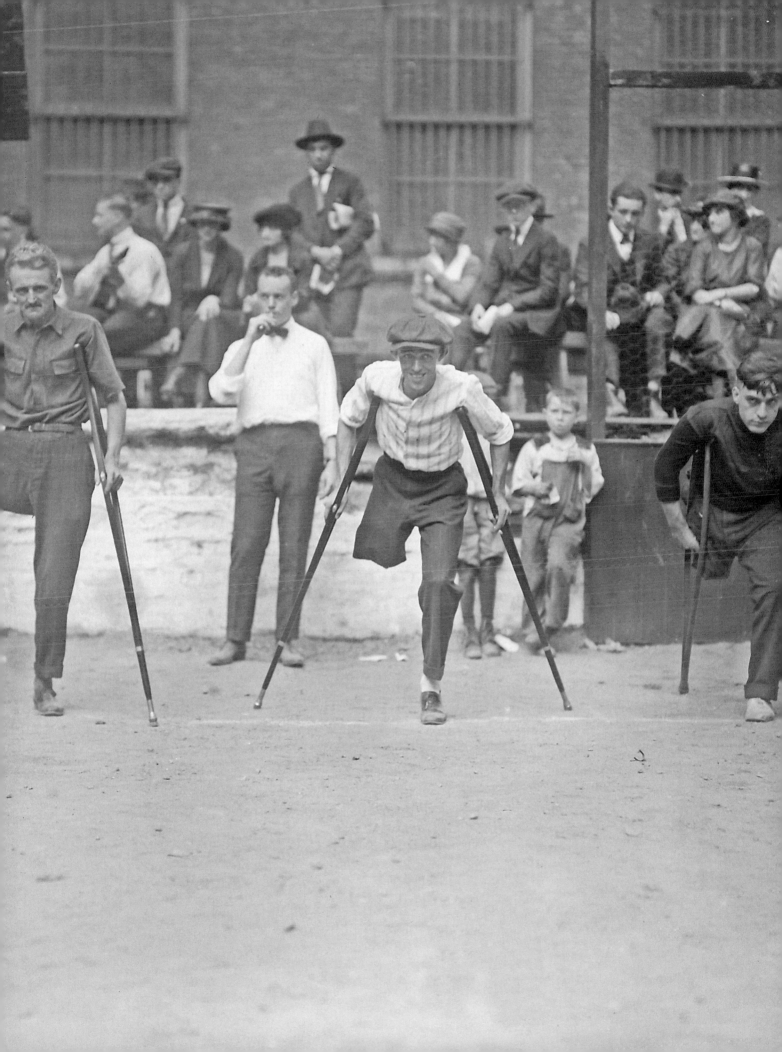

FARM FOR SCHOOL CHILDREN

The idea for children-run farms on city parkland originated with Fannie Griscom Parsons, a school inspector in New York's Eleventh District. In 1902, she persuaded authorities to convert a decrepit section of DeWitt Clinton Park at 11th Avenue between 52nd and 54th Streets to a farm planted and tended by children. The experiment worked brilliantly, and before long other parks, including the one seen here, Thomas Jefferson Park in East Harlem at 114th Street and the East River, established farms of their own.

On opening day, May 20, 1911, the farm at Thomas Jefferson Park occupied about two acres of land, divided into individual plots measuring four by eight feet. Participating children from ten public and two parochial schools received "deeds" to their own parcels, and teachers supplied both instructions and seeds. Markers at the foot of each farm plot served to make furrows into which children pressed vegetable or flower seeds. Girls and boys worked in separate sections.

Children's farms were meant to do much more than impart useful information about agriculture and the biological sciences. Mrs. Howard Van Sinteren of the International Children's School Farm League noted that farms could be a boon to those cooped up in TB hospitals or prisons, and might also help the "feeble-minded and backward." Others expressed the hope that the farm at Thomas Jefferson Park would offer a respite to children in Little Italy who spent their days working in factories or sweatshops and their nights in fetid, over-crowded tenements. Lawyer and diplomat Joseph Hodges Choate concurred with this view, and proposed more Board of Education support for the farms. "To save the children," he said, "is to save the State."

EASTER PARADE

By the turn of the twentieth century, the Easter parade in New York City was world famous. Begun in the 1870s, the slow march along Fifth Avenue between 42nd and 59th of well-to-do men and women in new spring fashions was an essential part of the social scene, an event eagerly anticipated by both the press and the City's merchant princes. Although the weather on Easter Sunday of 1911 was blustery and cold, the parade that day was the largest to date, according to the *New York Times*, attracting spectators from the lower east side and from out of town.

The cold wind and a threat of snow may have dampened the usual practice of wearing bright, summery costumes, but the display of the latest millinery fashions made up for it. The *Times* reporter enthused that the "new hats have flat, low, rounded crowns faced with colored satin or silk and trimmed with huge roses" while the larger hats sprouted ostrich feathers in a rainbow of colors. Whether festooned with silk flowers or plumes, the women's hats seemed infinitely varied, as opposed to the staid haberdashery of the men, which consisted principally of black top hats and the occasional bowler.

The musical revue *As Thousands Cheer*, which opened on Broadway in 1933 with music and lyrics by Irving Berlin and book by Moss Hart, introduced Berlin's now classic song, *Easter Parade*. The lyrics included these lines, which provide the perfect caption for this picture.

In your Easter bonnet, with all the frills upon it,
You'll be the grandest lady in the Easter Parade.
I'll be all in clover and when they look you over
I'll be the proudest fellow in the Easter Parade.
On the avenue, Fifth Avenue, the photographers will snap us,
And you'll find that you're in the rotogravure.

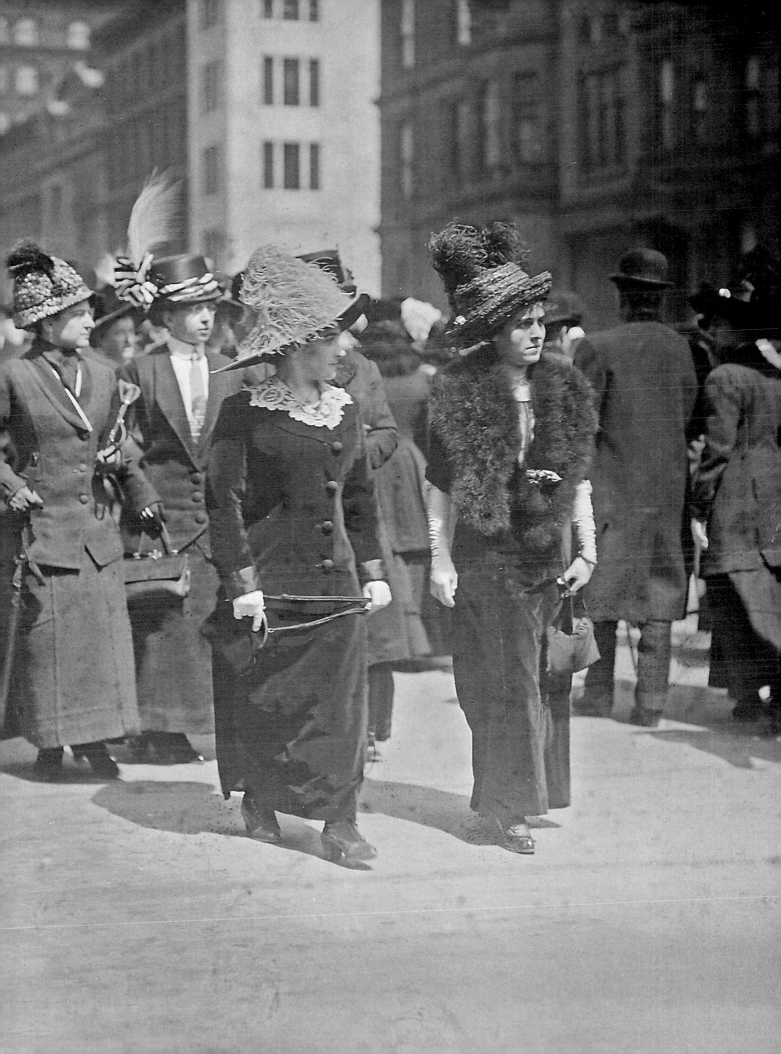

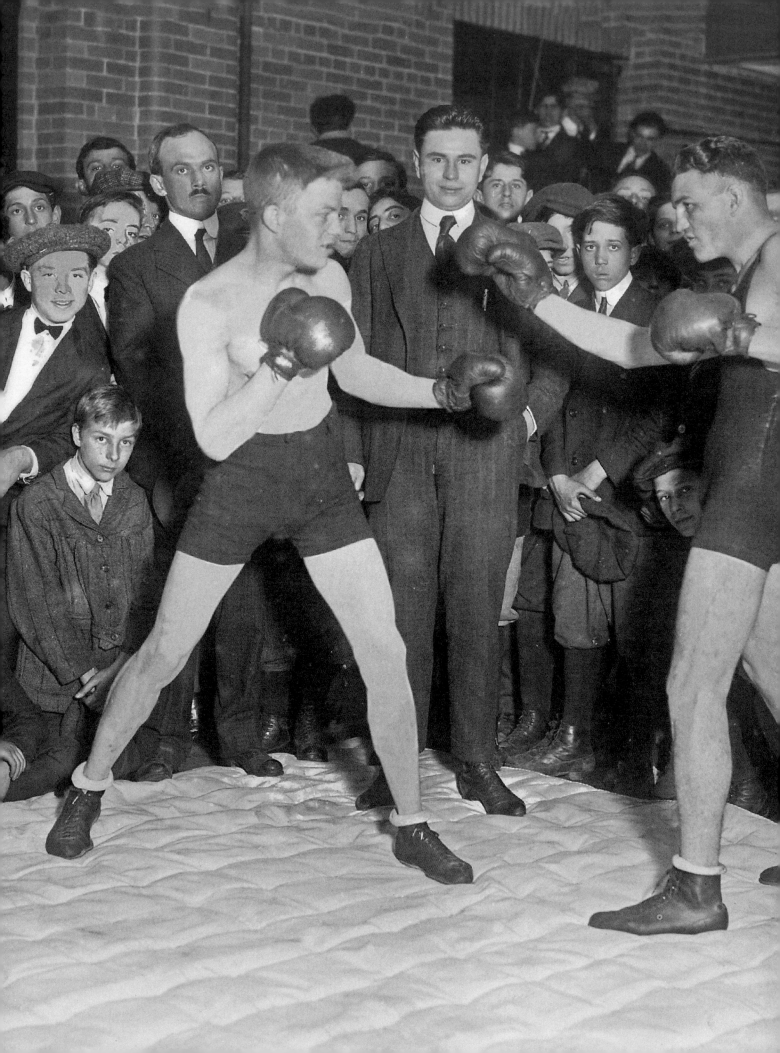

MICKEY McKAY AND FRANK CONIFREY

The Lenox Hill Settlement House, founded in 1884 by the Associated Alumnae of Normal College (now Hunter College of the City University of New York) as a free kindergarten for children of immigrants living on the Upper East Side of Manhattan, soon outgrew its original cramped quarters at 446 East 72nd Street. Funds for a new building on East 69th Street were difficult to obtain due to the outbreak of war in Europe, but finally on May 11, 1916 a brand new facility, complete with gymnasium, workshops, game rooms, and two roof gardens was officially opened.

After some speechifying by Police Commissioner Arthur Woods and Dr. George Davis, president of Hunter College, the keys to the new building were presented to Rosalie Manning, Lenox Hill's longtime manager, and the festivities began in earnest. Guests danced to music supplied by the Settlement's own orchestra—nine violins and a piano—and at a reception kids from the neighborhood mingled with swells from Fifth Avenue who were bussed over for the occasion. Later, impromptu boxing matches (there was no ring) in the new gym attracted a sizable crowd.

Boxing was an important activity at the Settlement House, producing a number of promising amateur fighters over the years. In intercity boxing tournaments, the boys from Lenox Hill did well, sometimes earning top honors. But there was (and is) more to Lenox Hill than sports. Vocational training, medical care, educational programs for children and adults, and activities in the visual and performing arts contributed to Lenox Hill's stature and importance in the neighborhood. It is not surprising, then, that the actor James Cagney, born and raised on the East Side, acted for the first time in an amateur production, a Chinese pantomime, at Lenox Hill.

SAIL WAGON

The idea of harnessing wind to propel a vehicle on land was not especially new in 1913 when this picture was made, though almost all attempts to do so happened out West where open spaces and plenty of wind seemed more promising. In Galveston, Texas in 1848, Gail Borden, inventor of condensed milk as well as a kind of dried beef-broth and flour biscuit, among other things, introduced what he called a "terraqueous machine," which he said could be used on land or water. It could not. Ten years later, Samuel Peppard, owner of a grist and saw mill on the Grasshopper River in Jefferson County, Kansas, built his own version of a prairie schooner, and by some accounts used it to get all the way to Fort Kearny on the Oregon Trail in what is now western Nebraska.

Interest in wind-driven transportation across the Great Plains continued throughout the nineteenth century. In 1877, in fact, the Kansas Pacific Railroad installed sails on some handcars. Eventually, however, interest in sail vehicles as transportation gave way to their use by racing enthusiasts and hobbyists. Just after the turn of the last century in California's Mojave Desert, two brothers, Carl and Charles Hoyt, reached speeds of fifty miles an hour in their fourteen-foot-long gaff-rigged sail wagon.

In February 1903, the *Brooklyn Eagle* sponsored the first organized ice-scooter race on the Great South Bay of Long Island, and interest in all kinds of wind-driven vehicles picked up. The boys shown here were probably familiar with some of the press reports on sail wagons and ice scooters and used the same fore-and-aft rigged mainsail and jib used by the speedy Hoyt brothers and others for their wagon.

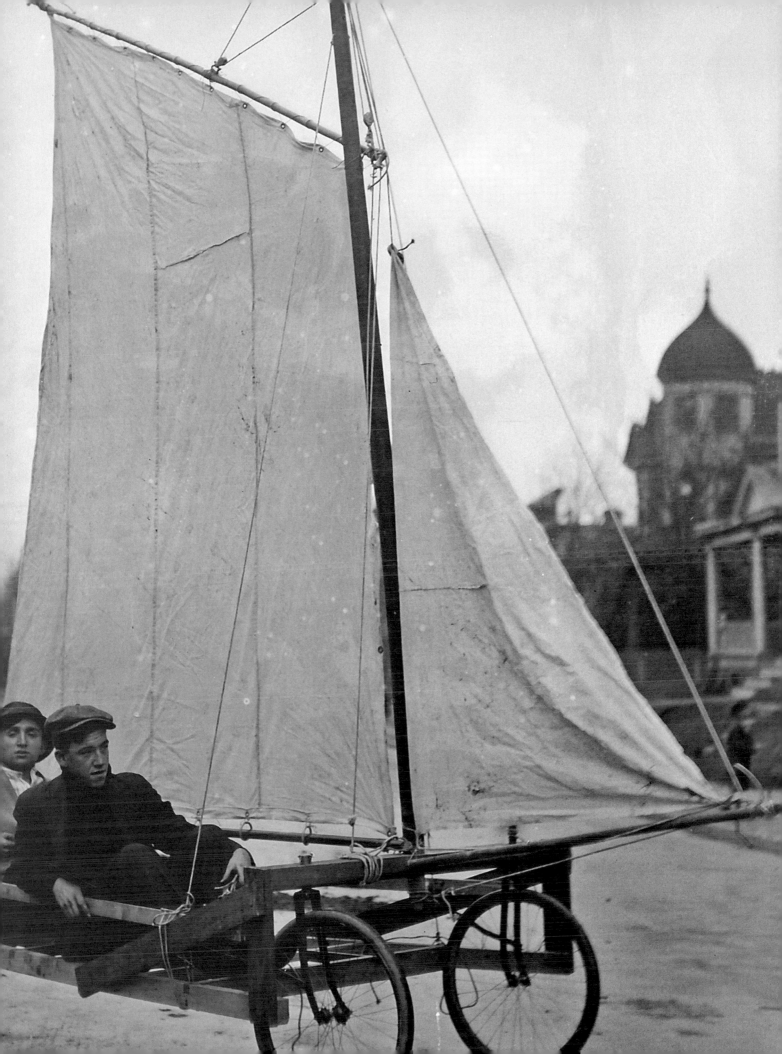

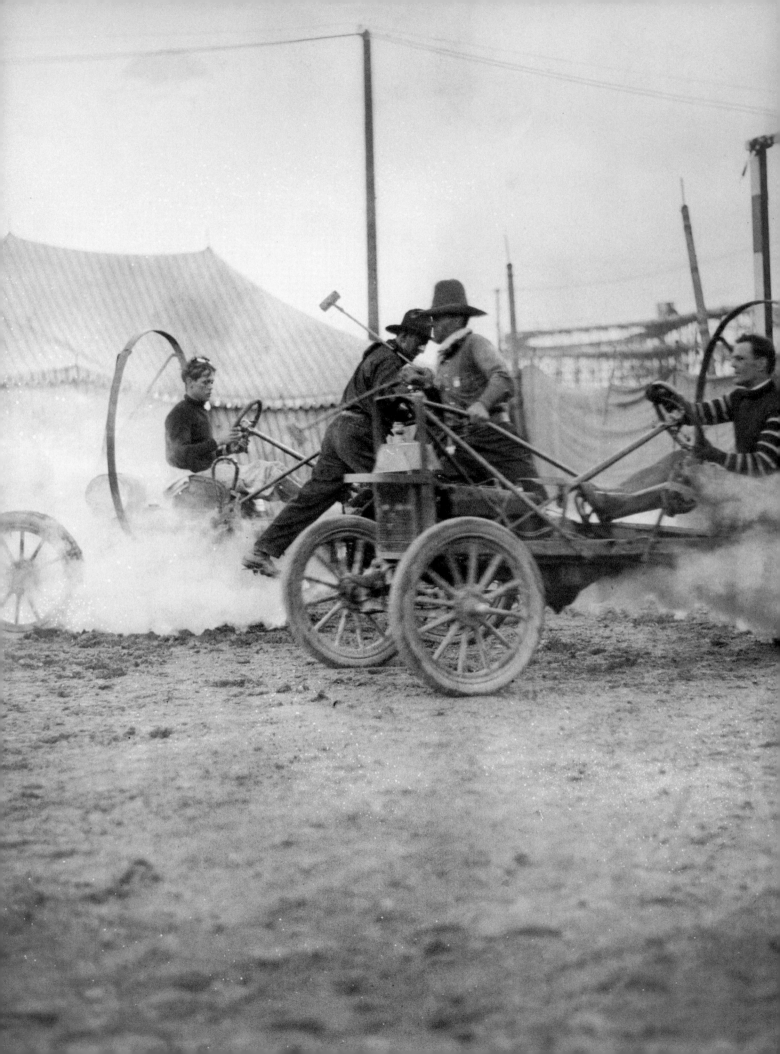

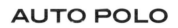

AUTO POLO

The dubious but highly entertaining sport of auto polo was the invention of Ralph "Pappy" Hankinson, a Ford dealer in Topeka, Kansas. From its modest beginning in 1911 as an advertising stunt to sell Model-T's, the sport spread across the country, attracting rabid fans and press attention—at least until several spectacular crashes and the deaths of drivers and their assistants caused some states to ban the activity. Of course, crashing cars for entertainment never did disappear completely. The demolition derbies of today are not unlike auto polo, but without mallets, goalposts, and ball.

The first grand auto polo exhibition in the East was at American League Stadium, home of the Senators in Washington, D.C. on November 22, 1912, and promoters in New York were not far behind. Madison Square Garden became a favorite venue, though some drivers complained about the lack of space. Coney Island, where an unnamed Bain photographer made this picture, and the aviation field at Garden City, nicknamed the Polodrome, seemed to offer more room to maneuver, though the main attraction of the sport was always the crashes, not the near misses.

Besides the threat of serious injury or even death, auto polo was hampered from the start by the need to replace cars too damaged to continue. Matches scheduled to last an hour or two sometimes took twice that long as "play" had to be stopped whenever a car stopped running. Though the sport briefly enjoyed some international success in 1912 and 1913, World War I may have finally slaked the public's appetite for these displays of mechanical death and destruction.

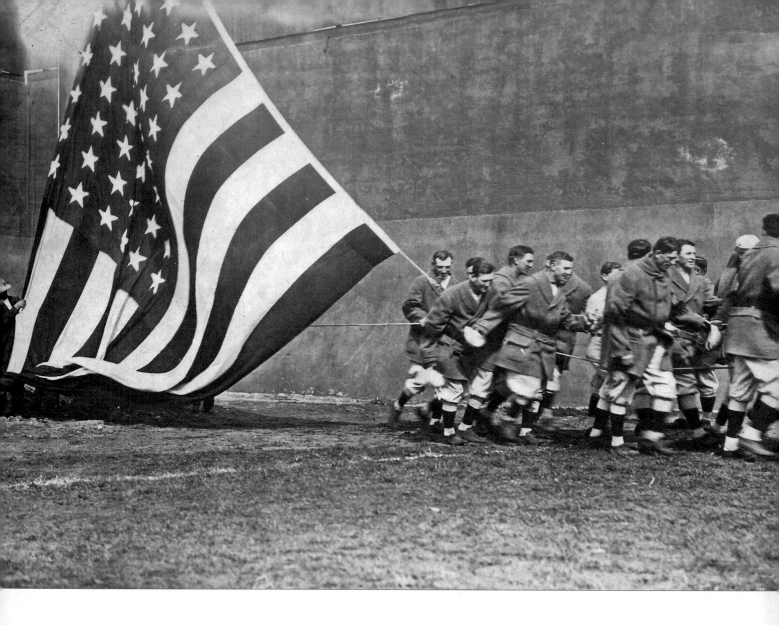

HAULING FLAG—EBBETS PARK

On opening day in Brooklyn hopes ran high for Charlie Ebbets' baseball team. Called the Superbas back then, the team finished a dismal sixth in 1913, but they had a new manager now—Wilbert "Uncle Robbie" Robinson—and they got to play again in the finest ball park in the National League, completed just the year before. The day began with the traditional parade of the players, though Ebbets also had his team haul a huge American flag out to the flagstaff near the center field bleachers. John Kinley Tener, a former pitcher with the old Chicago Cubs and now both governor of Pennsylvania and president of the National League, threw out the first ball.

The starting pitcher for the Superbas was right-hander Ed Reulbach, traded in July 1913 to Brooklyn by the Chicago Cubs after eight seasons during which he often bedeviled the hapless Superbas. On September 28, 1908, for instance, Ruelbach pitched two shutouts against Brooklyn in a single

day, one in the morning and one in the afternoon, a record that is not likely to be broken—ever. Ruelbach's best days were behind him, but on April 14, 1914 he pitched well for six innings, holding the Boston Braves to just three hits. In the seventh, however, he fell apart, allowing two runs on six hits, and Robinson brought in another big right-hander, Ed Pfeffer, who finished and saved the game for Ruelbach after a shaky start.

Despite the promising beginning, the 1914 season was disappointing as the Superbas, or Robins as they came to be called (named for their manager, not the birds), finished in fifth place. This would be Ruelbach's last season with Brooklyn; he played three more seasons of professional ball—with the Newark Peppers of the Federal League, the Boston Braves, and finally with the Providence Grays of the International League.

BATTER UP—FEMALE GIANTS

In 1913, three decades before chewing-gum magnate Phil Wrigley established the legendary All-American Girls Professional Baseball League, women played professional baseball in New York. The New York Female Giants, which was probably the creation of John McGraw, the formidable manager/impresario of the Giants, played most of their games during the 1913 season at the Lenox Oval, a field at Lenox Avenue and 145th Street. Occasionally, as in this picture, they performed with their male counterparts; the catcher here is most likely John Tortes "Chief" Meyers, the Giant's starter in 1913.

Recruited from local high schools, the Female Giants consisted of thirty-two players divided into two teams, the Red and the Blue. Their captain was Ida Schnall, best known as an award-winning diver and swimmer. In 1912, officials at the Amateur Athletic Union (AAU) and the American Olympic Committee prevented American women from competing in the Olympic games in Stockholm, Sweden although fifty-seven women from eleven other countries vied for medals in swimming, diving, and tennis. Under withering criticism from Schnall and others, the men later relented slightly, decreeing that women could participate, but only if they wore long skirts. Deprived of a chance to compete for America, Schnall turned to baseball.

Not long after the 1913 season, Schnall went to Hollywood. In 1915 she organized what *Motion Picture Weekly* called "a fair sex baseball team" at Universal City, and a year later she starred in the silent fantasy movie *Undine*, the story of a water nymph who falls in love with a mortal. The picture featured Schnall and a bevy of lissome young women in skimpy bathing suits—at least for the time. Though her acting career soon ended, she continued to support and play in women's sports for the remainder of her long life. She died on February 14, 1973.

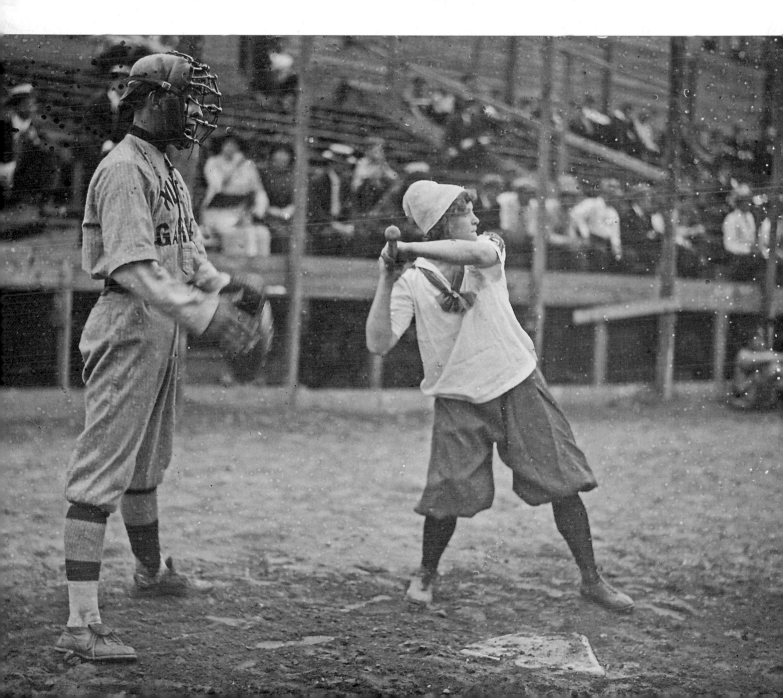

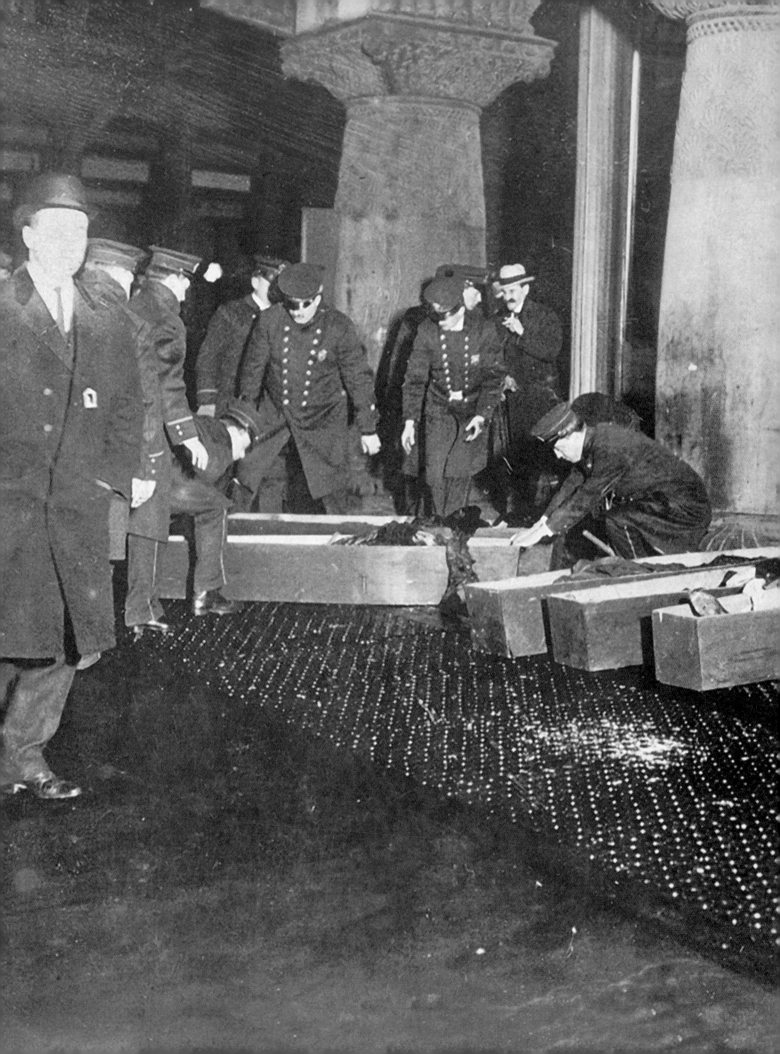

BODIES FROM WASHINGTON PLACE FIRE

The fire that coursed through the Triangle Shirtwaist Company on the top three floors of the ten-story Asch Building on Greene Street and University Place lasted about a half hour. The factory was filled with workers then, most of them young immigrant women putting in a few hours of overtime late on a Saturday afternoon, and many found the exits blocked or locked or too filled with smoke and fire to get through. A few (including the owners) managed to get up to the roof and then over to an adjoining building, and some squeezed into the only working elevator, but 146 workers died, many of them in desperate, fatal plunges from 8th and 9th floor windows.

The factory and its owners had already achieved a kind of notoriety. In the great Shirtwaist Strike of 1910, tens of thousands of workers walked out of textile factories and sweatshops throughout the city, but the Triangle owners, Max Blanck and Isaac Harris, refused to give in. They immediately hired strikebreakers to replace those who left, and work continued as before—same long hours, same paltry wages, same cramped and over-crowded workrooms.

Firemen arriving at University Place on March 25 could do little except watch in horror; neither their hoses nor ladders reached the top floors. In the end, it was mostly a matter of cleaning up, of collecting charred bodies from inside the factory and crumpled ones on the street and transporting them to the Charities Pier on the East River at 26th Street. Workers brought over crude wooden coffins from the morgue at Bellevue Hospital, and police and firemen began separating the bodies, placing them face up inside the boxes. This photograph was made on Greene Street as darkness fell, the photographer illuminating the grisly scene with a sudden flash of magnesium powder that forever obliterated the features of the living.

147

BRIGHTON BEACH FIRE

In the pre-dawn hours of June 5, 1912, a fire caused by defective electrical wiring in a photographer's shack on the Brighton Beach boardwalk threatened to destroy several hotels and the famous Parkway Baths, and with them, prospects for the summer tourist season. A sudden and fortuitous shift in the wind, however, forced the fire back onto itself, and firemen were able to douse the remaining flames. The fire consumed seventy-five feet of boardwalk, several concessions, and scorched a bit of the grand old Ocean Hotel, but the wind shift saved the district. In fact, the planned three-day festival for the benefit of the Summer Home for Helpless Crippled Children, scheduled to begin on June 6 at the Ocean Hotel, began right on time.

By the time Bain's photographer arrived at the scene on June 6, the fire was mostly extinguished. He made two routine pictures, one of firemen hosing off the remnants of a section of the boardwalk, and a close-up of burned boards and timbers, then looked for something else, something visually compelling perhaps, to illustrate what had happened. His solution was an image showing the entire expanse of charred boardwalk with the Parkway Baths in the distance, and a single person perfectly illuminated as he walked along pilings between the burned out boardwalk and the water's edge.

A little more than five years later a much larger fire did finally destroy the Baths along with two small hotels, a drug store, a shooting gallery, and several beachfront stands selling mementos and knickknacks to tourists. Since the buildings were all made of wood they burned quickly, and a stiff breeze from the ocean fanned the flames. Once again a slight shift in wind direction eventually helped firemen extinguish the flames, and most of Brighton Beach was spared.

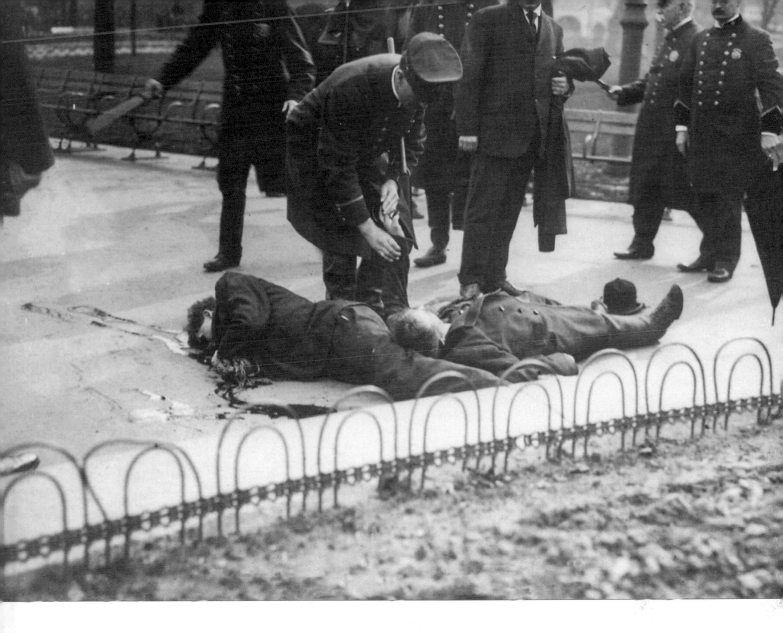

TAKEN 20 SECONDS AFTER
BOMB THROWN

In the mid-afternoon of Saturday March 28, 1908, a large crowd gathered in Union Square, brought there by the published announcements of a mass meeting of the City's unemployed. However, the Parks Department had refused to give the Socialist organizers of the event a permit to meet, and police broke up the nascent demonstration, forcing most of the protesters and the merely curious onto side streets. There was a lot of grumbling, of course, and some singing of *La Marseillaise*, but for a while it looked like the day would end without serious incident.

Suddenly, a young man who was later identified as Selig Silverstein, an immigrant from Bialystok, Russia, rose from a bench near the fountain in the center of the park, fumbling with an object that witnesses later said was the size and shape of a grapefruit. Silverstein was about to hurl what turned out to be a homemade bomb at a nearby contingent of police when it exploded prematurely, critically wounding Silverstein and killing Ignatz Hildebrand, an innocent bystander, who was standing nearby.

Several news organizations sent photographers to Union Square that day, and after the blast they converged on the fountain. Bain's photographer, possibly Henry Raess, got there quickly, perhaps first, and made a picture of policemen and one dapper man in suit and tie clustered around the two bodies. Silverstein is face down, blood streaming from his mangled head (he died two weeks later), as a policeman lifts Hildebrand's left arm, possibly to feel for a pulse. It is a fine, hard news picture, and Bain stressed its immediacy in the caption, and made sure the image would be properly credited by those who ran it. But he did not credit the photographer who made it.

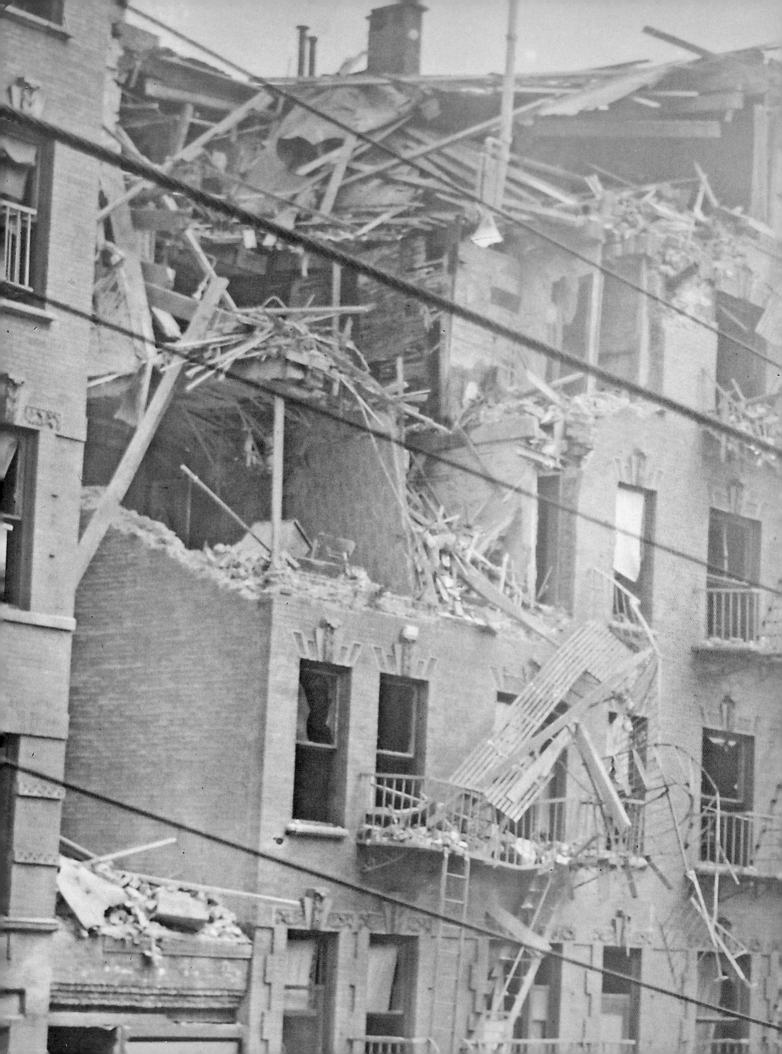

HOUSE WRECKED BY CARON BOMB

Shortly after 9:00 A.M. on the fourth of July 1914, an explosion ripped through the top three floors of an apartment building on Lexington Avenue in Harlem, killing four people and injuring seven more. The cause was the premature detonation of a bomb intended for oil baron John D. Rockefeller, and perhaps his son as well, in retaliation for their efforts to stifle noisy labor and free-speech protests at the Rockefeller estate in Tarrytown, New York.

The Rockefellers became the focal point of protests in the wake of the so-called Ludlow Massacre on April 20, 1914, when state militia assaulted and destroyed an encampment of striking miners and their families at the Rockefellers' Colorado Fuel and Iron Company. Among those killed were two women and eleven children who suffocated when the militia torched the miners' tents. The reaction of company spokespersons and the Rockefellers seemed callous and uncaring, as they blamed the strikers themselves for the violence and loss of life.

Ludlow energized the left, especially a growing number of anarchists committed to using violence against both the state and capital. The four killed in the bomb blast, Charles Berg, Carl Hanson, Arthur Caron, and Marie Chavez had ties to the anarchists and to the IWW (Industrial Workers of the World). Though celebrated briefly as martyrs to the cause of social justice, in the end their use of dynamite to force change turned much of the public and the press against them.

AT GAYNOR NOTIFICATION

On September 3, 1913, supporters of the re-election of Mayor William Jay Gaynor gathered in front of City Hall to celebrate his nomination as an independent candidate. They brought shovels with them—hundreds of them—symbols of their determination to "shovel away" the filth and corruption of Tammany-style politics. Four years before, Gaynor ran successfully as a Democrat with the backing of Tammany Hall, but this time the enemy was Tammany itself and its boss, Charles Francis "Silent Charlie" Murphy.

The Gaynor campaign organized the ceremony in front of City Hall as a public and seemingly impromptu nominating convention, the exact opposite of the back-room deals preferred by Murphy and his associates. The sign just behind the shovels refers to Murphy's central role in the impeachment and eventual conviction of Governor William Sulzer who, like Gaynor, steadfastly refused to appoint Tammany-backed politicos to positions in Albany.

That Gaynor was able to defy Tammany at all was miraculous, for in August 1910, James Gallagher, recently fired from his job with the New York City Docks Department, shot Gaynor in the neck. Physicians saved the Mayor, but elected not to remove the slug, which lodged in his larynx. Although the wound healed quickly, it bothered Gaynor throughout his term, causing intense bouts of coughing, and more or less constant discomfort. But his desire to reform city politics never waned. At the City Hall notification ceremony he vowed, "the people of this city are going to shovel all these miserable little political grafters into one common dump heap." It would not be, however, for a week later Gaynor died suddenly on board the *RMS Baltic,* headed toward Europe and a much-needed vacation.

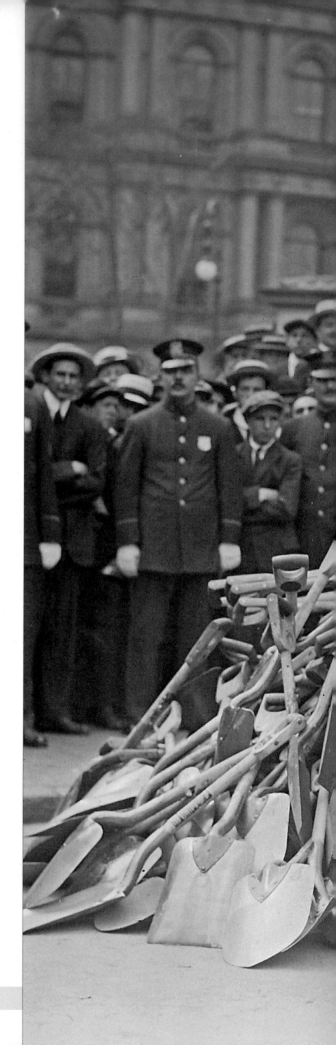

DETECTIVE COONEY–
GRAFT HEARING

Detective Joseph A. Cooney was one of several New York City officers caught up in investigations into widespread police corruption following the killing of Herman Rosenthal and the subsequent trial and conviction of Lieutenant Charles Becker for master-minding the murder. No one accused Cooney of a part in the Rosenthal-Becker affair, but the press—led by the *New York World*—railed against what they saw as a culture of corruption in the department. The Board of Aldermen responded by establishing an Investigating Committee to determine the extent of the problem.

Detective Cooney was called before the committee in September 1912 to answer questions about an incident involving two private detectives at the apartment of Winfield R. Sheehan, secretary to Police Commissioner Rhinelander Waldo. Many of the officers and officials called to testify, including Commissioner Waldo and Mayor Gaynor, believed the investigation was little more than political theater inspired by an unfriendly press. Cooney's insouciant posture and unhelpful responses reflected the department's official stance, and chief counsel Emory Buckner's grilling of the detective produced little hard information. The implication that Sheehan received special treatment due to his association with Waldo was clear but unsubstantiated. The *Times* concluded that Cooney was "an unsatisfactory witness, and he left the witness chair without adding much of value to the records."

Months of investigations by the Aldermanic Committee and the press produced no great bombshells, but the police department did change. Ardolph Loges Kline, chair of the Board of Aldermen in 1912, became mayor when Gaynor died in office in 1913. One of Kline's last official acts before leaving office on December 31, 1913 was to fire Rhinelander Waldo. As for Detective Cooney, he was demoted to patrolman in August 1922.

"LEFTY LOUIE," "GYP THE BLOOD" AND THEIR CAPTORS

Shortly after the murder of the notorious gambler Herman Rosenthal, police arrested two of the killers, Frank "Dago Frank" Cirofici and Jacob "Whitey Lewis" Seidenschmer, as well as the driver of the get-away car, though Louis Rosenberg ("Lefty Louie") and Harry Horowitz ("Gyp the Blood") remained free for more than a month. Employees of William J. Burns's National Detective Agency, hired by Manhattan DA Charles Whitman (who was skeptical of the ability of the police to find the perpetrators,) finally captured the two fugitives without firing a shot, in the small Catskills town of Fonda.

The case against Horowitz and the others was pretty airtight, and testimony by the driver, a small-time hoodlum named William Shapiro, and Rosenthal's former colleague Jack Rose led to swift convictions and death sentences for all four. In return for their testimonies, Shapiro, the driver, and Jack Rose, the fixer, were released. The executions took place on April 13, 1914 at Sing Sing Prison. Two hours before his turn in the chair, Frank Cirofici issued a statement saying, among other things, "So far as I know, Becker had nothing to do with the case. It was a gambler's fight. I told some lies on the stand to prove an alibi for the rest of the boys...."

The last-minute statement notwithstanding, New York City Police Lieutenant Charles Becker, the supposed mastermind of the entire sordid affair, was tried (twice), convicted, and executed.

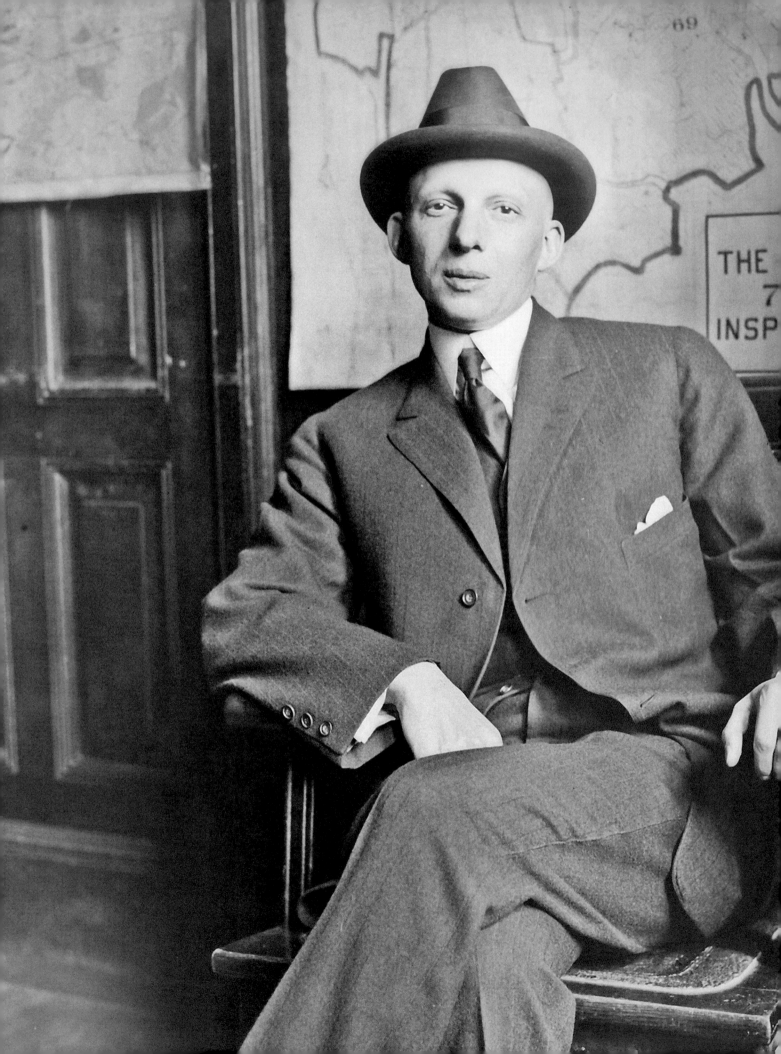

JACK ROSE

His real name was Jacob Rosenzweig, though among the gamblers and fixers with whom he associated he was known simply as "Bald Jack" (the lack of hair due to an early bout with typhoid fever), and in 1912 he was at the center of a story that riveted New Yorkers for years. Rose acted as part-time stool pigeon and collector for the police, especially for Lieutenant Charles Becker, leader of a unit established to break-up gambling dens. Instead, according to Rose and others, Becker demanded and pocketed pay-offs from the gamblers. Herman Rosenthal, who ran a fancy gambling parlor on 45th Street near Broadway, had a public falling out with Becker and Rose. When police raided his place, Rosenthal announced his intention to blow the whistle on Becker's operation.

Less than a week after the raid, on the night of July 16, four gunmen killed Rosenthal as he stood in front of the old Metropole Hotel. The assassins took off in a rented grey Packard that was traced to Jack Rose (an eyewitness got most of the tag number). Two days after the murder Rose turned himself in, and almost immediately began singing for his life. Promised immunity by Manhattan District Attorney Charles Whitman, Rose fingered Becker as the mastermind of the murder and provided scintillating details about the intertwined worlds of illegal gambling and the police.

Rose's testimony, corroborated by a pair of jailhouse snitches named Bridgie Webber and Harry Vallon, sealed the fate of Lieutenant Becker, and after two trials he was convicted of murder and sentenced to die. After his execution on July 30, 1915, evidence accumulated suggesting that Becker was framed by Rose and the others in return for their freedom, and that the vast political ambition of the DA, who parlayed his reputation as reformer and crime fighter into a successful run for the governorship, led to a miscarriage of justice. After his release from prison, Rose became a minor celebrity, speaking to civic groups about the pleasures of the straight life as a born-again Christian.

BECKY EDELSON UNDER ARREST—
TARRYTOWN

During the spring and summer of 1914, the seemingly demure young woman pictured here was at the center of intense and sometimes violent confrontations between police and a loose coalition of anti-war activists, unemployment protestors, and anarchists, among others. Becky Edelsohn (the newspapers consistently misspelled her name,) was closely aligned with the leadership of the Industrial Workers of the World (IWW or Wobblies), and her condemnation of capitalism and the government at public meetings brought her to the attention of the police.

At a large gathering near the Benjamin Franklin statue in Printing-House Square in the midst of the city's newspaper district on April 22, 1914, Edelsohn shouted that the flag was not worth defending, and that working people ought to band together to fight their rapacious and war-hungry government. Indignant shouts and threats erupted from the unsympathetic crowd, and the police took Edelsohn and one companion prisoner. Edelsohn was accused of speaking

disrespectfully of the flag, and when she refused to agree to a judge's order that she refrain from speaking publicly for three months, she was sent to prison. To protest the conviction and sentence, Edelsohn began a hunger strike, the first woman in America to do so.

For the next several months Becky Edelsohn remained in the news as reporters followed the course of her hunger strike and sympathizers worked for her release. When one supporter paid her fine in early June she was set free, and immediately traveled to Tarrytown to take part in demonstrations against John D. Rockefeller at his grand estate. There she was re-arrested and once again used the hunger strike to call attention to the injustice of her sentence. In mid-August Edelsohn, weakened by weeks of hunger, was released when Eleanor Fitzgerald, who worked at Emma Goldman's journal, *Mother Earth*, paid her fine. After writing a brief report on her arrest and imprisonment, she disappeared from public view.

RUN ON EAST SIDE BANK

To the thousands of immigrants who lived on the lower east side early in the 20th century, Adolf Mandel's private bank at 155 Rivington Street provided easy access to money orders destined for family members still in Europe and a supposedly reliable place to deposit modest savings. However, the reliability, safety, and convenience of Mandel's bank suddenly seemed at risk in mid-February, 1912, as rumors swept through the neighborhood that most of the money was gone, lost to thieves or some mysterious malevolent force. The panic began on the evening of the eleventh and continued the following day as crowds of anxious depositors swarmed around the entrance to the bank, frantic to retrieve whatever was left of their funds.

Both the *Times* and the *Tribune* characterized the scene as a kind of collective hysteria, noting the excited Babel of voices demanding money and the efforts of police from the Delancey Street station to maintain order. But in 1912 there was good reason to fear the collapse of a local bank. The disastrous Panic of 1907 during which banks across the country suddenly collapsed was recent history, and though some in Congress had promised to reform the financial institutions of the country, the system remained perilous, and depositors remained basically unprotected. The panic on Rivington was understandable, and in hindsight, justified.

In August 1914, State Examiners took possession of Mandel's bank in the wake of a raft of withdrawals at the outset of war in Europe, and Mandel was accused of accepting deposits despite his bank's insolvency. On April 30, 1915, Judge Vernon M. Davis of the State Supreme Court sentenced Mandel to serve two and a half years in Sing Sing Prison, while outside a crowd of his victims cheered the verdict of the court.

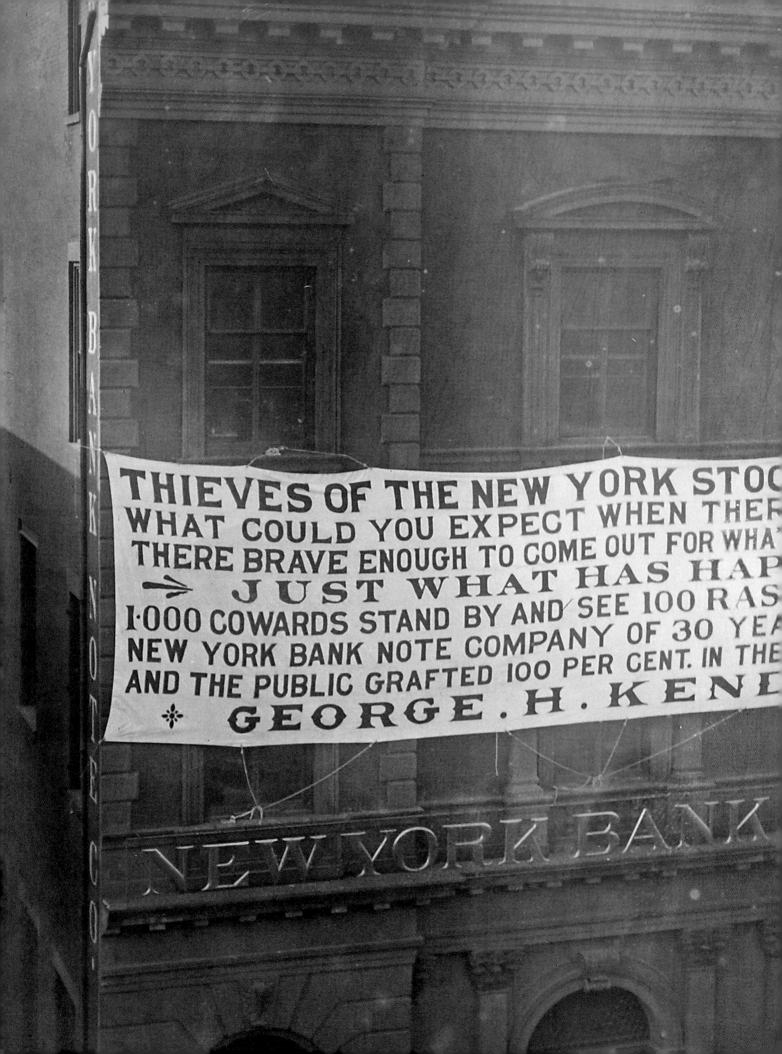

NEW YORK BANK NOTE COMPANY

By all accounts George H. Kendall, president of the New York Banknote Company, was a difficult man. He argued with his neighbors in the affluent community of Grymes Hill on Staten Island and they took him to court twice, once for cutting down trees on an adjoining property in order to improve the view and once for assaulting a coachman. However, these local legal skirmishes paled in comparison to his three-decade long dispute with the New York Stock Exchange, a dispute played out in federal court, the state legislature in Albany, Congress, and, as in this photograph, on the façade of his company's headquarters on Sixth Avenue.

The New York Banknote Company specialized in printing stock certificates and bonds. Kendall's troubles with the NYSE began in the 1890s shortly after several directors—including the financier Russell Sage—resigned and Kendall assumed the presidency of the firm. Soon after the departure of Sage and the others, the NYSE's Stock Listing Committee announced that certificates printed by Kendall's firm were not acceptable, and furthermore that only those printed by his chief rival, the American Banknote Company, would be listed. Kendall was effectively blackballed.

In June 1910, Kendall filed suit in the Southern District of the United States Circuit Court, charging the directors and each of the 1,100 members of the Stock Exchange with conspiracy, and demanding $5,000,000 in damages, the amount he said his firm lost during the past two decades. Judge Emile Henry Lacombe dismissed the suit on October 27. Thereafter, Kendall carried on his argument against the Exchange in Congress in hearings before the Senate Committee on Banking and Currency, and in Albany, and though he never did succeed in reinstating his company, he did manage to raise serious questions about the inner workings of the country's premier stock exchange.

POLICE AND DETECTIVES GUARDING CHINATOWN

The ostensible reason for sending policemen into Chinatown during the July 4 holiday in 1909 was to prevent war between members of at least two powerful tongs that vied for control of the district. In a celebrated trial that ended on July 3 in Boston, Judge John Freeman Brown had condemned to death five members of the notorious Hip Sing Tong, based in part on testimony from members of the rival On Leong Tong. New York officials assumed that the Boston tong war would spread to their city as well, sparked by calls for retaliation and revenge.

Besides the talk of gangs and violence in Chinatown, New York City newspapers still endlessly rehashed the sordid details of the murder on June 9 of nineteen year old Elsie Sigel, granddaughter of Franz Sigel, the famous Civil War general, whose body was found stuffed into a trunk in the apartment of a Chinese immigrant named Leon Ling. The unsolved murder (police failed to capture Ling), and the threat of gang violence on the 4th, convinced Acting Mayor Patrick F. McGowan and Chief Inspector Max Schmittberger to send units from the Second Inspection District and the Elizabeth Street Station into Chinatown. The presence of police guards would presumably keep the peace between rival tongs, and coincidently prevent outsiders from marching into Chinatown intent on exacting revenge for the murder of Miss Sigel.

By the evening of the 6th of July, the day this photograph was taken, the extra police presence ended without incident. It took a while, though, for Chinatown to lose its unwelcome reputation as a dangerous place. A tour guide named Otto whose business declined in the wake of a month's worth of negative coverage, complained to the *New York Sun* that "Nobody wants to see Chinatown when they reads that it is built on vice and crime, [but] there ain't any more here than anywheres."

CASTRO LANDING

Cipriano Castro, ruler of Venezuela since 1899, left Caracas in 1908 for kidney surgery in Germany and was immediately deposed by General Juan Vincente Gomez, his supposedly loyal lieutenant. This made Castro—who Bain described in an article in *Current Literature* as the Peter the Great of Venezuela—a man without a country. When Castro announced his intention to come to New York on what he claimed was an innocent visit, immigration authorities ordered him held him at Ellis Island while they and the State Department debated what to do next. Bain's photographer made this image on December 31, 1912, as officials escorted the former president (sixth from left) to temporary quarters in a building reserved for non-steerage detainees.

Castro could not be excluded for health reasons. Although his body was festooned with numerous scars, Ellis Island doctors could find no good reason to deny his admittance. However, officials at the State Department, concerned that Castro's real plan was to return to Venezuela and overthrow the Gomez government, ordered his detention. During the first weeks of 1913, several hearings on his status took place, during which Castro became increasingly uncooperative, refusing to answer questions about the source of his wealth, his intentions, or any of his actions while president.

After several weeks of hearings, officials decided to exclude Castro, a decision that was upheld in Washington. But Castro appealed, with the help of New York Democrats who provided the former president with legal counsel, and a federal judge said he could stay as long as he liked. Castro left the United States in the spring and settled in Trinidad, hoping in vain that his followers back home in Venezuela would return him to power. He briefly revisited Ellis Island and America in 1916, but ended his days broke and alone in San Juan, Puerto Rico.

BILLY SUNDAY REACHES NEW YORK

On April 7, 1917, after months of careful preparation by hundreds of workers and volunteers that included the construction of an enormous wooden tabernacle on the northern edge of the old New York Highlanders' baseball field at 168th Street and Broadway, the evangelist Billy Sunday arrived in New York City. Thousands crowded into Pennsylvania Station that day, hoping for a glimpse of the famous preacher; reporters and photographers—including Bain's man—waited outside.

William Ashley Sunday was born near Ames, Iowa in November 1862. In his youth he spent time in an orphanage, worked in a variety of menial jobs, and eventually discovered that he could really play baseball. In 1883 he debuted with the Chicago White Stockings, the defending National League champions, and in 1887 they sold him to the Pittsburgh Alleghenys. He ended his career with the Philadelphia Phillies, having compiled a lifetime batting average of .248 with 12 home runs and an impressive 246 stolen bases.

Sunday left professional baseball in 1891 after his conversion at the Pacific Garden Mission in Chicago. He learned how to organize revival meetings as an advance man for evangelist J. Wilbur Chapman, and five years later hosted his own revival meeting in Garner, Iowa. By the time he began planning for the New York meeting, Sunday was a national celebrity, popular with the masses for his plain language (his critics said it was simply vulgar) and theatrical performances, and with business and political elites for his conservative politics and patriotism. In New York, Sunday railed against the devil, the Kaiser, rum, Unitarians, and society women too busy to accept Christ. In June he told a reporter at the *Tribune* that "New Yorkers are keener than country folk; they are more used to seeing and hearing new things; they catch on quicker…. I couldn't give them any Class B stuff, not even when I was tired…" Even skeptics might have agreed with that assessment.

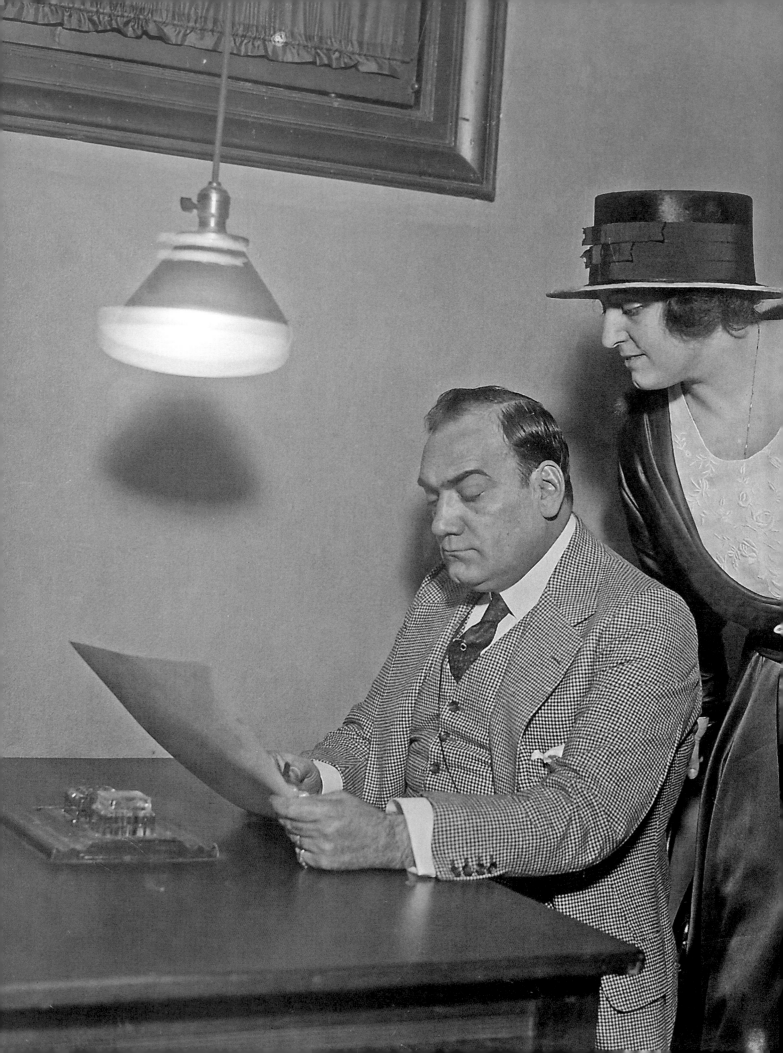

CARUSO AND MUZIO

Enrico Caruso was at the height of his creative power in 1918. His long association with the Metropolitan Opera in New York began in November 1903 when he debuted as the Duke of Mantua in Giuseppe Verdi's *Rigoletto*. Caruso's spectacular career coincided with the early development of the recording industry, and as a result his magnificent voice was available to a mass audience via inexpensive cylinder and disk, making him the best known and most admired opera singer in the world. In February 1904, Caruso signed with the Victor Talking Machine Company and for the next sixteen years he made numerous recordings, many of which were advertised with posters made and distributed by the Bain News Service.

In this photograph made in mid-March 1918, Caruso poses with Claudia Muzio, a much-admired young soprano with whom Caruso appeared in performances both here and abroad. The occasion of the photo shoot was likely the revival at the Met of Italo Montemezzi's *L'Amore dei Tre Re*, which opened on March 14. The opera had not been performed in New York for some years, and this would be a first for both Caruso and Muzio. The prospect of the famous tenor and his prima donna tackling new roles in a little known opera in the midst of war attracted what the *Times* critic called "one of the finest audiences of the season."

Reviews of the performance were mostly positive, though both the *Tribune* and the *Times* remarked that Caruso suffered from a cold (he was a heavy smoker) and was not, therefore, in top form. Muzio, by all accounts, was brilliant. The cold may explain Caruso's grim expression in the photograph. For Caruso the combination of a cold, a new role in an unfamiliar opera, and the arcane activities of one or more photographers may have been just a little too much.

WRIGHT'S START

At the behest of the organizers of the two-week long Hudson-Fulton Celebration in 1909, Wilbur Wright made four successful flights in five days over New York Bay and parts of Manhattan. During his second flight on the morning of September 9, Wright steered his Model A biplane around the Statue of Liberty, a maneuver captured by several photographers, none of whom worked for George Grantham Bain. *Harper's Weekly* put the photograph of the little plane and the statue on the cover of the October 9 edition, and both the *New York Sun* and the *New York American* ran pictures of the feat on the top of the fold on page one.

Bain's staff photographers may have missed that shot, but one of them did capture the dramatic lift-off of Wright's plane as it sailed serenely past a photographer standing next to the makeshift launch site on the sandy southeastern tip of Governor's Island. The juxtaposition of the photographer in bowler hat and Wright's flying machine is startling; so, too, is the unmistakable shape of a canoe affixed to the underside of the plane. Ever the careful planner, Wright bought the bright red canoe at the H & D Folsom Arms Company at 314 Broadway in Manhattan and mounted it under the Model A's skids in case he had to make a water landing.

The obvious proximity of spectators—chiefly reporters and photographers—to the launch and landing site infuriated Wright, and may have caused his rough landing after the first flight. According to the *New York Sun*, police were immediately brought in to maintain order, and some of the most persistent reporters and photographers had their press passes confiscated. Later in the day the police returned their badges, but by then, of course, the flights were over for the day.

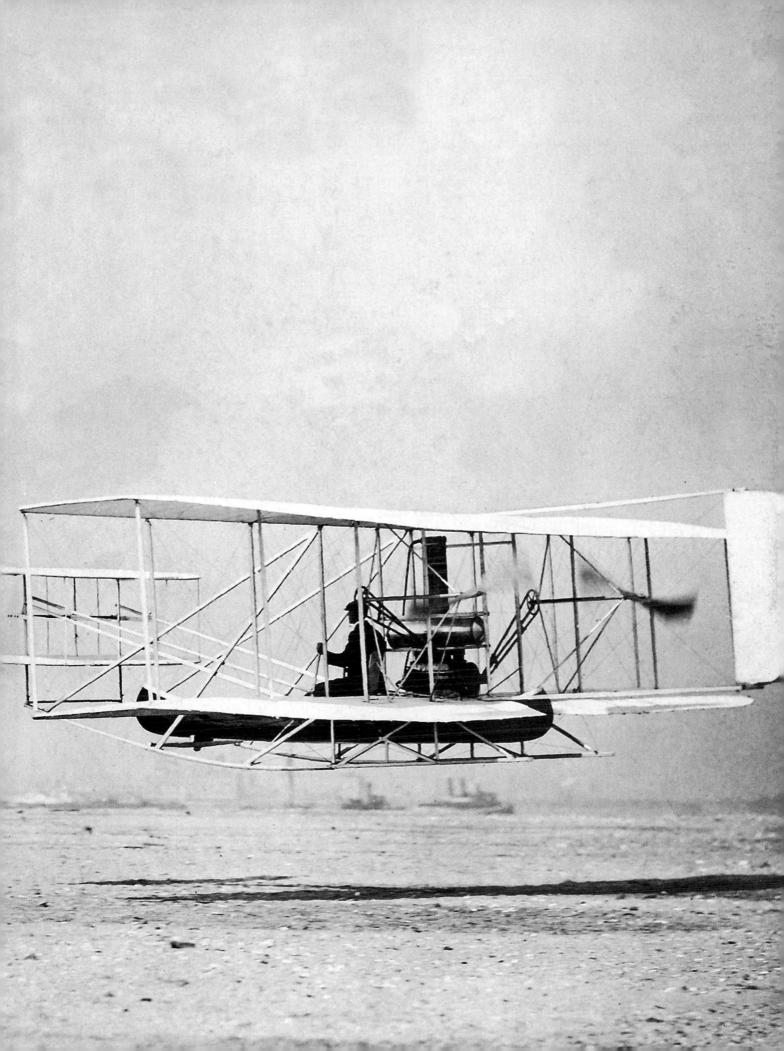

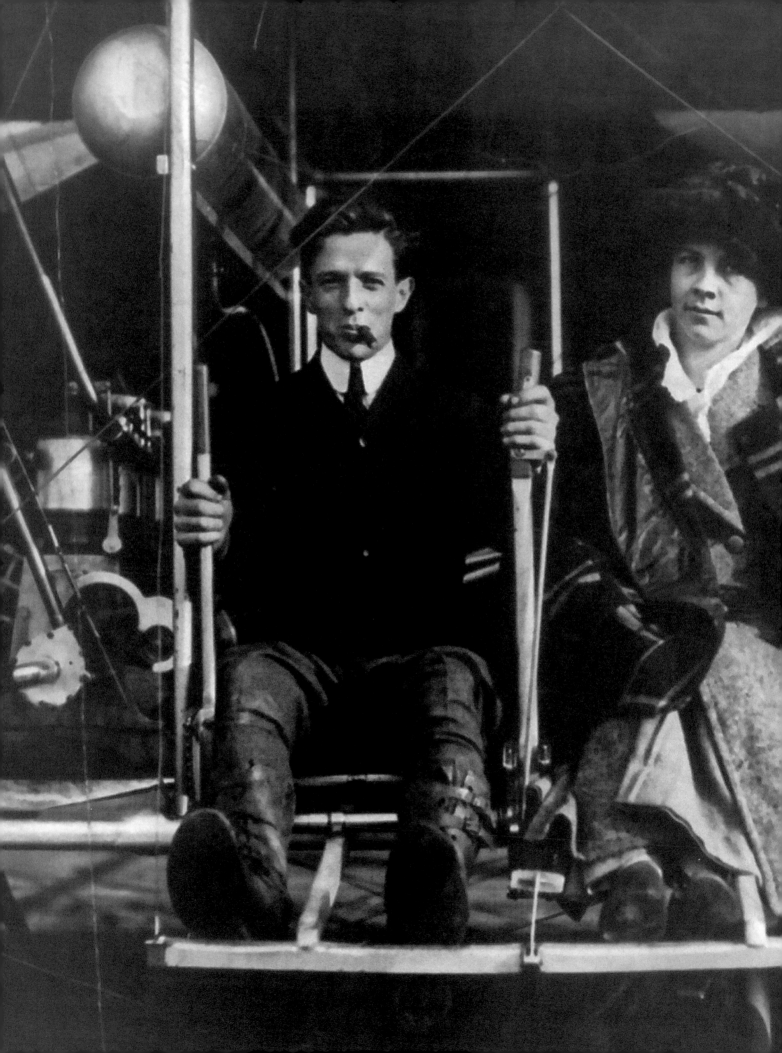

HARRY BINGHAM BROWN AND ISABEL PATTERSON

In the decades following the Wright brothers first powered flights at Kitty Hawk, North Carolina on December 17, 1903, the press enthusiastically reported on each new altitude and distance record, and profiled the dashing young men and women who made them. Harry Bingham Brown flew a Wright-made biplane, smoked cigars, and specialized in taking along a passenger on flights from one of three airfields on the Hempstead plains on Long Island or the field at Oakland Heights on Staten Island. On Election Day, November 5, 1912, Brown set a new American altitude record for accompanied flight when he and Mrs. Isabel Paterson soared to a little over five thousand feet during a forty-seven minute flight from Oakland Heights.

Isabel Bowler Paterson worked as a reporter, editorial writer, and drama critic for newspapers in Vancouver, Spokane, and New York. Between 1916 and 1940 she wrote eight novels, as well as countless articles and reviews for the *New York Herald Tribune.* She is best known today as the author of passionate essays on the need for minimal government and individual responsibility, essays that influenced Ayn Rand and William F. Buckley, Jr., among many others.

On May 31, 1913, Brown made the papers again when he flew first with General Rosalie Jones, Long Island's most famous suffragette, then with Arthur Lapham, a twenty-one year old parachutist. The fifteen-minute flight with Jones was uneventful, but on the next trip Lapham's chute failed to deploy and he fell heavily into a marsh. Though both the crowd and a tearful Brown feared the worst, Lapham was not seriously injured; years later he served several terms as City Commissioner in Union City, New Jersey.

HARRIET QUIMBY IN COCKPIT OF PLANE

Harriet Quimby was a journalist and photographer with *Frank Leslie's Illustrated Newspaper* in October 1910 when she attended the International Aviation Tournament at Belmont Park on Long Island (the famous racetrack was closed at the time due to anti-gambling legislation in Albany). A few months later, she enrolled at the Moisant Aviation School in Garden City, and on August 1, the Aero Club of America awarded her an official pilot's license, the first American woman to achieve this distinction.

Quimby's exploits in her fast little Blériot monoplane as well as striking good looks and a self-designed flying suit in purple satin, combined to make her an international celebrity. Just a few weeks after receiving her license she made a dramatic moonlight flight over Staten Island to the delight of thousands of spectators, and in September 1911 she won a distance race against the French woman champion Hélène Dutrieu. After several months of competitions and flying exhibitions around the country, Quimby decided to attempt a solo crossing of the English Channel, a feat performed by only a few men and no women at all.

With financial backing from *Leslie's* and *The Mirror* in London, Quimby readied her plane, and on April 16, 1912 she flew from Dover to Hardelot, a small seaside resort about twenty-five miles south of Calais. Though her achievement received little notice in the papers due to continuing coverage of the *Titanic* disaster, her fellow aviators certainly took notice. Two months later, on July 1, she entered yet another air show—this one at Harvard Field at Squantum in Massachusetts. During a routine flight, her two-seater Blériot was up-ended by a sudden gust of wind, and she and her passenger, William A. P. Willard, fell to their deaths. Quimby was just 37 years old.

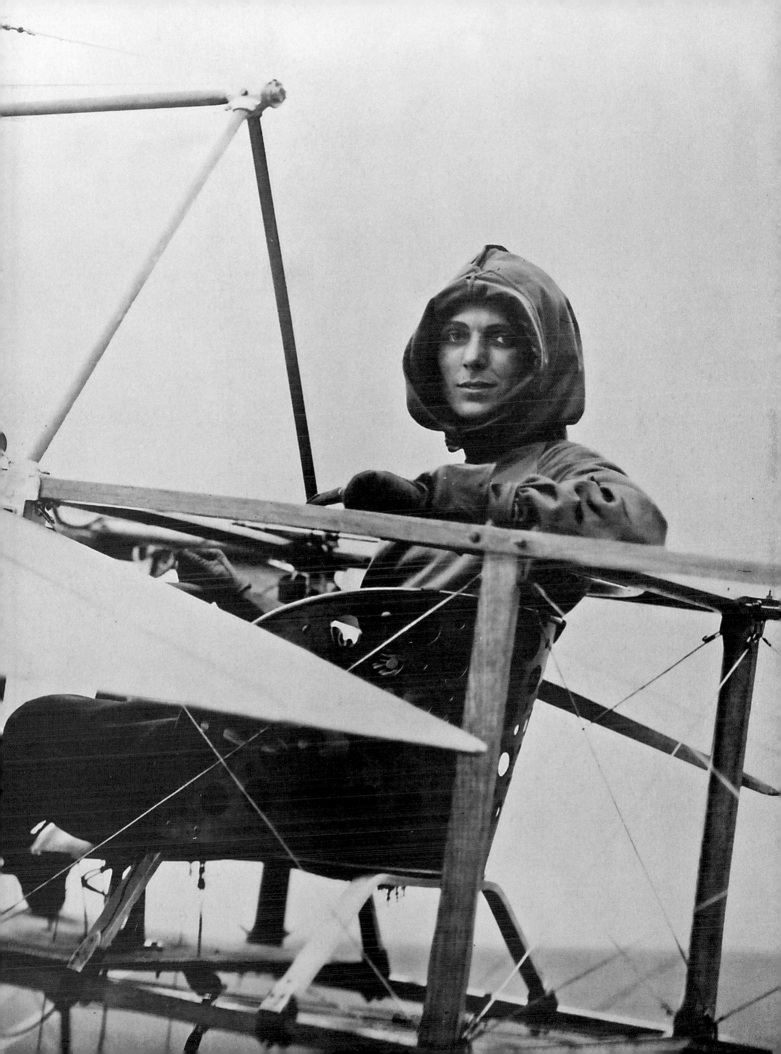

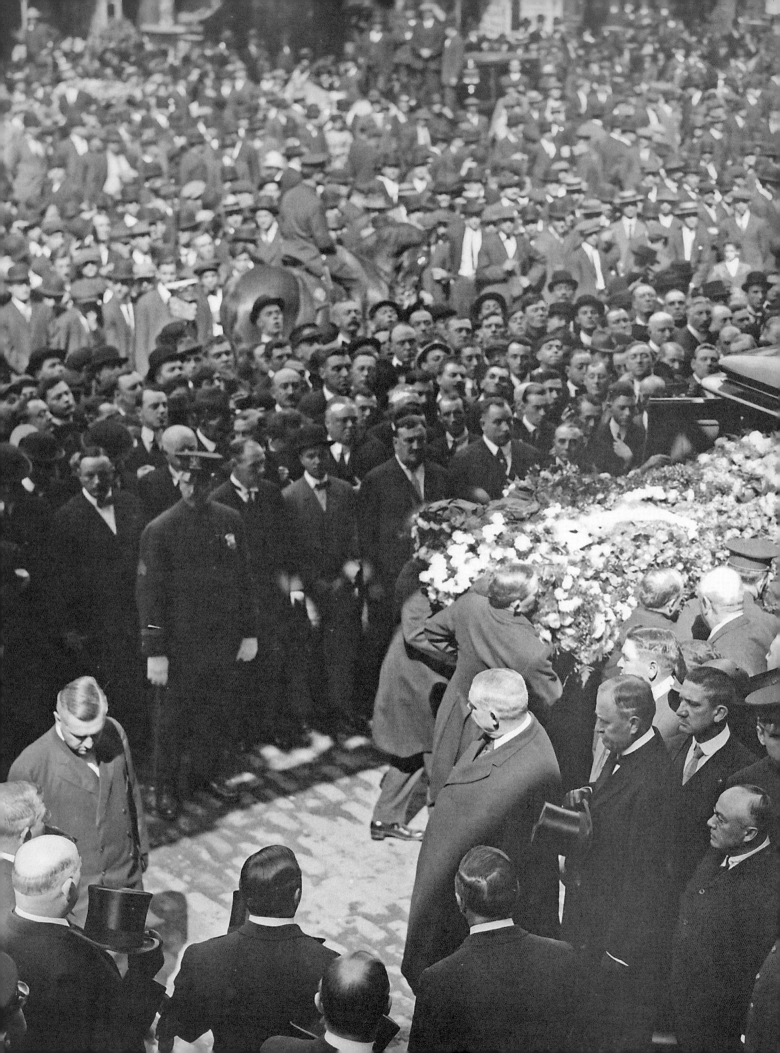

SULLIVAN FUNERAL

Timothy Daniel Sullivan, known to supporters and detractors alike as "Big Tim" or simply "The Big Feller," was a popular and powerful politician who represented the crowded neighborhoods of lower Manhattan in both Albany and Washington, D.C. from the late 1880s until his death in 1913. His close association with Tammany Hall and the New York underworld contributed to a reputation for political corruption and lawlessness, though his long support for women's suffrage, his work on behalf of some of New York's poorest citizens, and his sponsorship of comprehensive gun control legislation (the so-called Sullivan Law) make any simple categorization impossible.

In 1912, Sullivan decided to run again for Congress (he served there from 1903 to 1906), but though easily elected, he never took his seat. In July of that year he began to suffer bouts of manic-depression accompanied by increasingly paranoid delusions and hallucinations, and in September he had a complete nervous breakdown. For most of the next year he shuttled between various sanitaria, finally ending up under the care of a crew of male nurses at his brother Patrick's house in Eastchester.

On August 31, Sullivan wandered away from Patrick's house. For nearly two weeks the press speculated endlessly about his whereabouts, but he seemed to have disappeared without a trace. In fact, Sullivan was dead the whole time, hit by a train not far from the house. His body lay unclaimed at the Fordham Hospital morgue until a patrolman assigned to the unenviable morgue detail recognized the shabby, mangled man on the slab as the big man himself. On the day of Sullivan's funeral, as many as 75,000 people lined the streets as his flower-covered coffin was brought out of the Sullivan Clubhouse at 207 Bowery, and taken slowly by hearse to St. Patrick's Old Cathedral on Mott Street. Big Tim is buried at the Calvary Cemetery in Woodside, Queens.

E. ROEBER AND HIS SALOON

Ernest Roeber, known to wrestling fans as the Adonis of the Bowery, reigned as European and American champion of Greco-Roman wrestling from 1892 to 1902. He fought here and abroad, achieving celebrity status in well-publicized contests with the likes of Sorakichi Matsuda, described by the *New York Times* as the "illustrious Mikado of wrestlers," and Yusuf Ismail, whom the press saddled with the nickname "The Terrible Turk." Roeber actually fought Ismail twice, the second time on April 30, 1898 at the old Metropolitan Opera House on 39th and Broadway in a fight that ended with a "no contest" decision.

Roeber established his saloon at 499 Sixth Avenue (now Avenue of the Americas) about a year before his official retirement, and operated it until Prohibition took effect in 1920. He owned another saloon in the Ridgewood section of Brooklyn. As the proprietor of a popular bar in a rough section of town, Roeber had several run-ins with the Manhattan police, though none of them seriously damaged his reputation for honesty and fair fighting. In fact, in 1930 he went back into the ring, this time as referee. Finally in 1934 his physician advised that he retire for good because of a seriously enlarged heart. Roeber died at age 82 in his home in Auburndale, Queens on December 14, 1944, leaving his wife Minnie, two sons, Ernest Jr. a New York City fireman, and Frederick, a merchant from Sayville, several grandchildren and one great grandchild.

This picture was probably made in the spring of 1908; Ernest Roeber is the man on the left standing with his hands in his pockets. The other person leaning against a display of the day's newspapers may well be one of his sons, perhaps Ernest Jr. who worked just around the corner at the fire station at 6th Avenue and 33rd Street.

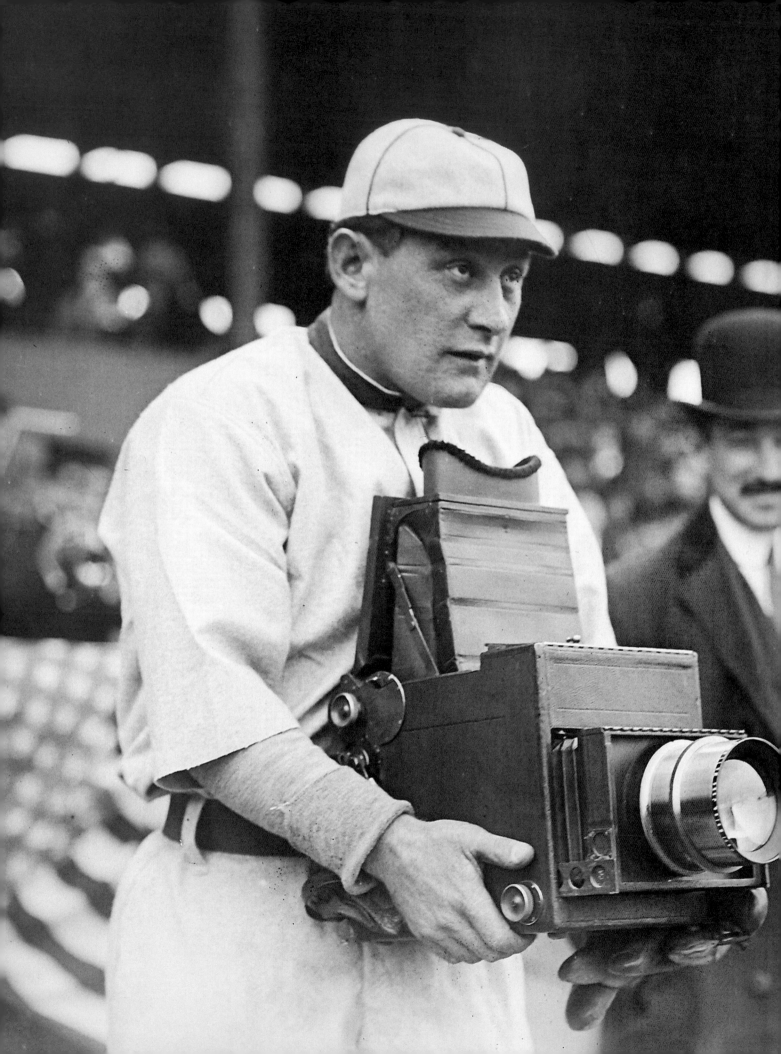

SCHAEFER–WASHINGTON

Herman "Germany" or "Dutch" Schaefer was never much of a slugger, but he played respectable major-league baseball from 1901–2 and from 1905–14. His career began in 1898 in Sioux Falls, South Dakota, where he played a year of semi-pro ball. From 1899–1901 he played for Kansas City in the Western League, then got his start in the majors with the Chicago Orphans (now the Cubs) in 1902. Poor hitting that first season led to another stretch in the minors, but in 1905 he joined the Detroit Tigers, staying until late in the 1909 season when he was traded to the Washington Senators.

Schaefer might not be remembered at all today if not for his decision in August 1911 to steal first base (from second) in an attempt to draw a throw from the White Sox catcher that would allow his teammate Clyde Milan to scamper home from third. The ploy failed to work, though Schaefer did arrive safely on first. Not long after that game, officials amended the rules to prohibit running the bases in reverse. Though never much more than a decent journeyman player, Schaefer was always entertaining and popular with the fans, known as much for his on-field capers as for his work in the field and at the plate. He once came to bat in a raincoat during a steady downpour, which drew the ire of the home plate umpire who ejected him from the game. The same thing happened when he came to the plate wearing a fake mustache.

In this photograph, taken in 1911 prior to a game between the Senators and the New York Highlanders (later the Yankees) at Hilltop Park at 165th and Broadway, Schaefer holds a Graflex 5x7 Press Camera. Equipped with a telephoto lens and a fast focal-plane (1/1000 sec.) shutter, the camera was for years the preferred tool of American sports photographers.

ILLUSTRATORS AT PLAY

The festivities at the Berkeley Theater in the evening of February 19, 1914 were out of the ordinary, even for the Berkeley. The small theater at 23 West 44th Street had a reputation for presenting programs designed to educate and uplift. On Sunday nights during that January and February, for instance, Emma Goldman, the famous (or infamous) Anarchist, feminist, and labor organizer, gave a series of lectures on theatrical drama as a purveyor of modern ideas and social reform. On the 19th, however, the Berkeley was rented out to the Society of Illustrators for their fifth anniversary celebration, and there was nothing especially uplifting or educational about the event.

As usual, this meeting was no staid affair suffused with the drone of serious speechifying and a strict adherence to the rules of order. Society members were some of the most creative artists in the country, and this was still the Golden Age of Illustration. So instead of formal speeches and the reading of minutes, the highlight of the evening was a presentation of two short plays complete with fancy costumes and some cross-dressing. The first work, "Perfectly Happy," was written and directed by artist and illustrator Charles Buckles Falls, who starred as the Philandering Queen; three of his fellow illustrators played the Red Lover, the Green Lover, and the Gray Lover. In the end, the queen found happiness in a rigorous ascetic life with a Hunchback King. The second play, described by the *Times* as a "smoker in two whiffs and a reel," was the work of illustrators Robert Wildhack and Fred Dayton.

It is likely that George Bain attended the meeting at the Berkeley Theater. He belonged to the Society and was friendly with many of its most famous members, including James Montgomery Flagg and John Wolcott Adams. This photograph is likely a cast picture of the evenings' entertainers.

BILL SNYDER AND HATTIE–CENTRAL PARK

In 1903, Bill Snyder, once the chief trainer of elephants for the Barnum and Bailey circus, purchased a baby elephant captured a year or two before in Ceylon (now Sri Lanka), from Carl Hagenbeck, a formidable collector and seller of wild animals, and installed her at the Central Park Zoo where she became an overnight sensation. Snyder named the little elephant Hattie, after his daughter, and taught the animal an array of tricks that delighted both audiences and the press. The *New York Times* described Hattie as the "most intelligent of all elephants," and followed her career closely.

Hattie's tricks included blowing into a specially constructed mouth organ and "waltzing" around her enclosure, and she seemed fond of Snyder and his daughter, who occasionally assumed the role of handler. Hattie's docile nature and intelligence, combined with a willingness to perform made her a valuable commodity, and Hagenbeck reportedly attempted to buy her back for four times the original price of $5000, but Snyder and the Zoo would have none of it. In this 1913 photograph, Hattie performs one of her tricks for Snyder, while her companion, probably Jewell, looks on.

Although the average life span of elephants in the wild is about seventy years, Hattie lived for just over two decades. She had been deathly sick once before, in April 1911, at which time Snyder concluded she suffered from colic caused by overeating clover and prescribed two quarts of whisky laced with plenty of linseed oil and laudanum. This seemed to work, and when Hattie became ill again in November 1922, the zoo's resident veterinarian, Dr. Harry F. Nimphius, prescribed more whisky. This time there was no cure, and Hattie died, though the news of her demise was withheld for several days until her body could be removed from the elephant house.

CONSUL PETER SMOKING

Either George Bain or his photographer mislabeled this picture. The chimpanzee's name was Peter, a.k.a. Peter the Great or Prince Peter, but he was no relation to either Consul or Consul Jr., two other famous chimps on the vaudeville circuit in the early 1900s. The three animals crisscrossed America and toured Europe, delighting audiences by smoking, eating with utensils, roller skating, and riding bicycles. They dressed in suits and wore shoes, and by all accounts worked hard, often doing two or even three shows a day, every day.

Peter arrived on the *SS Philadelphia* from Southampton, England on July 31, accompanied by his trainer, Vernarde McArdle and his wife Barbara. Before disembarking, Peter posed for pictures, all the while holding the hand of Barbara McArdle and puffing on a cigar. In New York, Peter played two shows daily at Oscar Hammerstein's Victoria Theater and Paradise Roof Garden, a grueling schedule for any performer but especially so for one just three feet tall with a smoking habit.

None of the performing chimps lived for very long. Consul died in Berlin in 1907. After being stuffed, mounted, and shipped to New York, his body was exhibited briefly at a Sixth Avenue saloon before being given to the Museum of Natural History. In March 1910, Consul Jr. died of pneumonia at the Hotel Delaware in Dallas despite the best efforts of at least three physicians. There were rumors that both he and Consul I were heavily insured. As for the Peter in this photograph, he is reported to have died just nine months after his triumphant arrival in the United States.

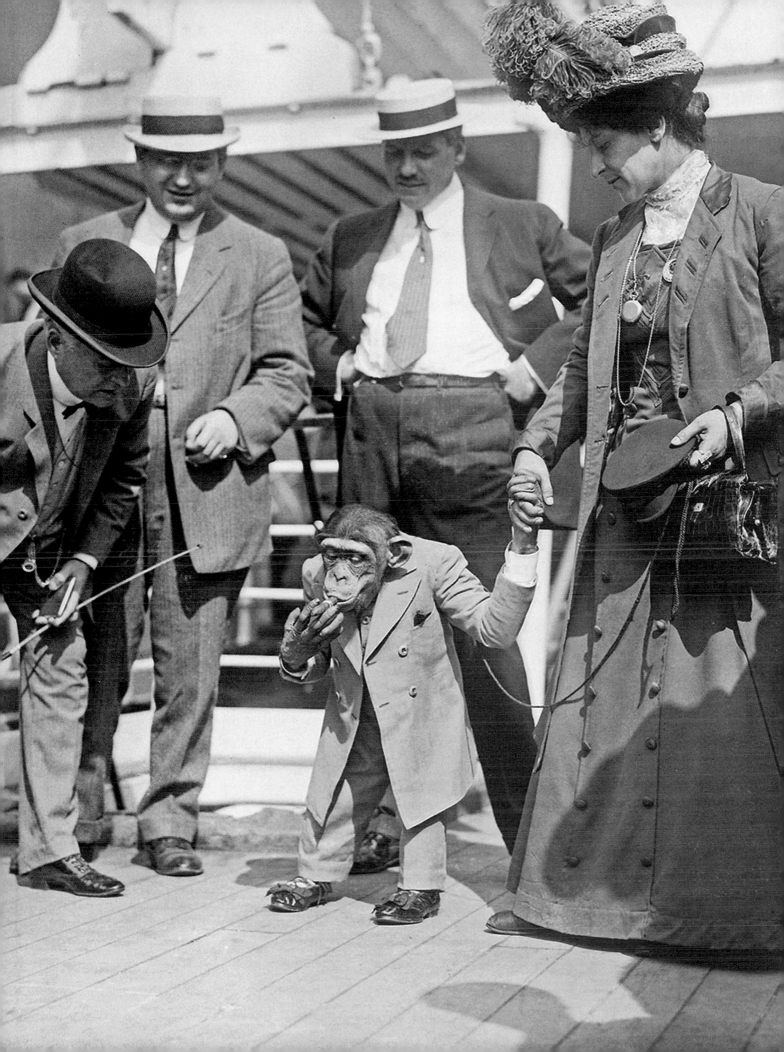

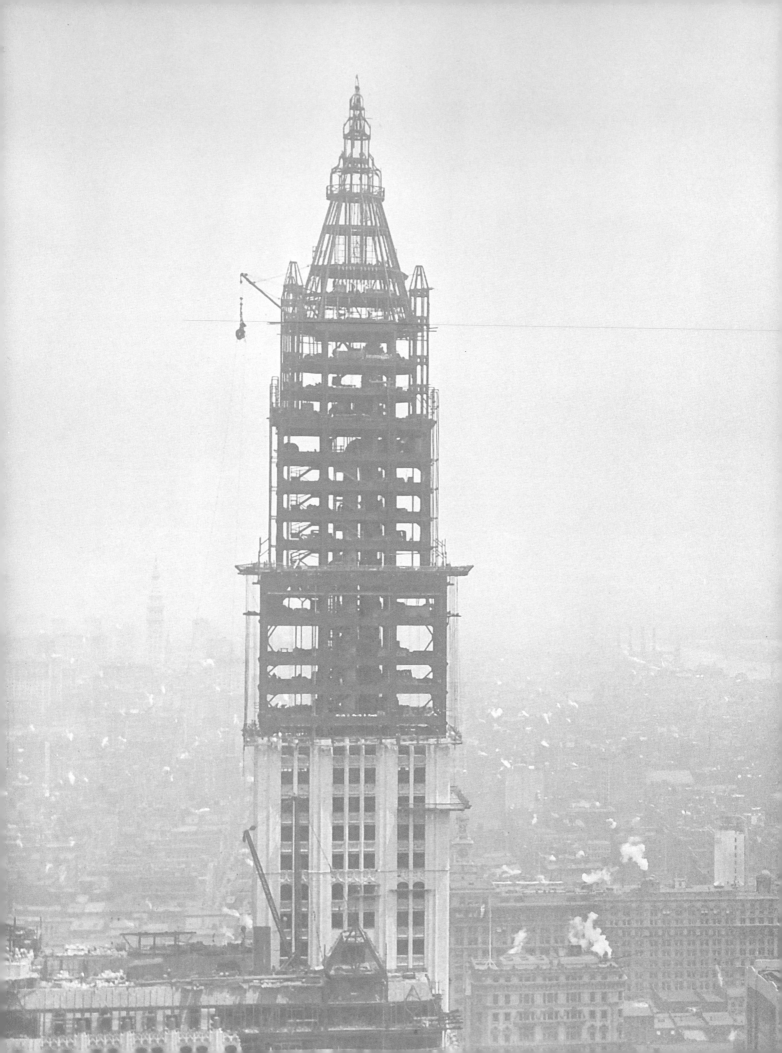